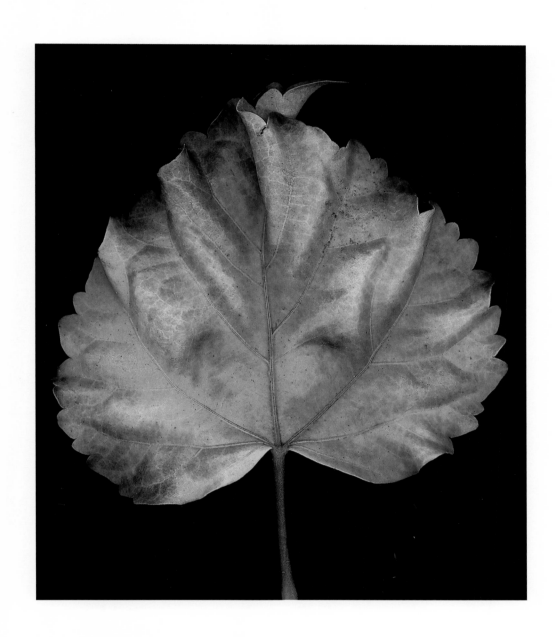

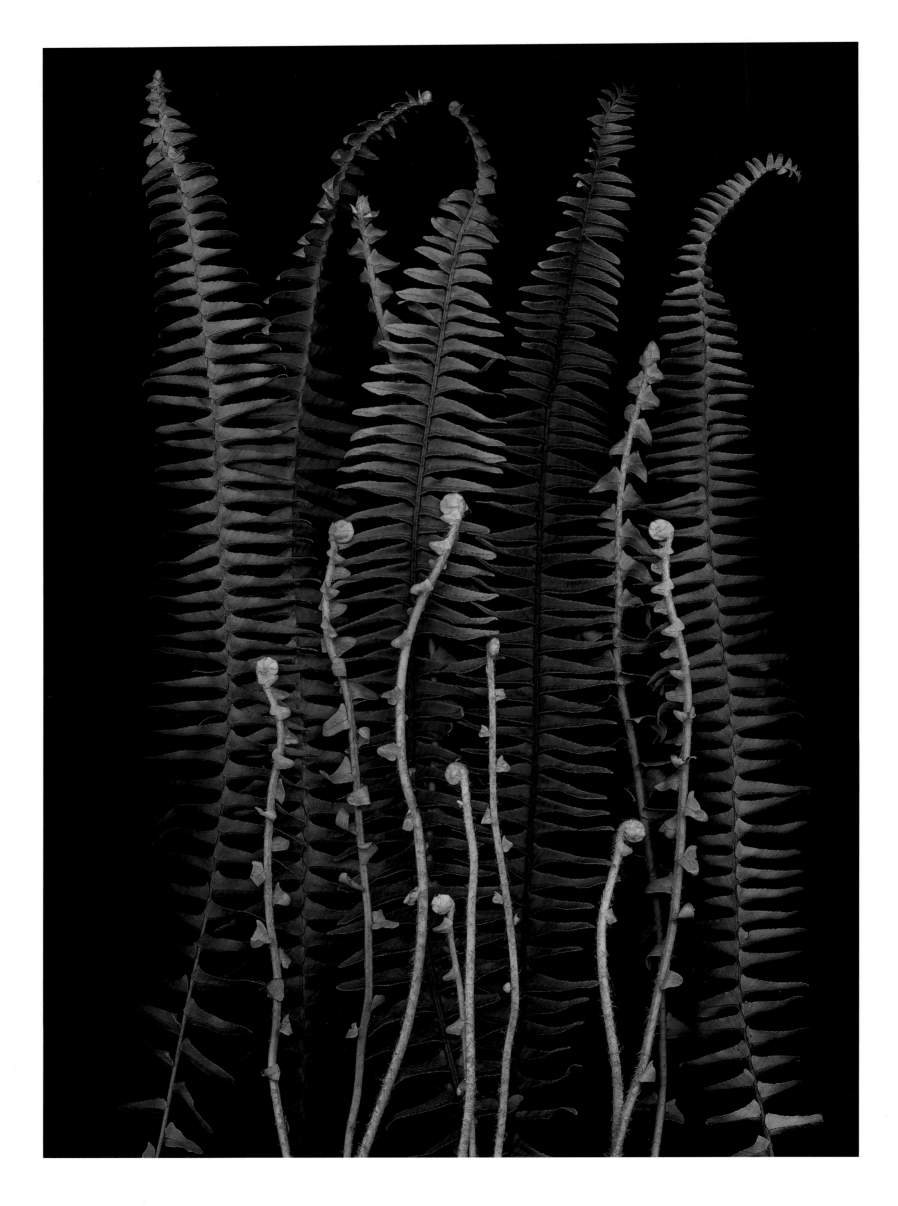

FOLIAGE

HAROLD FEINSTEIN

LOOKING BEYOND THE OBVIOUS
SYDNEY EDDISON

THE ARCHITECTURE OF NATURE ENHANCED
ALEXANDRA ANDERSON-SPIVY

BOTANICAL NOTES
GREG PIOTROWSKI

A BULFINCH PRESS BOOK / LITTLE, BROWN AND COMPANY
BOSTON · NEW YORK · LONDON

First Edition

ISBN 0-8212-2739-4

Library of Congress Control Number 2001091847

Bulfinch Press is an imprint and trademark of Little, Brown and Company (Inc.)

PREPARED AND PRODUCED BY CONSTANCE SULLIVAN / HUMMINGBIRD BOOKS

DESIGNED BY KATY HOMANS

Printed and bound by L.E.G.O.

Captions for pages 1 through 12

1. HIBISCUS LEAF, *Hibiscus rosa-sinensis* cultivar

2. CHRISTMAS FERN, *Polystichum acrostichoides*

5. JAPANESE PAINTED FERN, *Athyrium niponicum* 'Pictum'

6. BITTERSWEET, *Celastrus sp.*

8. PUSSYWILLOW FLOWERS, *Salix sp.*

14. GOLDLEAF, *Schefflera arboricolas*

PRINTED IN ITALY

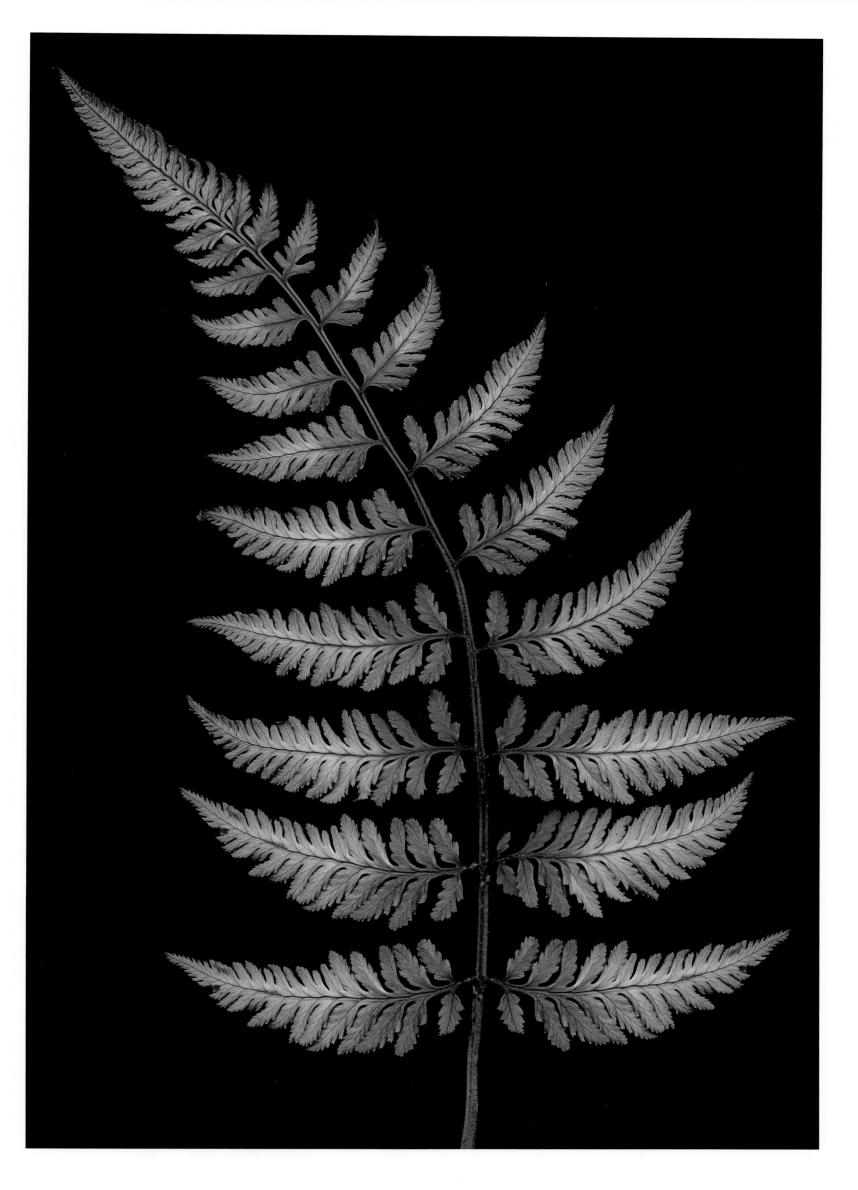

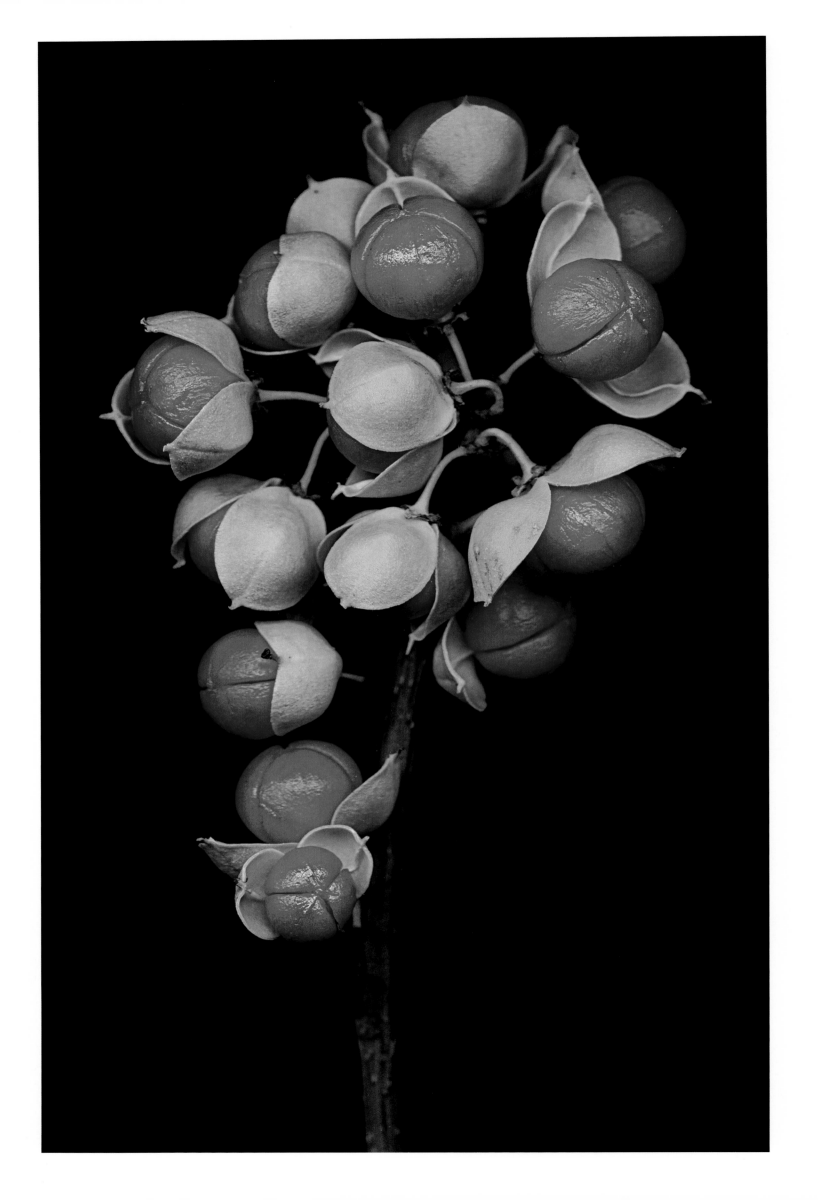

CONTENTS

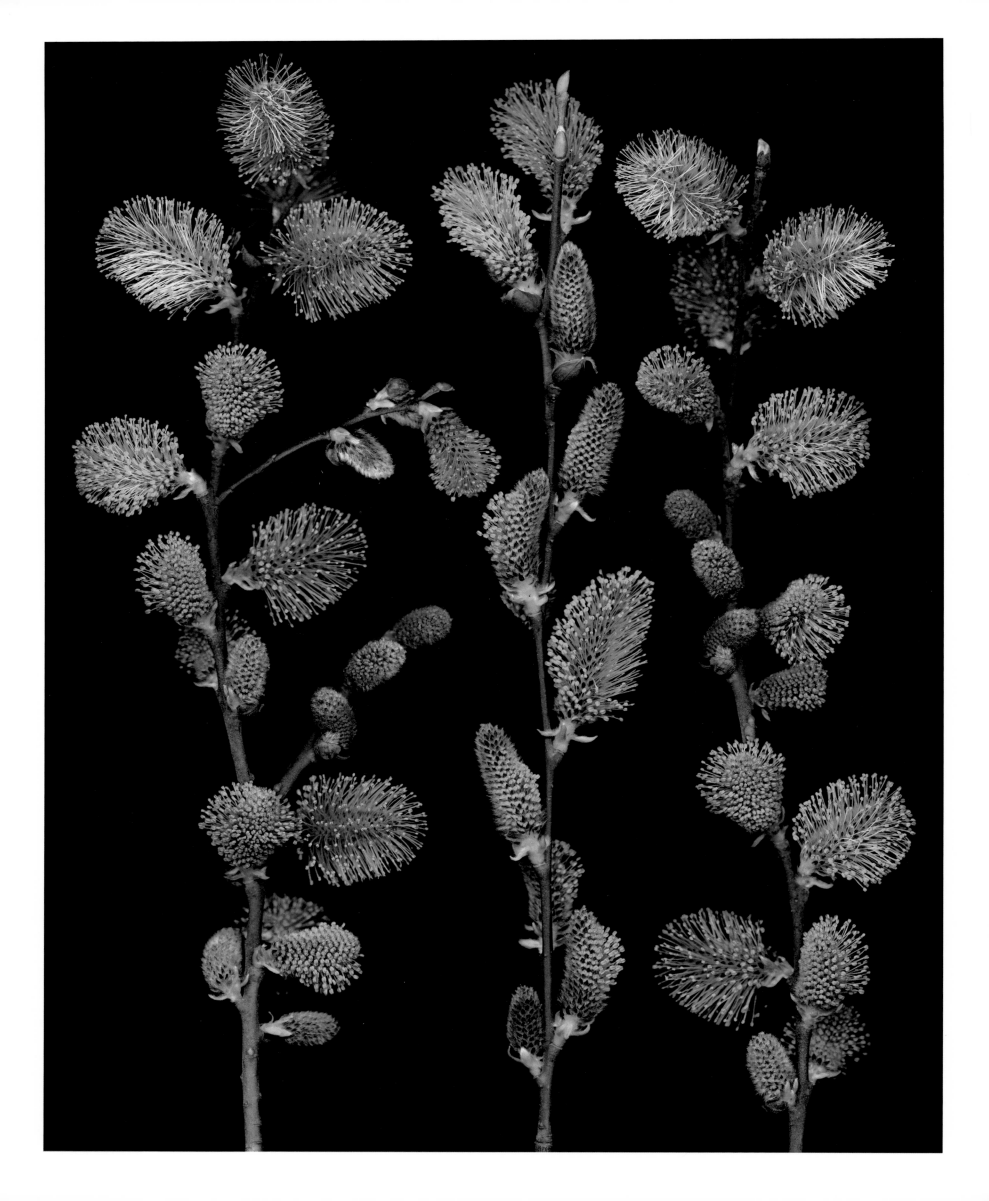

LOOKING BEYOND THE OBVIOUS

SYDNEY EDDISON

Children look at plants and wonder. They look at every part, wonder what it does, what it tastes like, feels like, and smells like. Do the flowers make you wrinkle up your nose in distaste, or do you want to bury your face in them?

Will a seedpod split, curl up, and fly apart at the slightest touch, like jewel weed, or do you have to crush the shell with a stone, like a hickory nut? What will the fruits taste like? Will they be as sweet as wild strawberries or as tart and woody as huckleberries? Will the leaves raise welts on bare young legs, or will a handful take the bite out of a bee sting?

Adults lose the ability to relate to plants in this fearless, intimate way. We become too rushed and busy to look at nature's handiwork with a child's attentive curiosity. Given a pinecone, a child will turn it upside down, right-side up, examine it from all angles, and wonder what lies beneath the brown scales. Adults, however, may assume they know all they need to know about a pinecone.

In this new collection of riveting photographs, Harold Feinstein restores our sense of wonder and shows us how to look at plants in a new way. His subjects range from the beautiful to the bizarre. Through his sensitive eyes and the lens of his camera, we marvel afresh at the complexity and strangeness of nature.

In *One Hundred Flowers*, the photographer showed us a world in which blossoms have dominion over insects and other pollinators. To insure their future, flowers trick and trap the unwilling, they woo and seduce the indifferent and lavish food and drink on the cooperative. He gave us an insect's eye view of these curious rites.

In *Foliage*, we are escorted further and deeper into even less familiar territory. This collection probes the secrets of leaf and stem, bulb, fruit, and cone. He slices through a red onion to reveal the layered design of translucent pink "leaves" and takes us to the heart of an artichoke's immature flower. We are invited to savor the sensuous forms of garlic and fennel. And in cacti and succulents, we are introduced to some of nature's oddest creations.

Desert plants, which thrive on as little annual rainfall as 12 inches, are often grotesque and forbidding in form, but also fascinating. To manage their sparse water supply, some plants store moisture in vastly enlarged stems, shaped like balls, barrels, and swollen cylinders. These are the most efficient shapes, providing a large reservoir but exposing a limited surface area.

Many cacti also fortify themselves with spines to protect their tough skin from the full brunt of the sun. The spines, which emerge from small pits called *areoles*, are numerous enough to provide insulation and a modicum of shade. These studies show us the exquisite precision with which these spiny areoles ascend a stout cylinder of mammillaria in a perfect helical pattern.

Succulents, with their flattened spirals of juicy leaves, are related to cacti and employ some of the same cooling and water-saving techniques. They have no areoles; their first line of defense is a bloomy coating of wax that makes the rosettes of echeveria look like carved jade.

The leaves of many plants are equipped with a waxy or corky layer on the epidermis in order to reduce water loss and discourage chewing insects. The gleaming cuticle on the surface of mature rhododendron foliage performs this function, while minute pores on the underside permit the exchange of gasses and escape of excess moisture. Sometimes, in the winter, rhododendrons curl their leaves inward. Unable to draw water from the frozen ground, they do so to reduce the permeable area and thus conserve water.

Rhododendrons are such a common sight in suburban gardens that we take them for granted. In his exquisitely detailed photographs, Harold Feinstein subjects the whorls of familiar evergreen leaves to minute scrutiny, giving green leaves their due, and so should we, as our lives literally depend on them.

In addition to the chlorophyll that makes leaves green, their cells are made up of water, minerals and carbon dioxide. The chlorophyll absorbs energy from the sun, uses it to manufacture food for the plant, and returns oxygen and water to the atmosphere. We, in turn, take in the oxygen and exhale carbon dioxide.

We need plants, and plants need us. Some botanists believe that talking to plants delivers a concentrated dose of carbon dioxide that actually stimulates more vigorous growth. Be that as it may, without carbon dioxide, plants could not grow and prosper. And without oxygen, neither could we.

Just as these photographs of leaves invest these deceptively simple structures with their true worth, so do the images of grasses, fruits, seeds, ferns and club mosses. They are recognized for what they are—"miracles of rare device."

Ferns and club mosses are among nature's oldest miracles. Fossil remains prove that these plants have been here for a hundred million years, and have remained relatively unchanged. Club mosses, that once crept across the forest floor beneath now extinct tree ferns, looked much the same as they do today. Their stems, branched like antlers, are thickly clothed in tiny, curved, awl-shaped leaves, which are depicted here in minute detail.

Except for their reduced size, today's ferns are also similar to their ancient forebears. The template for the elegant fish-bone design was determined before dinosaurs roamed the earth, and the ferns are still here. In the spring, the furled crosiers of hardy Christmas ferns are a welcome sight as they push their way up through last year's dry leaves. Maturing from the bottom upward, the tips of the young fronds remain coiled until the leaf blade expands completely, and the pinnae or leaflets unfold outward.

The camera captures a split-second in that surge of strong spring growth, the flow of energy and thrust of sap rising. Some fronds have completed their ascent; others, their tips still furled, continue to strain upward.

Whether the subject is a native fern, or an exotic fruit like the pineapple, Feinstein takes us beyond the obvious. Many of the images in this new collection seem unfamiliar to us only because the point of view is different.

At the tops of tall pine trees, female cones dangle, singly or in pairs, at the ends of the twigs. This miniature work of art is worthy of our consideration, not because it takes from two to three years to create, but because it is beautiful.

It takes time to make a pinecone. In the first season, the cone is so small and the scales so tightly compressed that it is barely recognizable. But beneath each scale a future seed has already formed. On the same tree, the male reproductive cells appear as clusters of short, plump anthers. In the spring when they are ripe, they shower the receptive female cones with yellow pollen. Finally, a season or two after fertilization has taken place, the female cones assume their familiar appearance. The scales dry, turn woody, and curl upward to shed the seeds.

The seeds of conifers are naked and unprotected because pines and other conifers are older, simpler plants than flowering trees. In flowering trees, the pistil in the center of each blossom arises from the ovary. Inside the ovary are ovules—the future seeds—awaiting fertilization. Once fertilized, the ovary begins to swell into a protective fruit or seed pod.

Here photographs explore the fruiting stage in the life cycle of flowering plants to particularly stunning effect. The harvest of fruits, seeds, seedpods and nuts is wondrously varied and arresting. In the odd beauty of a crumpled bell pepper, we see a three dimensional form as weighty and impressive as a Henry Moore sculpture. Five peas in a pod emerge as monumental sculpture, and the skin of a pineapple gleams like a sheet of beaten copper.

What we call the fruit of the pineapple is actually many small fruits fused together surrounding a woody stem. The eyes imbedded in the flesh are actually bracts and sepals, and account for the striking surface patterns.

Pineapples are amazing plants. Christopher Columbus is said to have discovered them growing in the Leeward Islands of the West Indies. The name was bestowed upon them by a member of his crew, who described the flavor as a combination of strawberries, apples and melon. A more plausible theory holds that the superficial resemblance to a pinecone accounts for the name.

Through the center of the fruit, the tough stem continues upward and culminates in the familiar crown of spiny leaves. If you remove the crown and plant it, it will grow into a new plant. In the remarkable photograph on page 117 showing a whole pineapple with a vertical section of the crown, you can actually see the beginnings of a new stem. Cultivated pineapples are propagated in this way, as well as from suckers or side shoots.

Fruits are actually fertilized, ripened ovaries. Many don't look like fruits at all. Nuts are fruits; burrs that cling to your clothes are fruits; grains are fruits. Wheat berries are single-seeded fruits arranged in spikes or panicles. At the tip of the tight skin enclosing each individual berry, a stiff bristle, as fine as thread, extends twice the length of the spike. Called an awn, its purpose is to catch the wind and ride it to a new destination.

William Bartram, the son of America's pioneering naturalist and botanist John Bartram, waxed eloquently in praise of the structures which permit seeds to travel. "Small seeds are sometimes furnished with rays of hair or down; and others with thin light membranes attached to them, which serve the purpose of wings, on which they mount upward, leaving the earth, float in the air, and are carried away by the swift winds to very remote regions before they settle on the earth."

Some of the most beautiful images in this collection are of these devices: the delicate awns of the wheat berry; the winged fruits of ash and maple, called *samaras*. In the ash, these dry, nonopening fruits each have one seed imbedded in a ribbon-like membrane an inch or two long. In the maple, the samaras come in pairs, joined in the middle. In flight, they all spin like the rotors of miniature helicopters.

If it were possible to have one favorite out of so many ravishing portraits of dry fruits, mine would be that of a dozen spikes of wheat. In the black void, their rigid parchment-colored stalks and fruiting heads stand out. And their awns, like the tails of so many shooting stars, streak the darkness behind them.

Wheat is as basic as it is beautiful. Probably resulting from a cross of two different varieties of wild grass, wheat has been cultivated for thousands of years. It somehow found its way from western Asia to Europe, thence to Britain, and eventually to the colonies.

William Bartram held it in high esteem. He deemed *Triticum*, ". . . which affords us bread, and is termed, by way of eminence, the staff of life, the most pleasant and nourishing food to all terrestrial animals." Certainly, members of the grass family, *Gramineae*, have fed animals and human beings since prehistoric times.

Carole Ottesen, author of *Ornamental Grasses: The Amber Wave*, described grasses as "friendly and familiar." She wrote: "Grasses grow everywhere but in the sea. At nearly every latitude, on every continent, in every country, these plants constitute a large and essential part of the natural landscape. Because they are a soft, downy vegetation that covers the entire surface of the earth, one enthusiast, the German plantsman Karl Foerster, called them 'Mother Earth's hair.'

But here the photographer often sees things in a different way. One memorable photograph shows two stalks of grass, standing side by side, elegant and solitary. These grasses are neither friendly, nor familiar, nor hair-like. They have no place in the vast congregations that make up the grasslands, but remain individuals, separate and alone.

In other grasses, we see the ornamental qualities that charm gardeners. We see the airy flowers of switch grass, a four season beauty that forms a narrow, upright sheave of foliage. In the fall, the fragile inflorescence, along with the leaves, turn a glorious shade of orange that lasts for weeks.

Many of the images in this collection belong to the fall season. No one has ever described this time of year better than nature writer Hal Borland: "It was for this that the year turned, the ice melted, the seed sprouted, the new shoot opened bud and the blossom opened petal.

This is the sequence, certain as sunrise, and there is a quiet triumph about it, a feeling of completion."

Spring, summer, fall, winter. All four seasons are represented: early spring fiddleheads; summer tomatoes and sweet corn; an autumn harvest of nuts and dried leaves; the tawny plumes of miscanthus grass in winter.

These striking photographs will guide you through growing season and beyond, and show you the downy indumentum on the young leaves of a rhododendron. In the summer, visit the farmers' market to see produce in a new light: colorful Swiss chard with a translucent crimson stem; magenta and green kohlrabi; savoy cabbage with a tree-of-life pattern embossed on its green leaves. Go to the woods in the fall, and look up at the trees as they begin to shed their leaves and spinning samaras.

The more you look at the photographs in this collection, the more you will begin to see the natural world like a child again, with awe and wonder. You will appreciate them, not only as art—pattern, design, and geometry, but as tantalizing glimpses of nature at work.

How inspired William Bartram would be by this volume! From his father, he inherited the family passion for plants and, even as a boy, accompanied his father on plant collecting trips. By the time he was fifteen, William was a knowledgeable botanist and skilled botanical artist. His early drawings of maple species illustrate the first catalog of American trees, shrubs and herbaceous plants. Delicate, detailed, and artfully arranged on the page, these drawings show leaves—front and back views—with clusters of paired samaras.

Far from breeding contempt, this familiarity with plants filled William with admiration. In the introduction to his book, *Travels of William Bartram*, published in 1786, he wrote: "Perhaps there is not any part of creation, within the reach of our observations, which exhibits a more glorious display of the Almighty hand, than the vegetable world; such a variety of pleasing scenes, ever changing throughout the seasons, arising from various causes, and assigned each to the purpose and use determined."

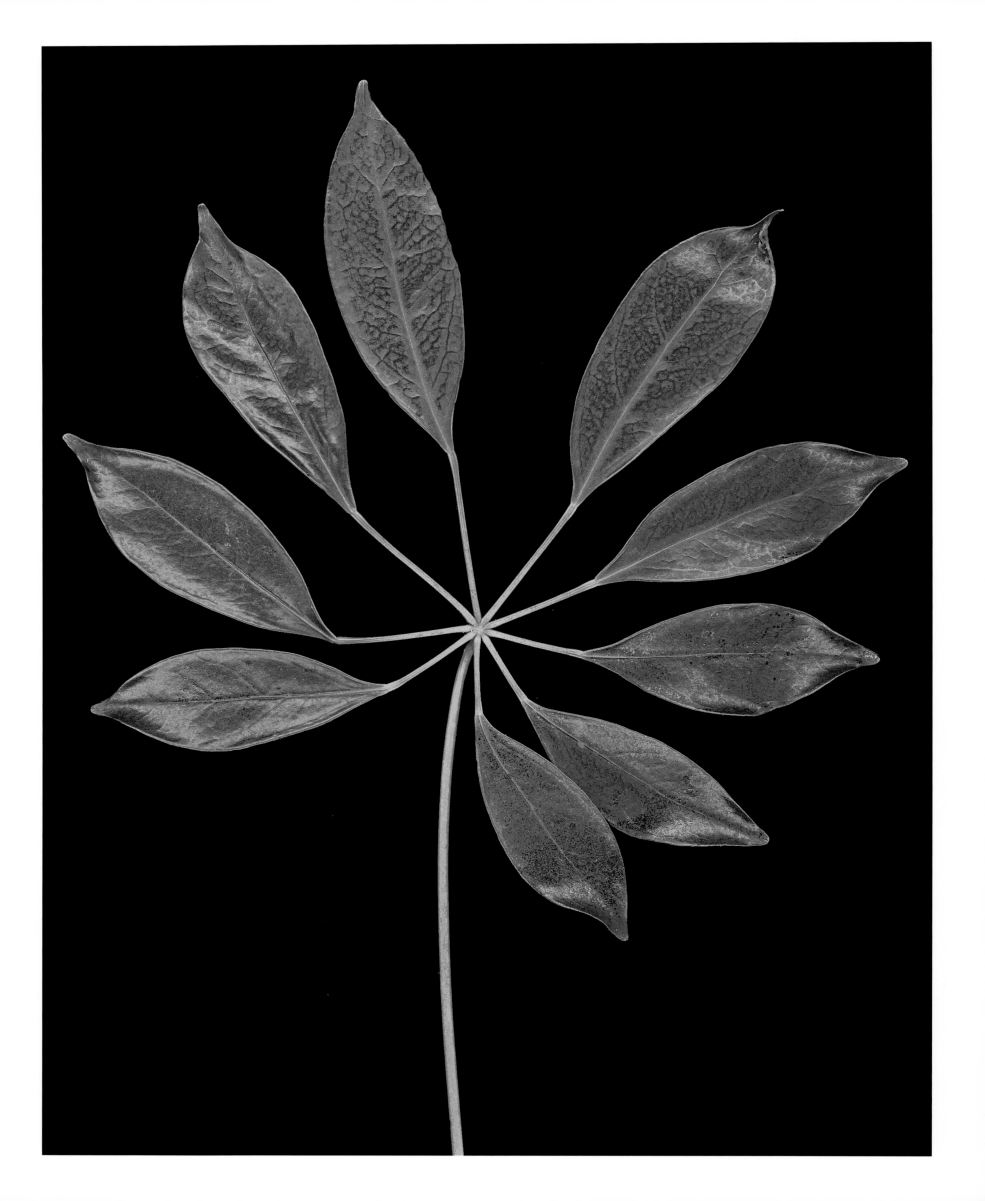

THE ARCHITECTURE OF NATURE ENHANCED

ALEXANDRA ANDERSON-SPIVY

Yet we find the works of Nature still more pleasant, the more they resemble those of Art:
For in this case our Pleasure rises from a double principle; from the Agreeableness of the Objects to the Eye,
and from their Similitude to other Objects.
JOSEPH ADDISON, THE SPECTATOR, 25 JUNE 1712

The breakthrough for our time has been the computer.
ADA LOUISE HUXTABLE [1]

Some of the world's best artists and photographers have been obsessed with natural forms, and artists have adopted the objective or scientific gaze ever since Leonardo da Vinci made anatomical drawings and studies of plants, wind, and water currents. John James Audubon's bird and animal paintings and Karl Blossfeld's austere black and white photographs of plants are other examples in which scientific observation and art converge. These artists rendered things as they are, yet they exceeded the dry exactitude of science or mere illustration by addressing their pictures simultaneously to both scientific and aesthetic concerns. Rather than hazily contemplating the pastoral sublime, such artists were meticulous and rational analysts of the specific. They broke new ground by picturing the unseen and the too-often overlooked in nature.

Harold Feinstein's photographs of fruits, vegetables, weeds, grasses, and other botanical forms fall strictly within a long tradition of such close and ecstatic seeing. Radical in their bold and skillful use of computer technology, his recent botanical, digitally-enhanced, color images are a contemporary variant of ideas that began with the Enlightenment. His latest work, *Foliage*, which you are about to enjoy, is both a companion to and a departure from his previous book, *One Hundred Flowers*. In this new book the veteran photographer explores the foliate and vegetable forms of nature using a virile precision and a painter's loving eye.

His horticultural vision is an extension of the conventions of Western botanical illustration set in the 18th and early 19th centuries by such European masters as James Sowerby, Franz Bauer, Joseph Banks and Pierre-Joseph Redouté. The work of these earlier artists is characterized by truth to nature that also emphasized pattern and symmetry, simplification, and the enlargement and isolation of forms. Feinstein's images for his latest book incorporate similar formal conventions.

The scale, style, and subject matter of *Foliage* make it clear that Feinstein has inherited the inquiring spirit first demonstrated in the great era of the taxonomic illustration of plants that began around 1700 and ran for over two hundred years. The results were published—often in severely limited editions—as sumptuously produced folio-size books of engraved color plates.

These were volumes whose development documented the rise of scientific thought, the investigation of natural history and the expansion of botanical exploration. These lavish products of the newest technical developments in printing and engraving represented the cutting edge of evolving printing technologies. Desirable at first for their visual elegance, as well as for the information they contained, they are still coveted by collectors today. (Satcheverell Sitwell documented many of the landmarks of botanical publishing in his beautiful *Great Flower Book*, published in 1956.)

Feinstein's dramatically architectural photographs of grasses, leaves, fruits and vegetables link him to a great historical tradition. Such images as his sensuous and monumental yellow pepper and his sculptural cactuses also reveal his modernist affinities with Edward Weston, Paul Strand and Minor White. But his new pictures really mark a new and different chapter in a long and distinguished career as a photographer and teacher. His horticultural pictures evidence a definitive shift in scale, subject and technique from the black and white photographs that made his reputation in the 1950s. Feinstein has been a widely published professional photographer for some 55 years. He established his name with his animated documentary images of dense, democratic urban life in and around Coney Island (where he was born) and New York City. His success came quickly; by the time he was 19, Edward Steichen had bought some of his prints for The Museum of Modern Art's permanent photography collection.

Even though he set out to be a painter, and painted throughout much of his adolescence, he recalls the fascination of his initial introduction to photography while he was in fifth grade. That was the day that one of his school friends showed him the rudimentary darkroom set up on the bureau in the friend's apartment bedroom. He began actually taking photographs when he was fifteen. Fascinated by technique from the start, Feinstein also became a renowned master printer and teacher of silver printing.

During his professional career as a photographer, painting never entirely receded from his thoughts. His initial botanical studies began when he was living in Vermont between 1973 and 1977. One day he shot some pictures of weeds that were growing in his back yard, thinking he would keep them as visual notes to serve as a sort of diary and sketchbook—"maybe provide something to paint from later," he says now. When he looked at the images later on, he was so struck by their power that he made them the basis for a gallery exhibition of black and white photographs he called "In Celebration of Weeds."

Feinstein has always been an avid technical experimenter and a technologically skilled printer. His "hands-on" approach and his emphasis on pragmatic clarity and concrete demonstration are some of the characteristics that have made him such a legendary teacher. He had begun his experiments with color photography by 1976, the year that *Life* magazine published a selection of images from his portfolio of dye-transfer prints of flowers. Later, he made a series of Cibachromes of flowers. Now, his luscious, digitally-enhanced, folio-sized botanical images simply represent the latest foray in a lifelong experimentation with available image-producing technologies.

The master printer recognized the artistic and archival limitations of chemical photographic

processes; especially those involved in color printing. So it's no surprise that the invention of digital technology made him an enthusiastic "early adapter" of the electronic tools that have revolutionized photography in less than a decade. Along with everything else they have changed, computerized technologies have utterly transformed the capturing, storing, retrieval, manipulation, and transmission of images, making the process more flexible and easier than anyone could have ever imagined. Quicker than many of his younger colleagues, Harold Feinstein saw that digital technology is as radical a force as the invention of movable type. It became a key element in the recent evolution of his work and he became an expert in using the new tools.

The photographer bought his first Macintosh in 1995, intending to use it to catalogue his archive of black and white images. What he discovered was a new technical flexibility that gave him back much of the freedom of painting. This was especially true when it came to color, since the computer, by providing the ability to manipulate and inexpensively produce color images at will, frees the photographer from dependence on turning color over to the lab. Feinstein, known for his excellence at silver printing, says, "The end of chemical development is not the end of photography. I can now make a better digital print than a silver print."

His new plant photographs have a freshness and strength that reflect a direct transfer of the artistic impulse to the final image. The digital camera and the computer enable this to happen through their ability to redefine processes and to remove many of the physical barriers between the artist and the realization of his work. "The gift of photography is that it is an art based in spontaneity," Feinstein says. "Yet in the darkroom, when you make a print, it takes time. Digital prints also take an enormous amount of time—each one can take eight hours or more—but it's different. But because you can make incremental changes, digital tools let you keep the immediacy of your original impulse." He points out that each step on the computer gives you an immediate response and "encourages more accidents, which are an essential element of creativity."

His large, ink-jet ("Gicleé") prints, made with pigmented inks (whose archival stability now rivals or surpasses that of Cibachromes) and his large Iris prints are tours de force of color deployed with a highly refined intensity. His digital skills have made Feinstein in demand as a leading industry consultant. They also have given him access to state-of-the art equipment. These days he is testing a prototype of a digital scanning device that attaches directly to the computer to produce an immediate 8 x 10 inch image on the computer screen.

Feinstein excels at making the humblest, most familiar vegetable or weed provoke our astonishment and scrutiny. His wonder at the world remains undimmed. He says, "With my photographs, I want to do for horticulture what Audubon did for birds and animals." The images in Foliage, perhaps even more than the photographer's flowers, invite his viewers to ponder the infinite architectural variety of nature. He examines everything from ferns and grasses to grapes and Hosta leaves; from dissected artichokes and tomatoes to a tapestry of maple seeds, every shape isolated against deep black backgrounds. These images teach us again that the gorgeous diversity of nature is an inexhaustible subject.

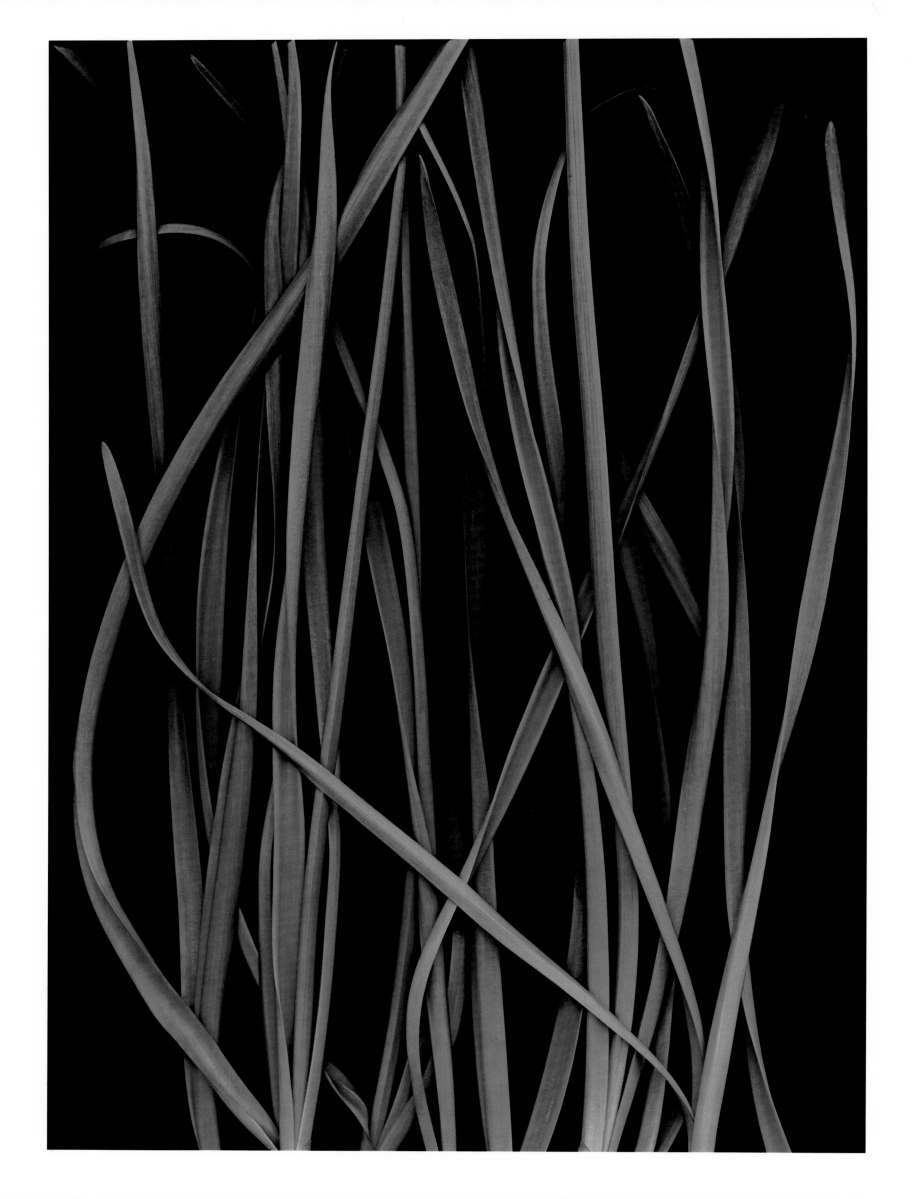

GRASSES AND FERNS

Centuries ago, before plant anatomy became a science, it was thought that all plants were more or less alike—with leaves and flowers, and seeds for reproduction. But because flowers and seeds are not visible parts of a fern's anatomy, common belief held that they were invisible. The mystery of this phenomenon evoked folklore and superstition; Shakespeare wrote in *Henry IV*, "We have the receipt of fern-seed; we walk invisible." It was thought that possession of the invisible "fern seeds" endowed a person with the power of concealment.

Although the majority of plants on earth bear seeds, ferns do not. Yet, they still reproduce— and without plant reproduction—life as we know it would come to an end. Ferns propagate by microscopic spores that they disperse by the millions. Lightweight and easily carried by wind or water, fern spores develop into *prothalli*. Flat, heart-shaped, and green—prothalli have male and female sex organs and grow into mature ferns when a female egg is fertilized. This only happens when moisture is present—allowing sperms to propel themselves to the female organs on the river of liquid connecting the two sexes.

As plants evolved over millions of years, maneuvering from water to land, some—such as ferns—were able to keep their ancestral, spore producing method of reproduction. Others migrated to areas where inadequate moisture hindered reproduction by spores. These plants transformed themselves by successfully reorganizing the concept of procreation into one that yields seeds instead of spores—a crucial development in the plant kingdom. Seeds are dormant plants containing live embryos waiting for the right moment to germinate and grow. Fossils of extinct "seed ferns" depict fern-like, seed-bearing plants that may have filled the evolutionary gap between spore-bearing and seed-bearing plants.

Seed-bearing plants prevail over all others—their valuable roots, stems, leaves, fruits, and seeds sustain the lives of almost all living creatures on earth. Among them, the bountiful grasses and grass-like plants nourish our bodies and our senses. Their fruits are the grains that have built civilizations. Wheat, rye, oats, barley, corn, sorghum, millet, and rice supply more energy and protein worldwide than any other foods in the human diet. And the cousins of these nutritional powerhouses—the ornamental grasses—beautify gardens and landscapes everywhere.

Grasses and grass-like plants have been in our gardens for centuries, but a recent cult-like devotion to them has gardeners and designers enthusiastically spreading them throughout the landscape. Success with these narrow-leaved, easy to care for plants of the prairies has stimulated their popularity. They interact so well with shrubs—the stature of some grasses reach shrub-like proportions—and when planted with perennials, they can help create a tapestry of eye-catching colors and contrasting textures. Other prairie plants—coneflowers, goldenrods, and asters—are obvious companions for developing a natural theme in the garden.

The grasses and grass-like plants grown in gardens are collectively called ornamental grasses, and include sedges, rushes, and the true grasses—they belong to the grass family, *Poaceae*. Some grasses effectively add a vertical element to the garden with their narrow, upright leaves. Others add color with leaves of gray, red, or green variegated with white or yellow. And some have fuzzy or spiky flowering stems, adding another dimension to the picture—especially when they catch the light of the rising or setting sun. Many change to a wonderful straw or tawny color in the autumn and remain handsome into the winter when wind rustling through their starched, dry leaves creates beautiful noise.

Perhaps grasses are symbolic—even on an unconscious level—of our connection to the earth. Regardless of what we eat, the nourishment from plants sustains life. And it's the grassy-leaved plants that feed the world. Thousands of years ago some sort of "farming" was inevitable, as large mammals became scarce or extinct by the hands of human predators, the need for other kinds of food became a necessity. With populations increasing and food supplies decreasing, hunter-gatherers began to practice horticulture by tending existing plants—wild grains and fruit and nut trees. Farming soon followed, and humanity evolved into what sociobiologist Colin Tudge has phrased *victims of success*. As farming becomes more successful, the population increases, and continual burdens are put on agriculture to be even more productive.

In nature, plants that disperse their seeds ensure the success of their species through continued generations. It was a lucky chance that hunter-gatherers found an anomaly among grain plants—some which did not disperse their seeds, but held onto them. This meant the grain didn't fall to the ground, nor was it carried off by the wind; it remained on the stem until it was physically removed. Along with domesticated animal power, this plant discovery contributed to the concept of farming. Plowing the land, planting it with one crop, and most importantly, being able to harvest it all at once, became an important building block in the history of many civilizations. Evan Eisenberg writes in *The Ecology of Eden*, "The alliance of grass and man has conquered the world about as thoroughly as any previous alliance, and in record time. The genus *Homo* has struggled for two million years to reach a population of five million; once the marriage with annual grasses was solemnized, it took only ten thousand years to reach the present level of almost six billion."

18. GRAPE HYACINTH LEAVES, *Muscari* sp.

"A child said *What is the grass?* fetching it to me with full hands; How could I answer the child? I do now know what it is *any more than he.* I guess it must be the flag of my disposition, out of hopeful green stuff woven."
—Walt Whitman, *Song of Myself.*

22. BENT GRASS, *Agrostis* sp.

"He who makes two blades of grass grow in place of one renders a service to the state."
—Voltaire, *Letter to M. Moreau.*

23. CLUB MOSS, *Lycopodium* sp.

The spores of some species, chiefly *Lycopodium clavatum,* form a powder that is yellow in color and very flammable. At one time this was used by photographers and in theaters to produce artificial lighting.

24. SWITCH GRASS, *Panicum virgatum*

"Pile the bodies high at Austerlitz and Waterloo. Shovel them under and let me work—I am the grass; I cover all."—Carl Sandburg, *Grass.*

25. FLORIST'S FERN, *Dryopteris dilatata* cultivar

"The ferns' great strength lies not so much in their colouring—any other leaves may be as fresh—as in their form: the delicate and sometimes intricate patterns created by a pinnately divided leaf. Ferns are good shade plants. Some enjoy sun as well, prefer it even, but most reach their maximum luxuriance in moist shade."—Christopher Lloyd, *Foliage Plants.*

26. BAMBOO, *Bambusa* sp.

From T. H. Everett's *New Illustrated Encyclopedia of Gardening,* comes the following—"Bamboo is a collective name for various tall, vigorous, evergreen ornamental grasses which are classified under their botanical names such as *Arundinaria, Bambusa, Dendrocalamus,* and a myriad others." One could become bamboozled.

27. TABLE FERN, *Pteris cretica* cultivar

Pteris comprises a large genus of ferns, many of which are popular houseplants. The name is derived from the Greek *pteron*—a wing, referring to the shape of the fronds of some species.

28. MAIDEN GRASS, *Miscanthus sinensis* cultivar

"It was beginning winter, The light moved slowly over the frozen field, Over the dry seed-crowns, The beautiful surviving bones, Swinging in the wind."—Theodore Roethke.

29. BREAD WHEAT, *Triticum aestivum*

"While the earth remaineth, seed time and harvest."—*Genesis,* 8: 22.

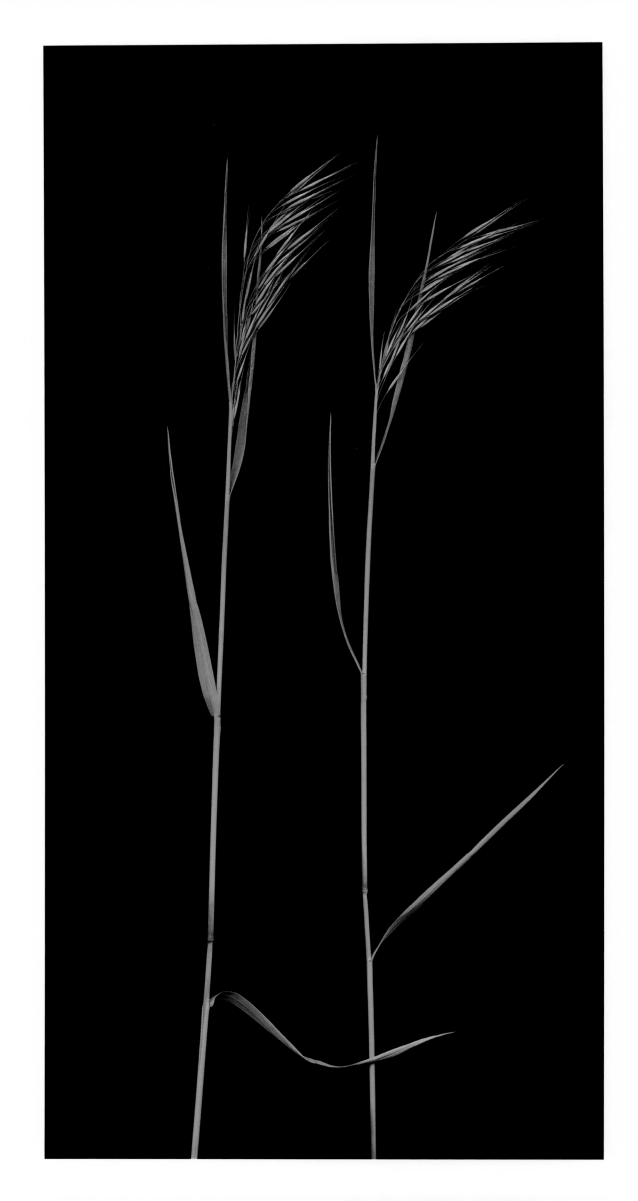

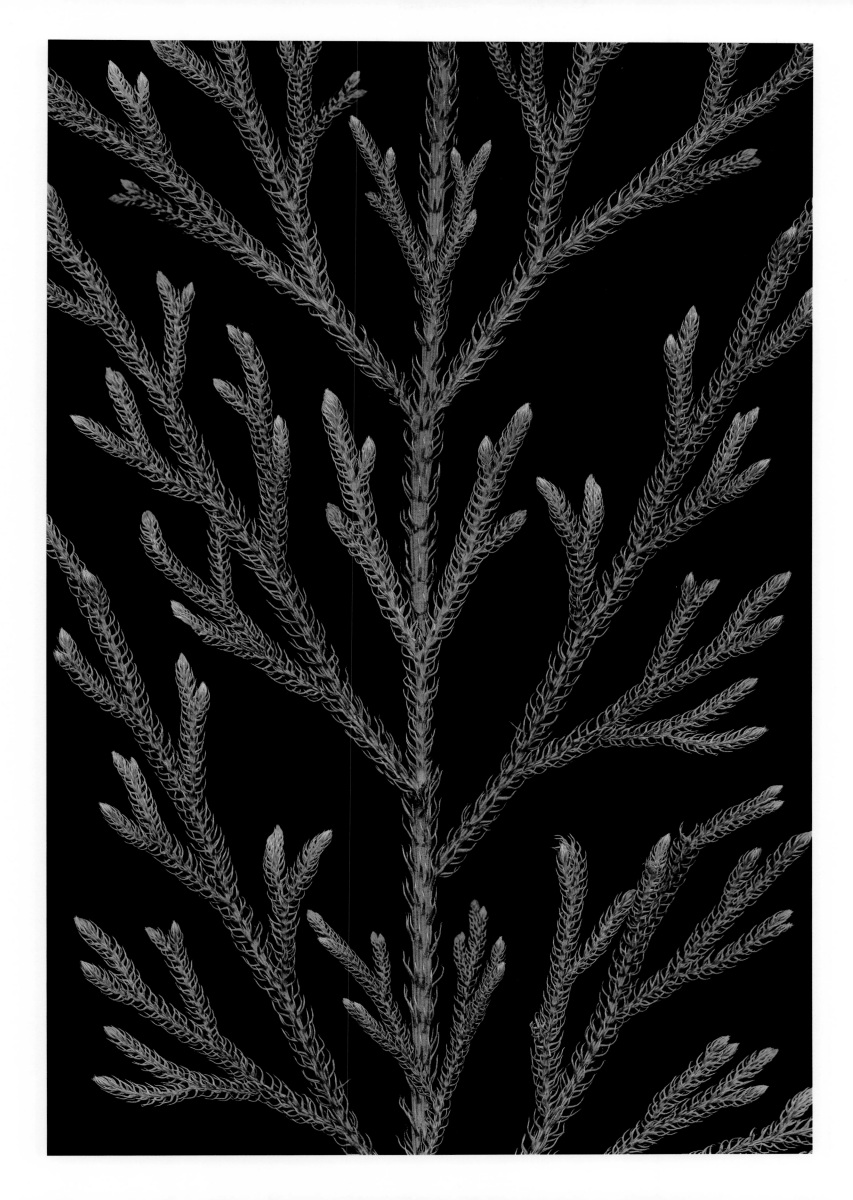

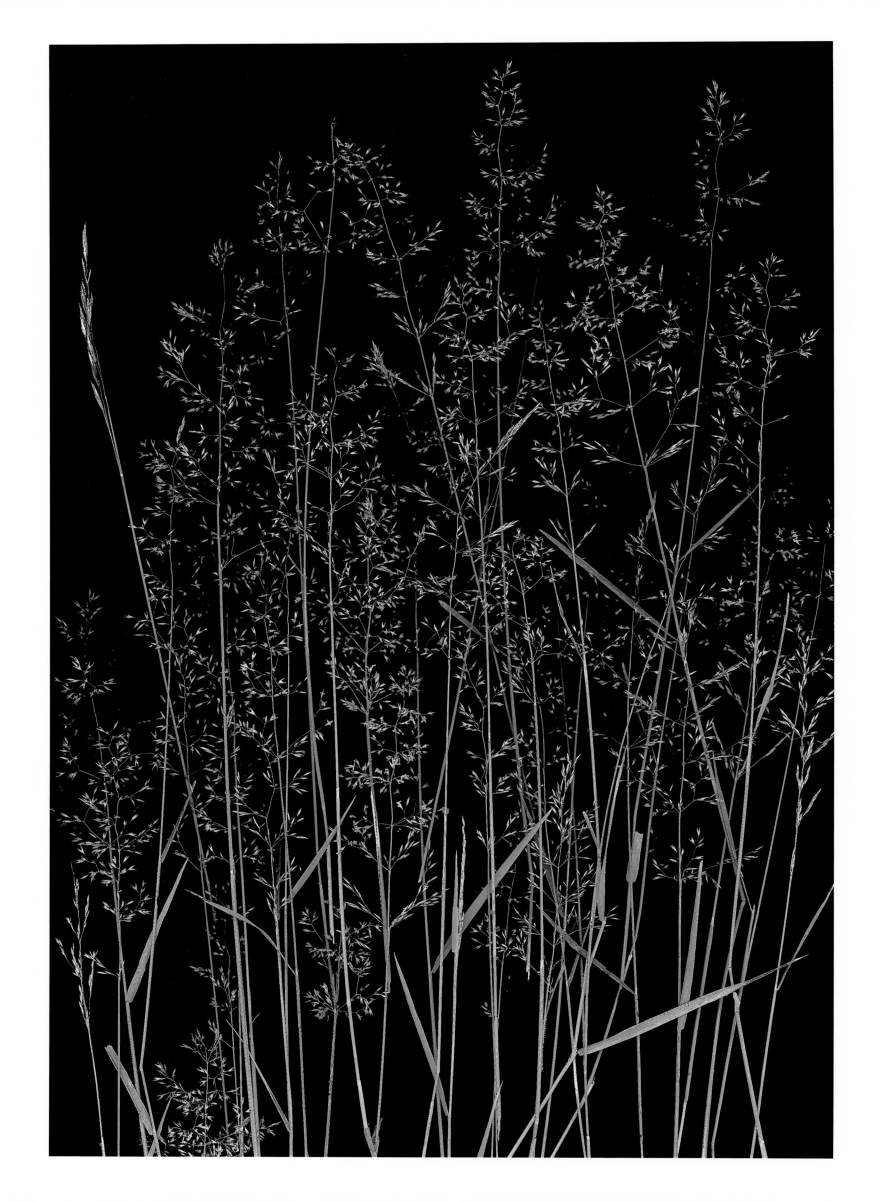

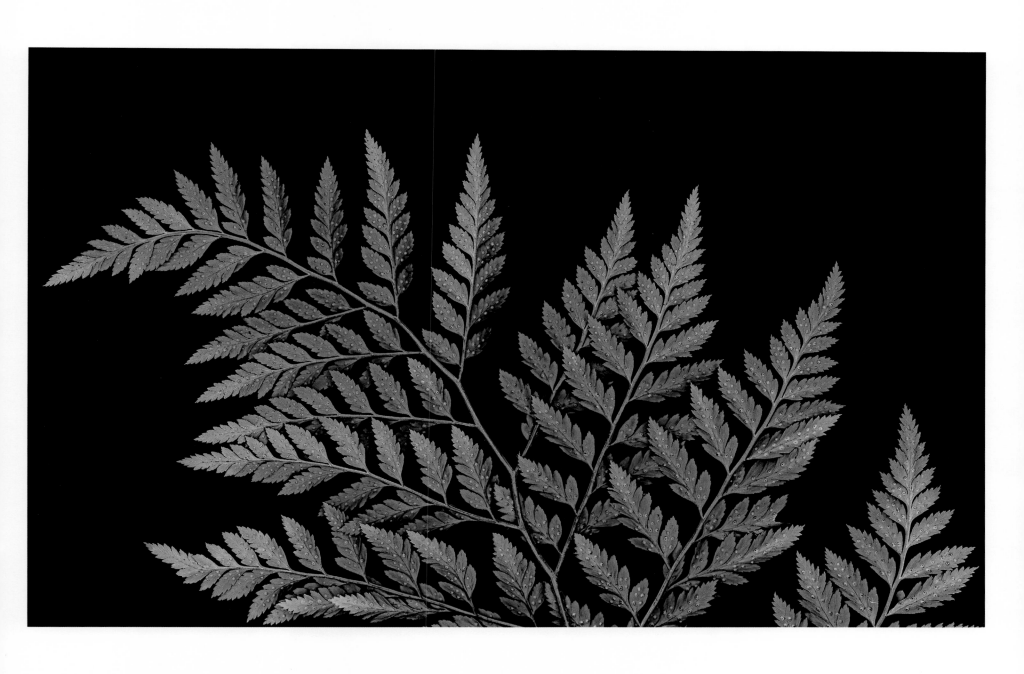

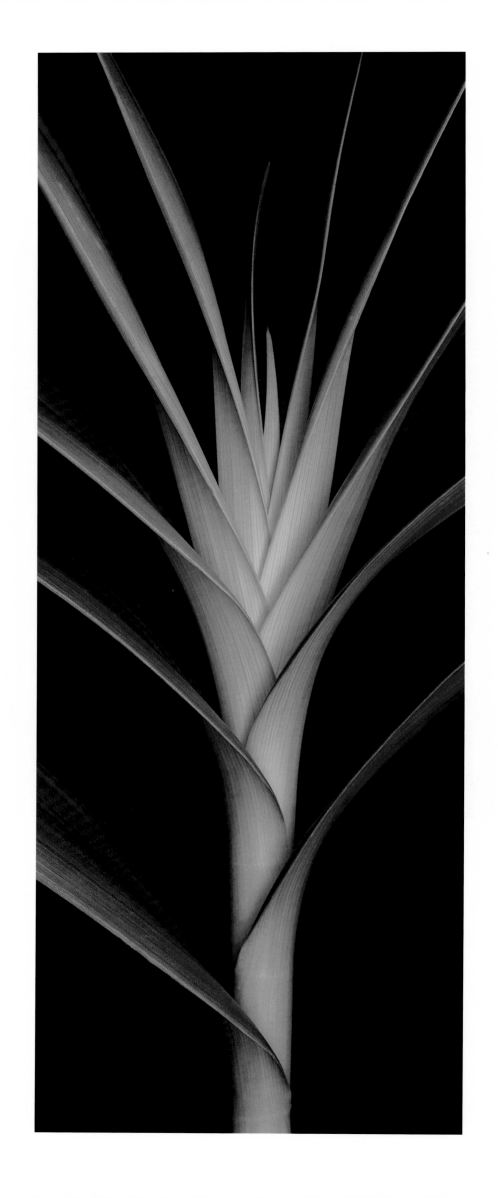

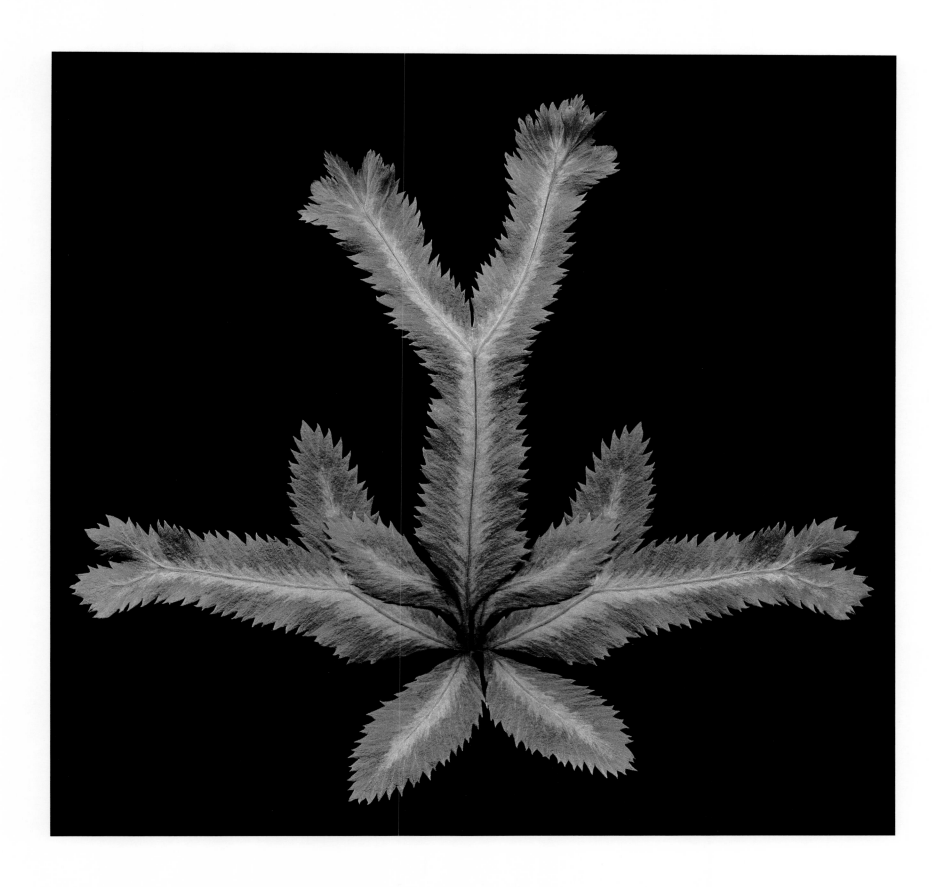

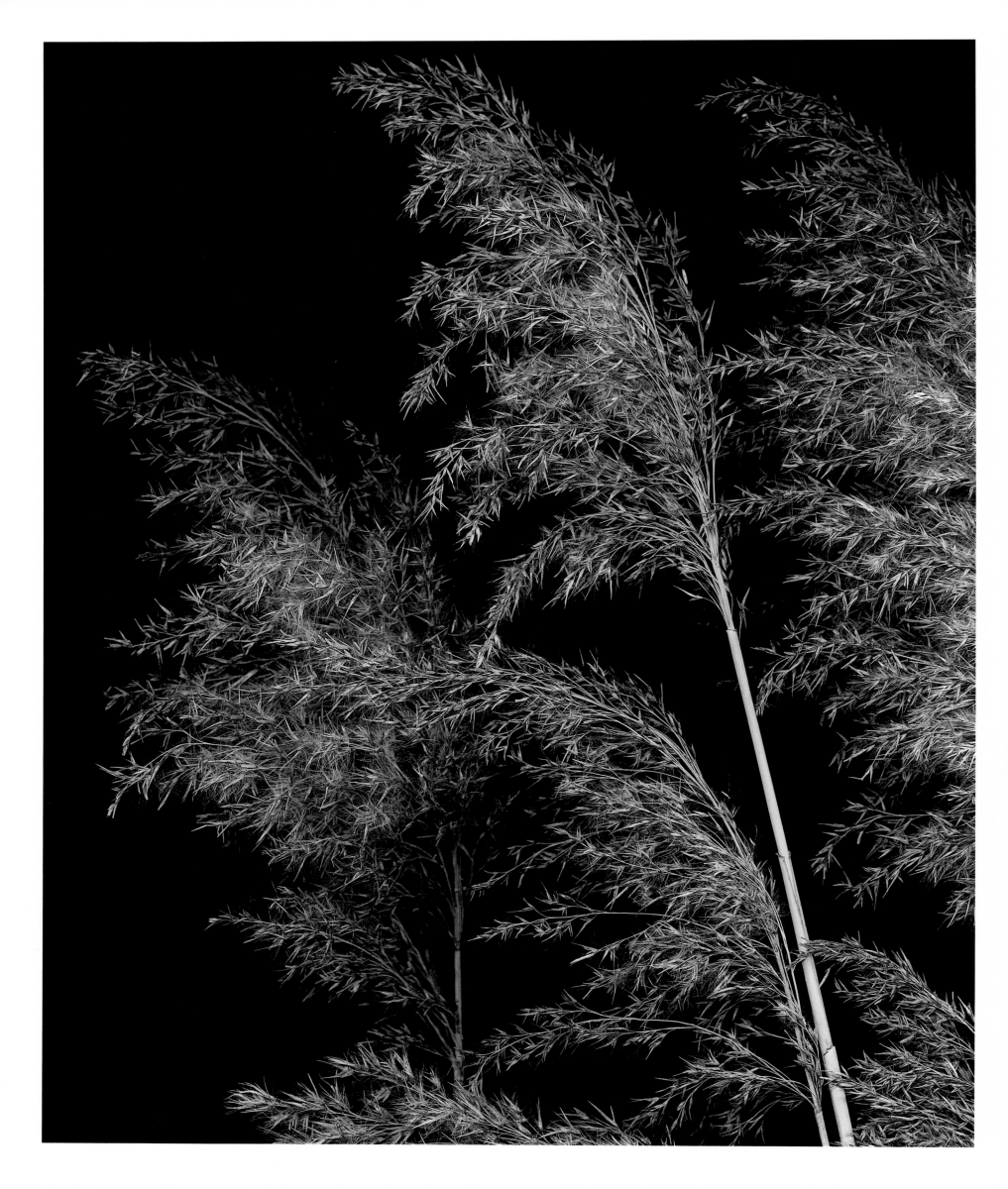

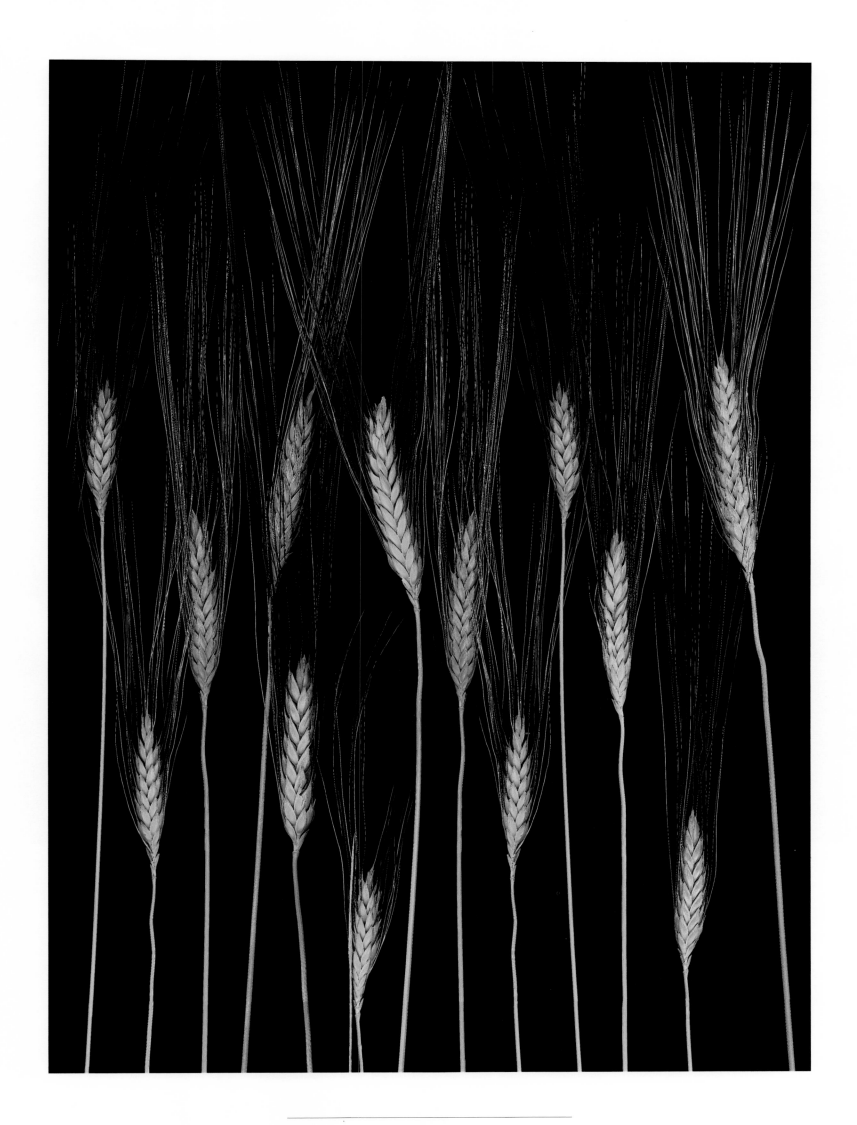

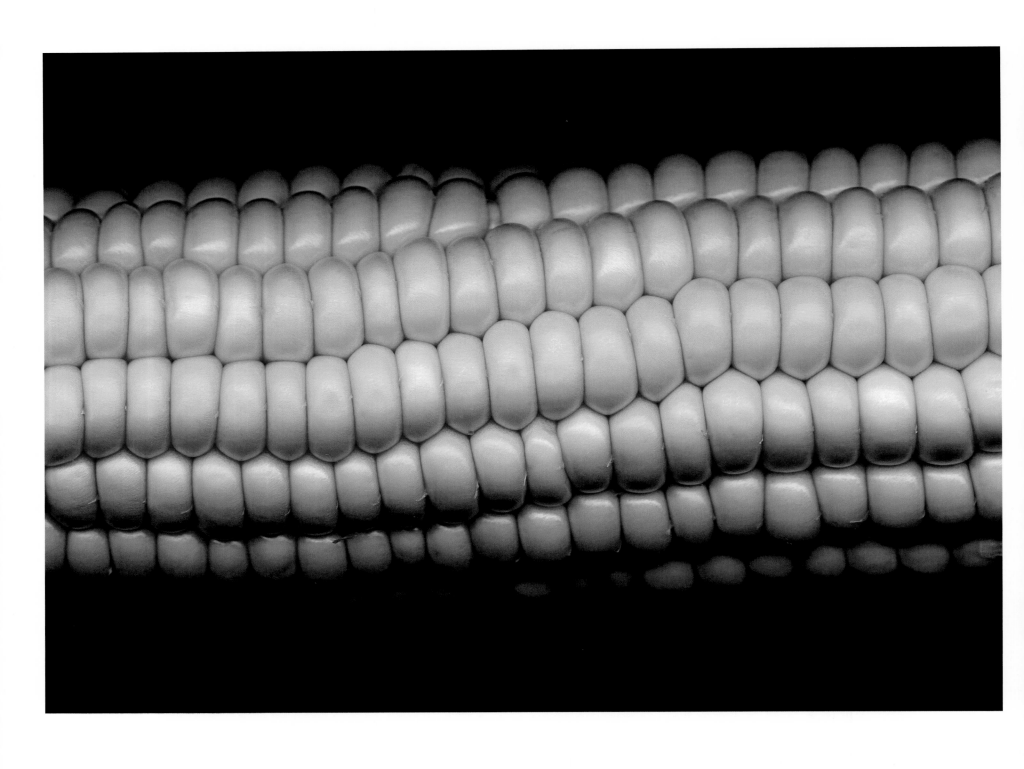

EDIBLES

Why is it we eat some plants and not others? The ones we enjoy are pleasing to the palate and adaptable to human environments—they are the domesticated offspring of wild ancestors. Not every plant makes suitable food for humans. Although oaks are plentiful, producing fruits high in protein, we find the bitter tannic acid in acorns unpleasant. It stands to reason that wild plants are not necessarily the best for human consumption because they didn't evolve with people. Birds easily carry the small fruits of wild berries; they are not the colossal, mouthwatering beauties that we prefer to eat. The selection and hybridization of plants by humans provides countless choices that appeal to human taste buds, and are easy to grow.

The plant parts that we eat are either fruits or vegetables. Fruits generally have seeds—exceptions being sterile hybrids such as grapes, oranges and bananas. A fruit is a ripened ovary—the result of a pollinated and fertilized flower. Usually, the ovary walls of the flower grow around the ovules, or seeds, creating a fruit that protects the seeds prior to their dispersal. Sometimes plants make false fruits when something other than the ovary wall enlarges and becomes part of the fruit. The fleshy part of an apple is a false fruit, called a pome; it is the receptacle that the apple blossom sits on, and grows around the ovary wall after fertilization. Ovid writes of the nymph Pomona in *Metamorphoses*, "No other Latin wood nymph could tend a garden more skillfully than she, none was more devoted to the cultivation of fruit trees from which she derived her name. She did not care for woods or rivers, but loved the countryside, and branches, loaded with luscious apples." Strawberries are another false fruit—what appears to be strawberry seeds are actually individual fruits attached to an enlarged floral base that turns red. False fruits are thought of as fruits because they are often attached to, or envelop, the true fruit. The flowers of pineapples and blackberries make multiple fruits; these are many individual fruits that are fused together. For the sake of classification, some fruits have distinctive names—corn, rice, and wheat are known as grains; and legumes include lentils, beans, and peanuts.

Vegetables are edible plant parts that come from stems, leaves, roots, or flower buds—which are not fruits because they never open, are never pollinated or fertilized, and never develop seeds. Broccoli and artichokes are examples of immature flowers that we eat. Asparagus and potatoes are edible stems—one grows above ground and is green because it photosynthesizes, the other grows below, where photosynthesis cannot occur. Lettuce, celery, kale, and Swiss chard are leaves that are used raw in salads or cooked. In addition to having leaves that grow above ground, some plants have underground leaves; known as bulbs, they are fleshy and wrap around each other. Onions and garlic are the two most commonly used, and along with leeks, are thought to have been grown by humans since 3000 BC. Beets, radishes, and carrots are plants grown for their edible roots. In *Blue Corn and Square Tomatoes*, Rebecca Rupp writes, ". . . Roman soldiers boiled carrots in broth to release the sexual inhibitions of their

female captives, and the Emperor Caligula, who had a fun-loving streak, once fed the entire Roman Senate a feast of carrots in hopes of watching them run sexually amok."

For over 5,000 years, plants have been uses as additives to make common food extraordinary. These nonessential luxuries are herbs and spices and, along with coffee, tea, chocolate, and sugar, are the most coveted of plants. Throughout history, fortunes have been spent and battles waged for control over these precious commodities. Their existence and procurement shaped history, and their ownership formed our economy. Daniel Quinn writes in *Beyond Civilization*, "Making food a commodity to be owned was one of the great innovations of our culture. No other culture in history has ever put food under lock and key—and putting it there is the cornerstone of our economy, for if the food wasn't under lock and key, who would work?"

30. YELLOW SWEET CORN, *Zea mays* cultivar
"The gods sent not Corn for the rich men only." *Coriolanus*, Shakespeare.

34. ROSEMARY, *Rosmarinus officinalis*
In her wonderful book *Leaves*, Alice Thoms Vitale explores plants in mythology, magic, and medicine. She writes about rosemary—"In the ancient world rosemary was considered an aid to memory, and to benefit from its powers, Greek students twined it hopefully in their hair before examinations. . . . And everyone who has read *Hamlet* knows Ophelia's famous line: 'There's rosemary, that's for remembrance.' . . . Even in England today rosemary wreaths are laid on soldiers' graves so all will recall their heroic deeds."

35. GARLIC, *Allium sativum*
Garlic and onions are close kin—both have papery coverings and an acid that lowers blood pressure. In Robert Fagles' translation of *The Odyssey*, Homer finds the glow of life in these dry bulbs. "I noticed his glossy tunic, clinging to his skin like the thin glistening skin of a dried onion, silky, soft, the glint of the sun itself. Women galore would gaze on it with relish."

36. RED KOHLRABI, *Brassica oleracea* cultivar
"Brassica vegetables, broccoli, cauliflower, and kohlrabi are consumed in enormous quantities throughout the world and are important in human nutrition. Kohlrabi's turnip-like globe is not a root but the swollen base of the stem (leaves are attached). Kohlrabi is boiled for human consumption."—*The New Oxford Book of Food Plants*.

37. SAVOY CABBAGE, *Brassica oleracea* cultivar
"The word cabbage has ranged from the endearing to the insulting: *mon petit chou* [a term of endearment] to stupid fool and cabbage-head thou art!"
—*Craig Claiborne's New York Times Food Encyclopedia*.

38. HONEYDEW MELON, *Cucumis melo* cultivar
All melons seem to have originated in Africa and became known to Europeans in the 4th century. The honeydew is sometimes called a winter melon because it ripens late in the season and has a hard skin, allowing it to be stored for winter use.

39. TOMATO, *Lycopersicon esculentum* cultivar

"The invading Spaniards saw the *tomatl* growing in Montezuma's gardens in 1519 and described it recognizably, though in less than glowing terms: they found the sprawling vines scraggy and ugly. Still, Cortez brought tomato seeds back to Europe, along with the more spectacular plunder, and tomato plants were soon growing in the sunny gardens of Renaissance Spain."—Rebecca Rupp, *Blue Corn and Square Tomatoes.*

40. ASPARAGUS, *Asparagus officinalis* cultivar

Asparagus is prized for its tender and flavorful young stems. It was grown by the Egyptians, Greeks, and Romans and is now popular throughout the world.

41. FLORENTINE FENNEL, *Foeniculum vulgare* var. *dulce*

"Legend has it that at one point in history, fennel was inalterably associated with fish in Europe, and on fast days the very wealthy dined on fish with fennel. The poor on those days dined, it is related, on fennel alone, the fish in absentia."
Craig Claiborne's New York Times Food Encyclopedia.

42. YELLOW BELL PEPPER, *Capsicum annuum* cultivar

Rounded forms are essentially female—yielding, accepting, encompassing. Knowledge that enclosed in this vegetable torso is a multitude of seeds reinforces its femininity.

43. GLOBE ARTICHOKE, *Cynara scolymus*

"The young flower heads have numerous large bracts with fleshy bases which are the parts usually eaten. The flower head may be baked, fried, boiled, stuffed and served hot with various sauces, or served cold with vinaigrette."—*The New Oxford Book of Food Plants.*

44. RED SWISS CHARD, *Beta vulgaris* cultivar

The complimentary colors in the leaves of red Swiss chard satisfy the appetite for beauty and the need for healthy greens.

45. RED ONION, *Allium cepa* cultivar

In *My Summer in a Garden*, Charles Dudley Warner writes—"In onion is strength; and a garden without it lacks flavor. The onion in its satin wrappings is among the most beautiful of vegetables; and it is the only one that represents the essence of things. It can almost be said to have a soul. You take off coat after coat, and the onion is still there"

46. PORTABELLA MUSHROOM, *Agaricus bisporus*

Nearly 1,900 species of edible mushrooms are recognized throughout the world. Because of their texture, mushrooms are sometimes used as a meat substitute. Many have good flavor, are low in calories, and high in vitamins. The protein they provide contains all the essential amino acids.

47. GARDEN PEA, *Pisum sativum* cultivar

"Dried peas were used to piece out wheat flour, or were boiled to make the ubiquitous pease porridge that was eaten hot, cold, and in the pot nine days old."
—*Blue Corn and Square Tomatoes*, by Rebecca Rupp.

48–49. GOURDS, *Cucurbita* sp.

Gourds contain the bitterest substance known in the plant kingdom, cucurbit acid. Rebecca Rupp writes in *Blue Corn and Square Tomatoes*, "The very earliest cucurbits—probably originating in Central America—were considerably smaller. They were also unpleasantly bitter-fleshed, and are thought to have been valued by primitive man for their protein and oil-rich seeds.

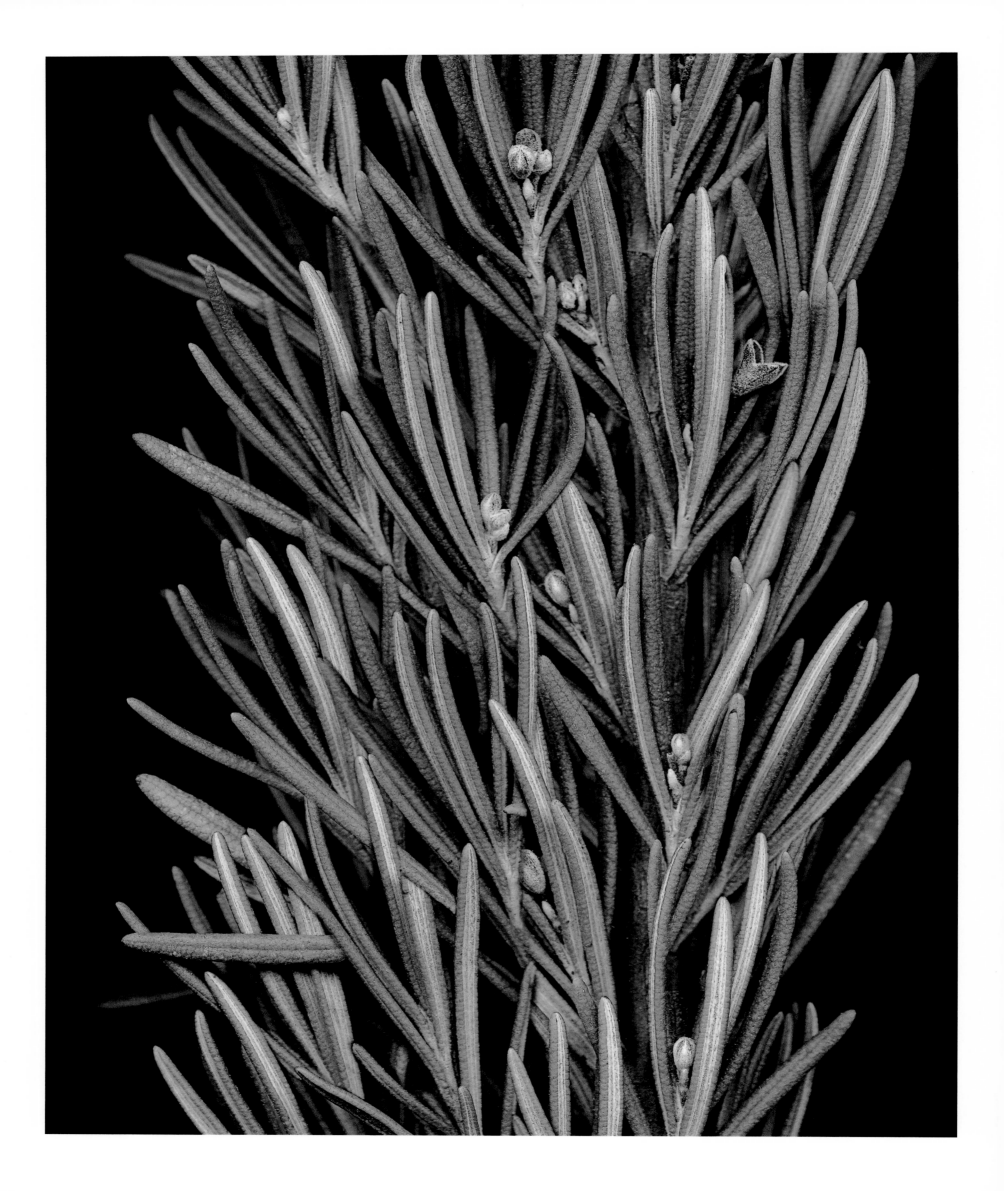

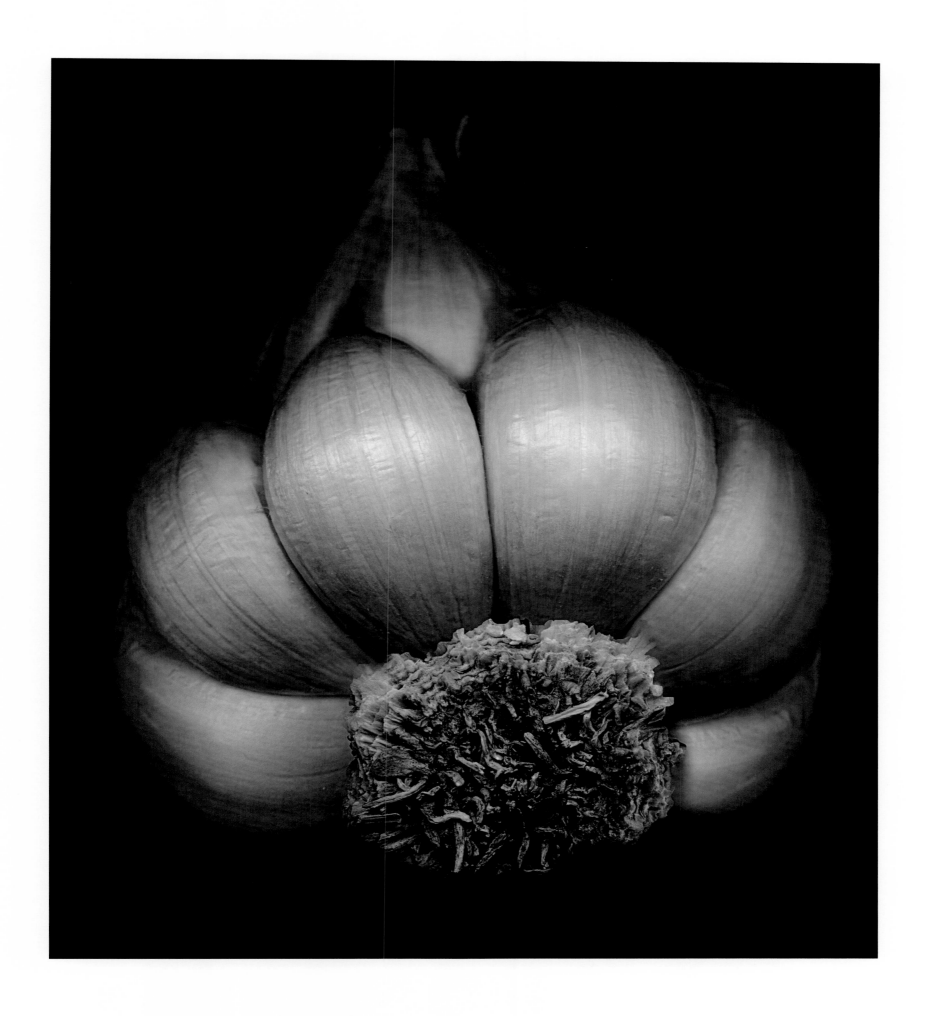

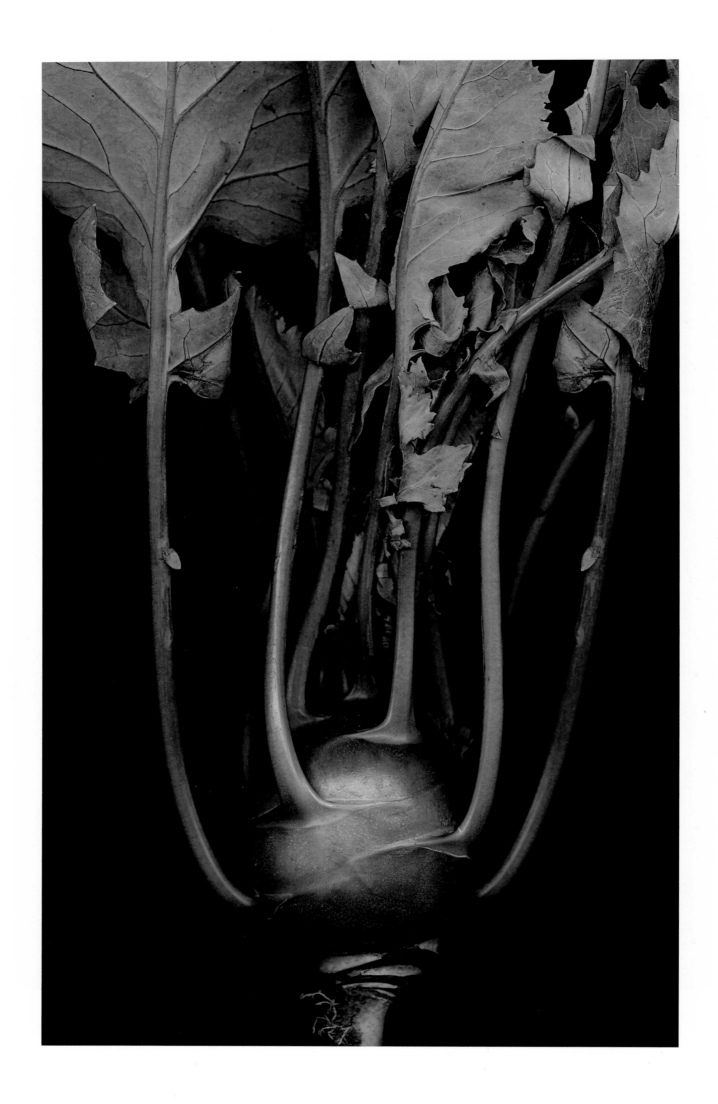

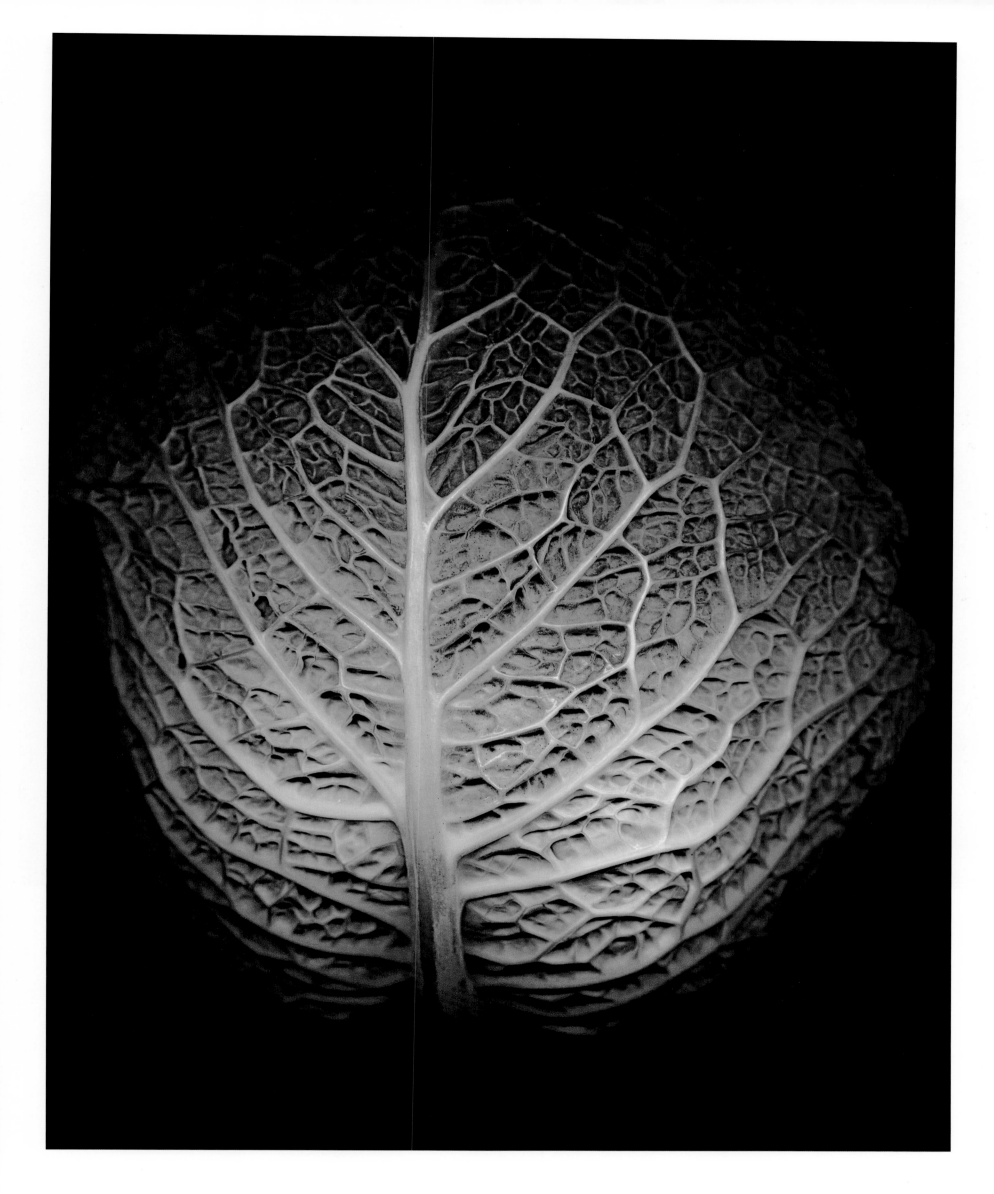

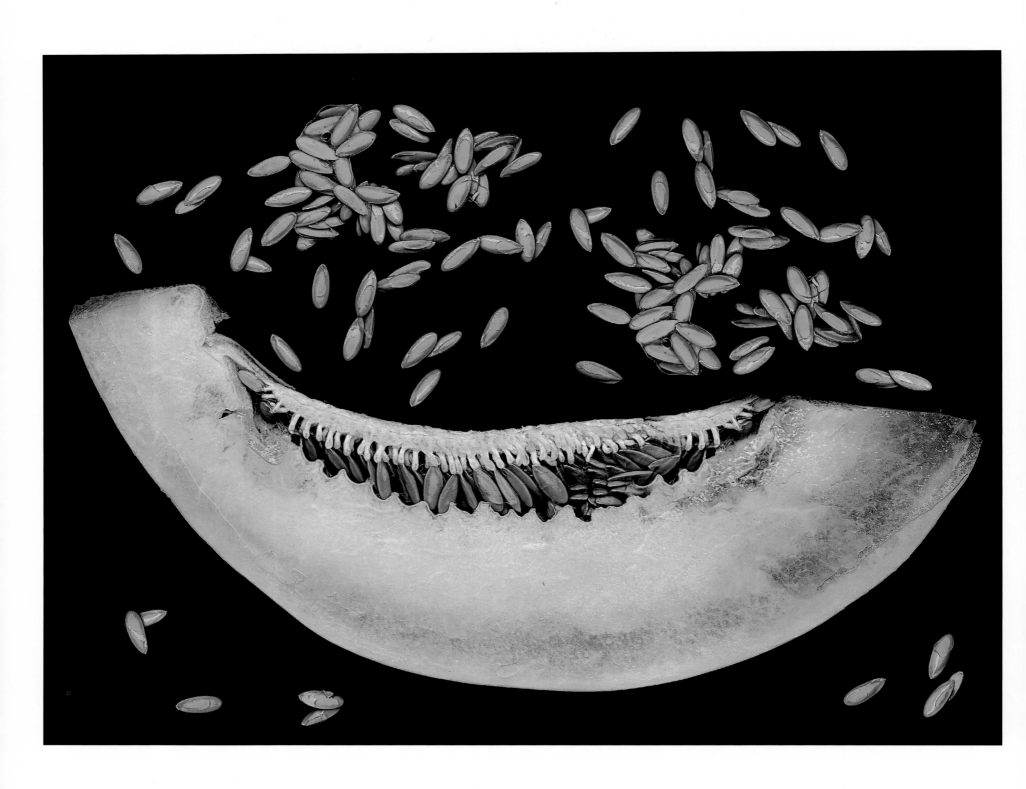

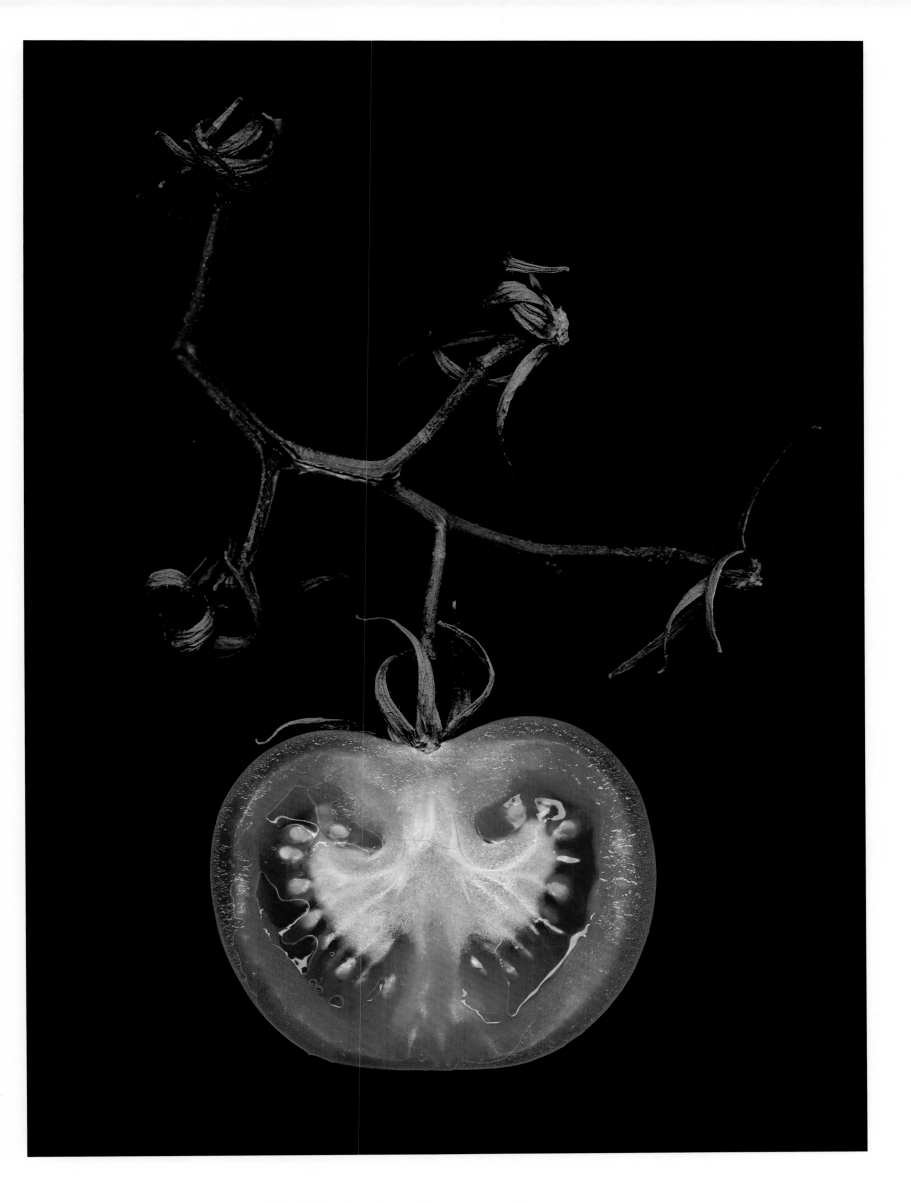

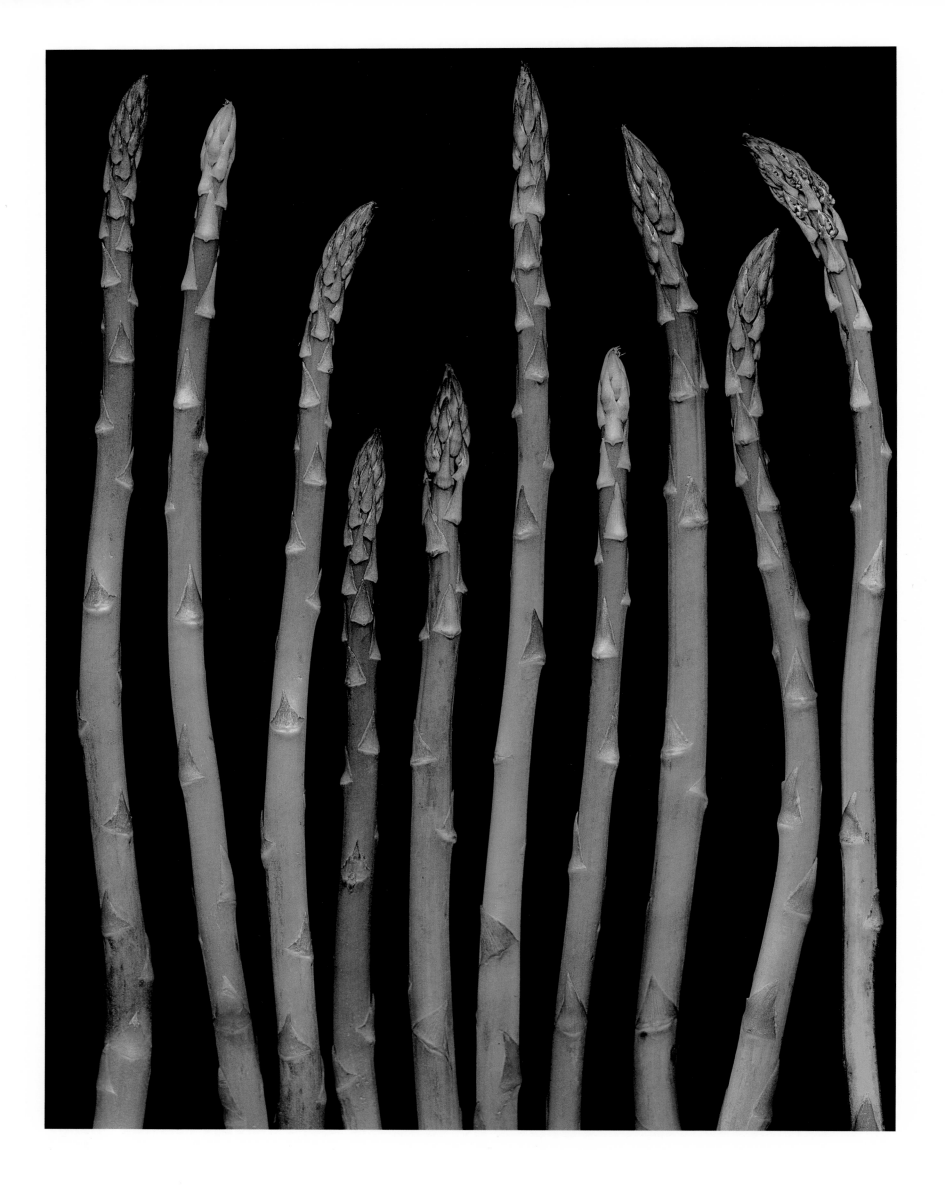

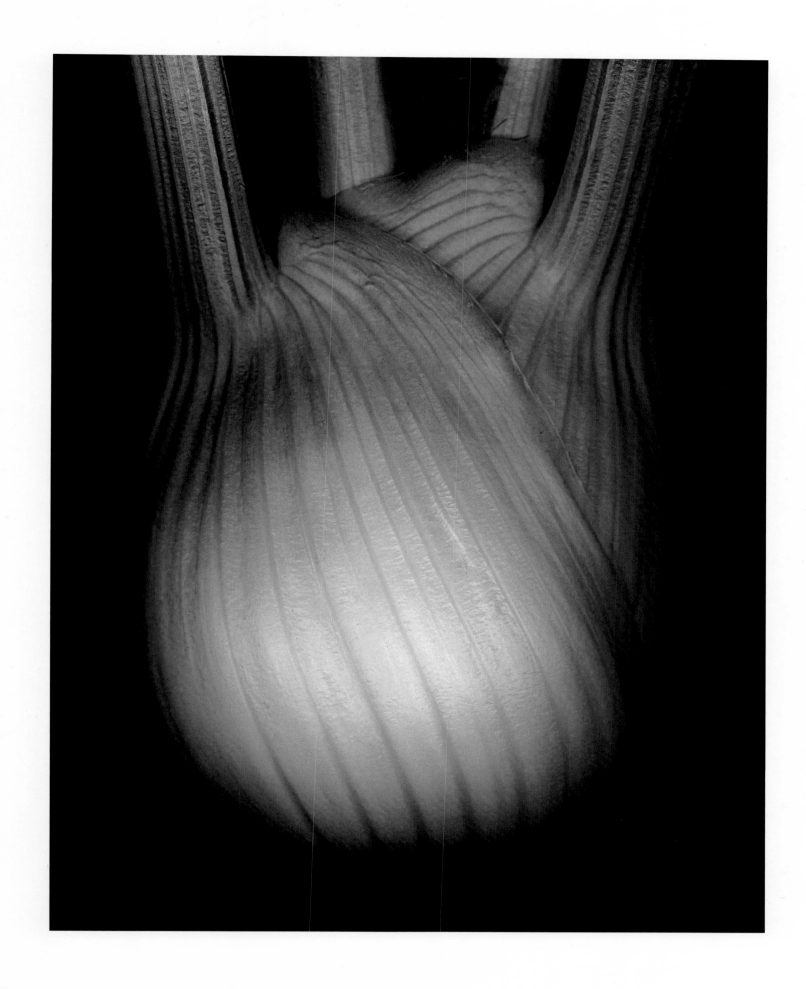

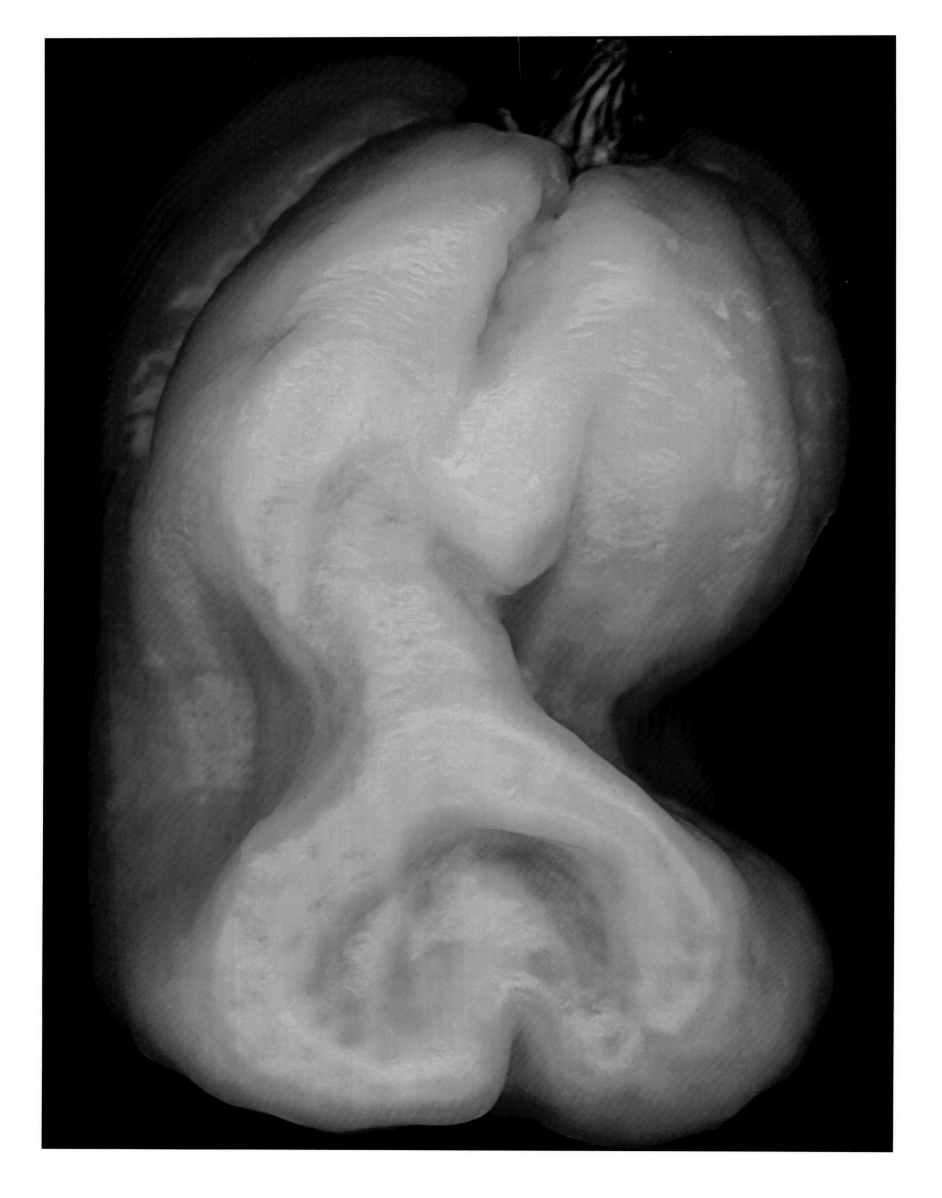

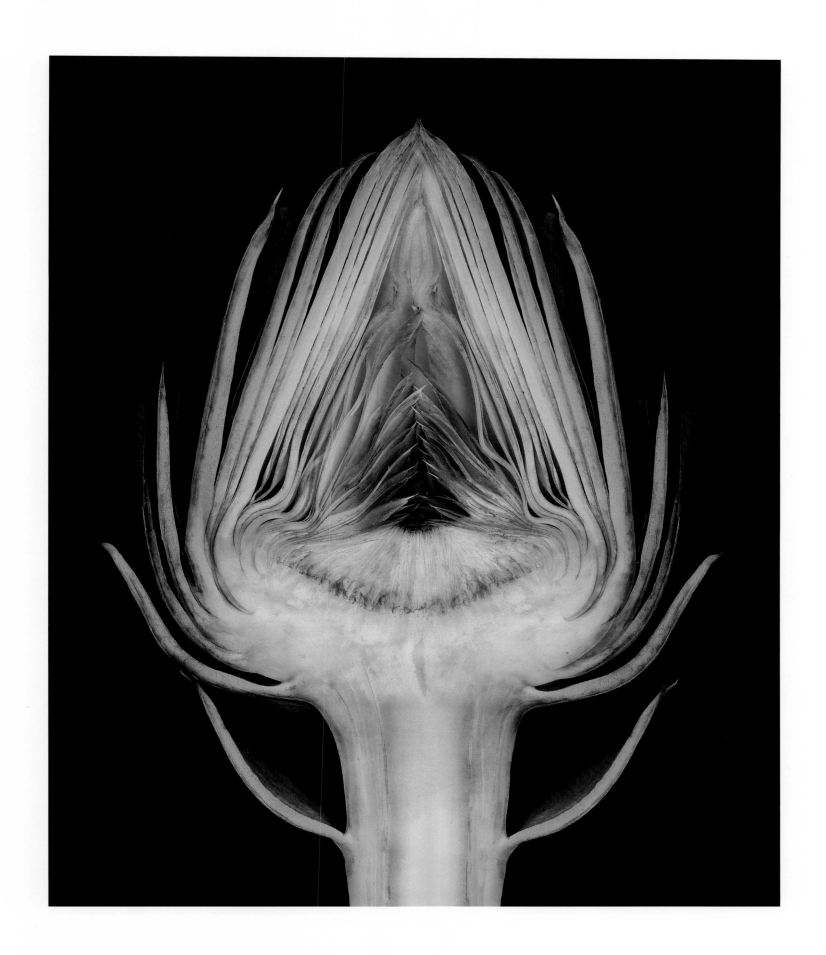

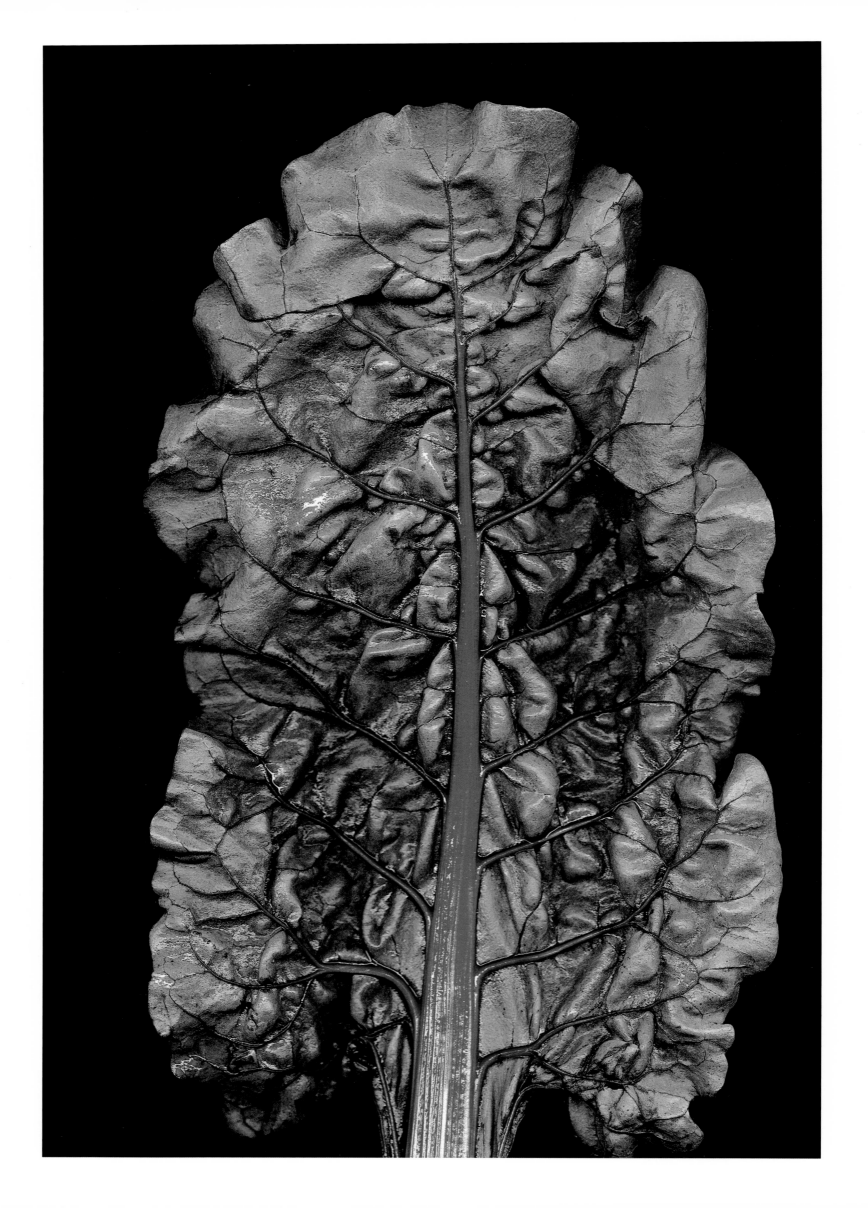

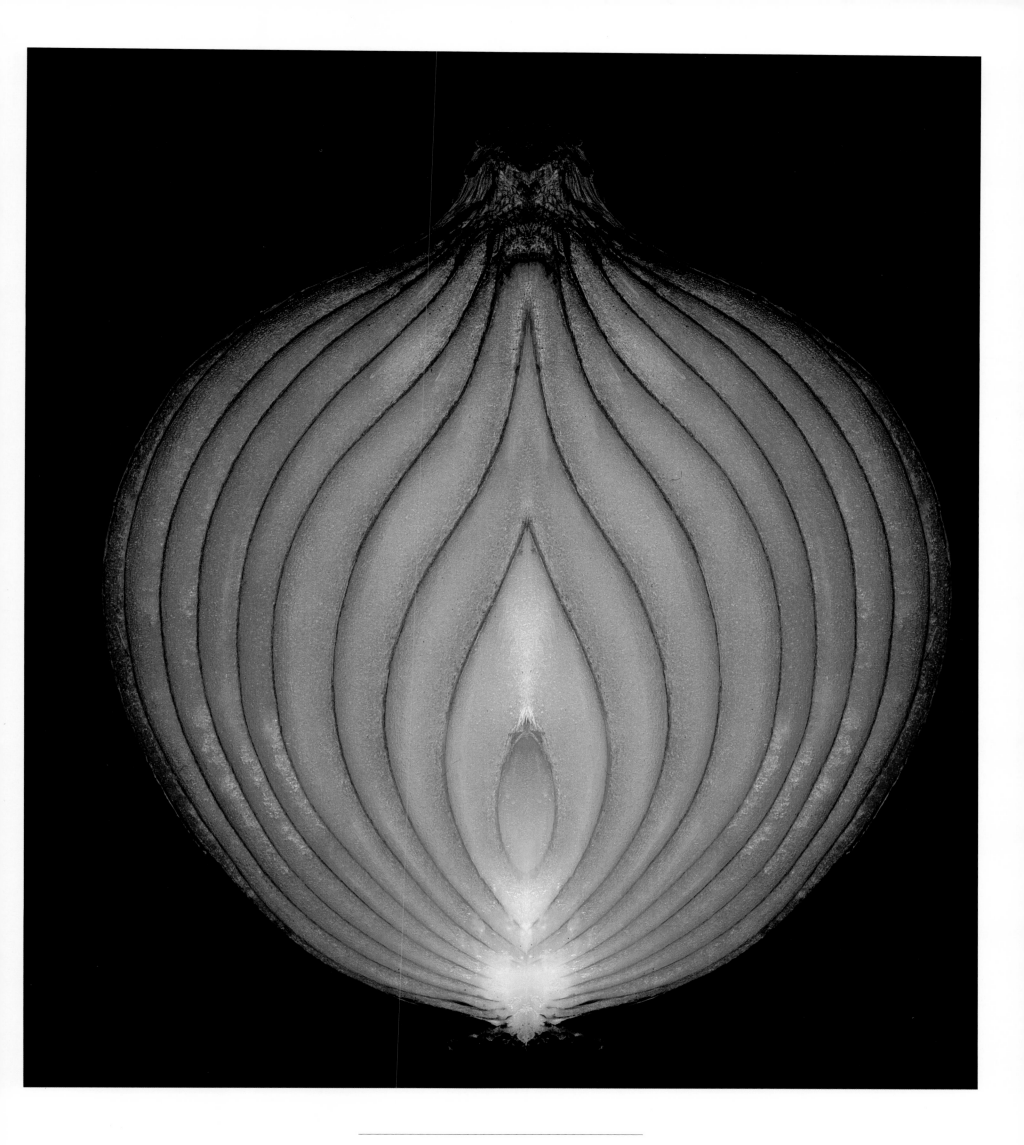

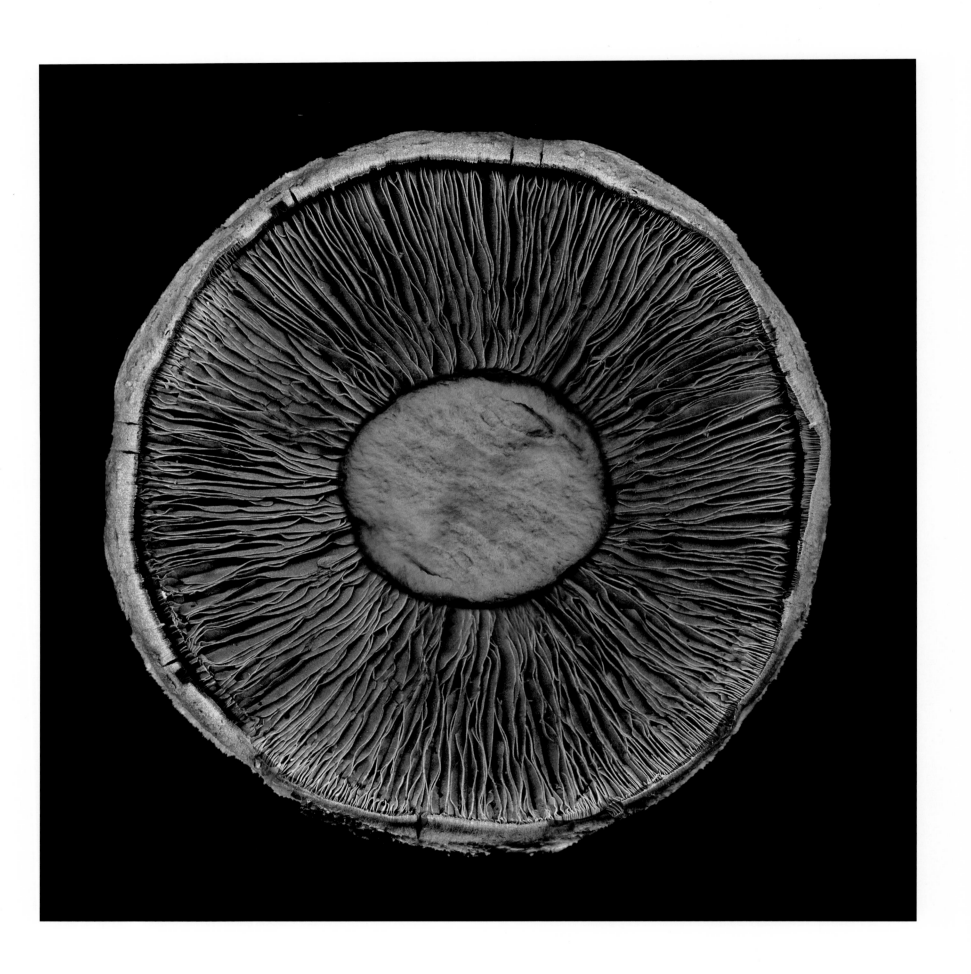

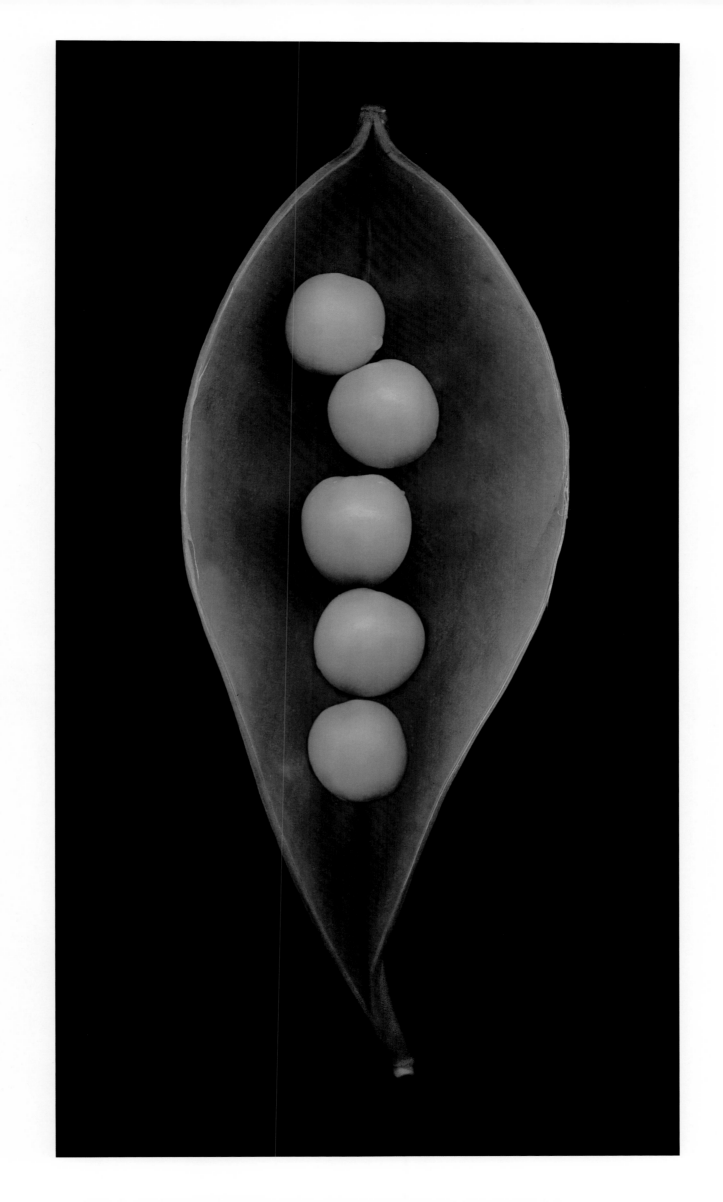

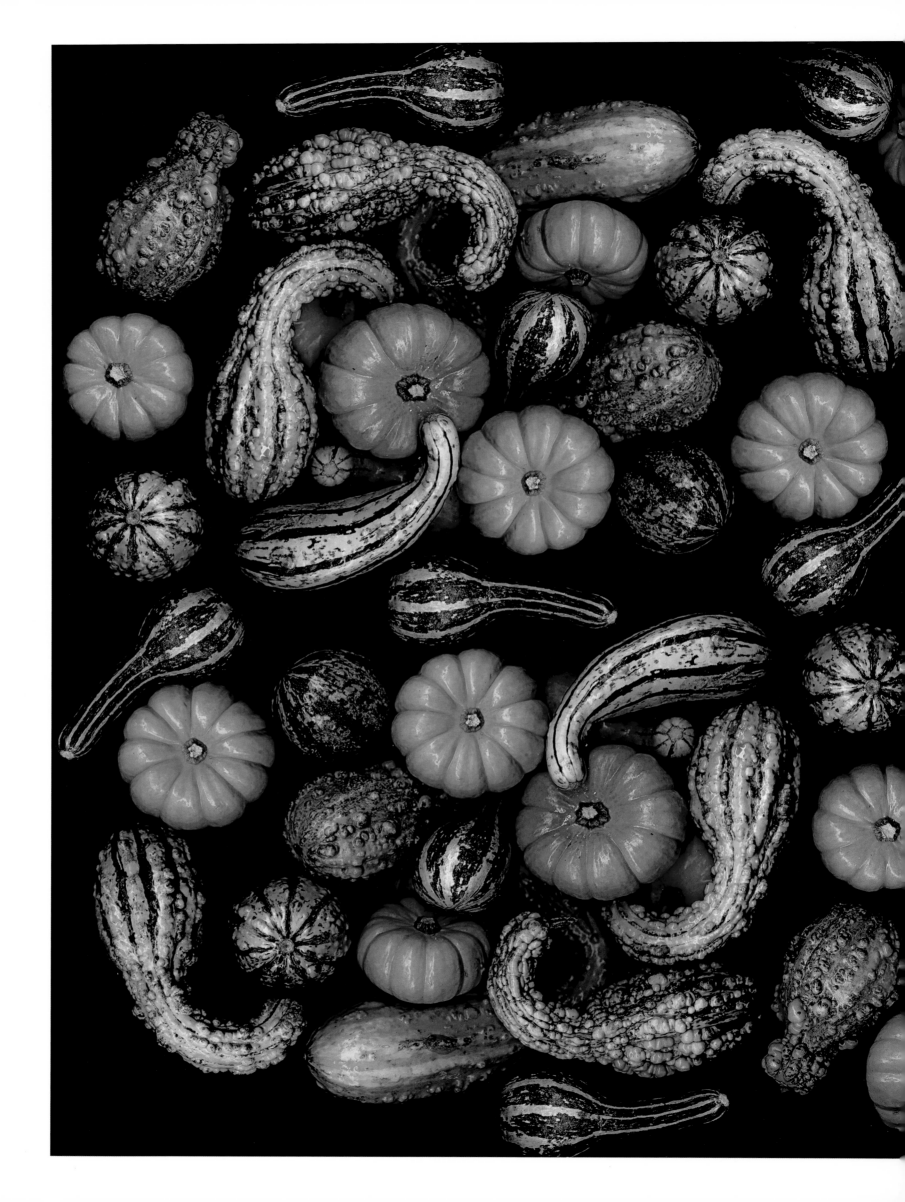

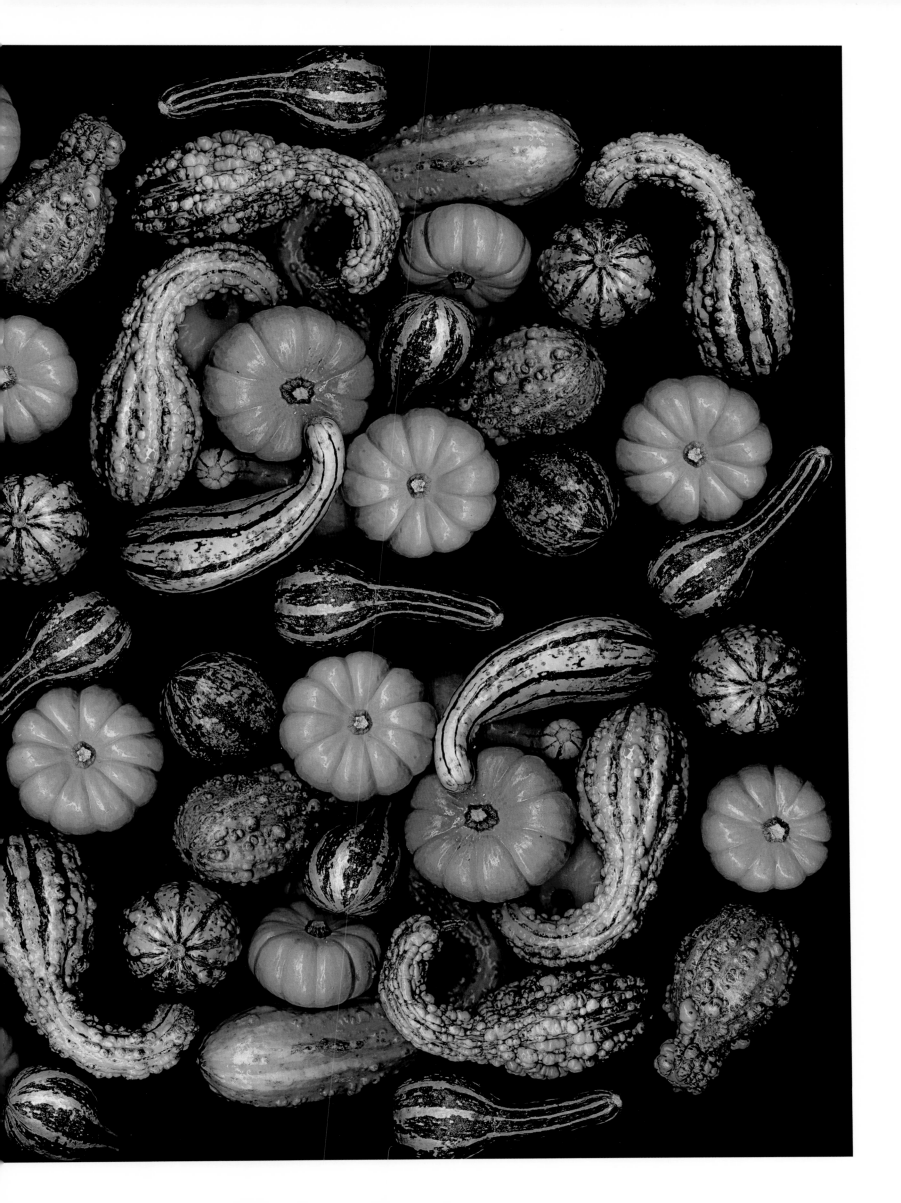

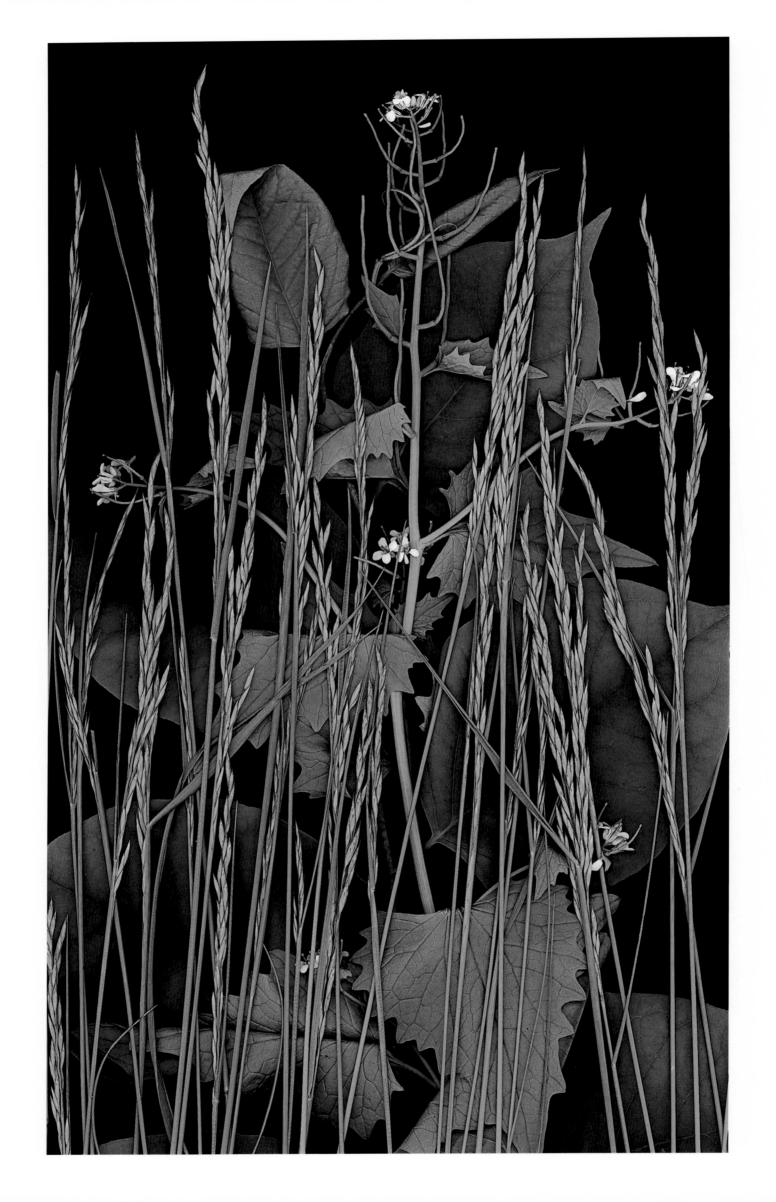

THE ESSENCE OF GREEN

In Dante Alighieri's *Commedia*, three theological virtues—faith, hope and charity—appear as specters clothed in the colors white, green and red respectively. Hope is dressed in green, a color symbolizing resurrection from the dead. In nature, green dominates the season when the earth springs back to life from its death-like dormancy. By its association with spring, green is synonymous with hope; exuding optimism, it expresses a new beginning. Dante's poem follows the journey of a pilgrim being escorted through hell, purgatory, and heaven. In purgatory, he meets the image of his dearly beloved, recently departed. Using a green metaphor, her words echo the sensations of being purged and reborn—

> Remade, as new trees are
> Renewed when they bring forth new boughs, I was
> Pure and prepared to climb unto the stars.

The word green reflects the essence of nature—abundant, fruitful and vigorous. Perhaps with the exception of blue, it is primary to all other colors in the landscape. Yet to many, the simplistic green landscapes that nature provides do not convey beauty. A movement in the 18th century gave rise to the theoretical and critical analysis of all art forms. It was thought that the painter, poet, and even the landscape gardener, must tamper with nature to make it beautiful. In the next century, Edgar Allan Poe echoed these sentiments in his story *The Domain of Arnheim*—"In the most enchanting of natural landscapes, there will always be found a defect or an excess—many excesses and defects. While the component parts may defy, individually, the highest skill of the artist, the arrangement of these parts will always be susceptible of improvement." The manipulation of individual components resulted in what was called the artificial landscape garden and the long held axiom that art should imitate nature was no longer credible. These newfound beliefs shaped our sense of what is beautiful; these fashionable ideas even had their influence on John Muir, the prophet of wilderness. In *Landscape and Memory*, Simon Schama writes of this phenomenon and includes some excerpts by Muir's own hand, "It was John Muir . . . who actually characterized Yosemite as a 'park valley' and celebrated its resemblance to an 'artificial landscape-garden . . . with charming groves and meadows and thickets of blooming bushes.'"

Sometimes green plants simply suggest power, vigor or youth as in "bursting forth with new spring growth." Alexander Theroux wrote in *Secondary Colors*, "Green is power, nature's fuse, the color of more force and guises than are countable. . . ." Mr. Theroux evokes the image of a green explosion—a stimulating explosion, making other things happen. And an uncountable number of things do happen since the survival of most living creatures depends upon the photosynthetic green plant. Vigor in plants is illustrated by their growth—their energetic movement

by expansion. The words grow, green, and grass are closely connected, all being derived from the same root word. Grow suggests the motion of plants, green refers to the color of actively growing plants, and grass is a common example of a plant combining the action of growth with the color green. In *Leaves of Grass*, Walt Whitman writes, "Youth large lusty and loving . . . youth full of grace and force and fascination. . . ." Youth is the early stage of life—bursting with energy but not fully developed. Lacking the experience that only age can bring, youth is sometimes described as immature, unripe, or even green.

50. KNOTWEED, GRASS, & GARLIC MUSTARD, *Polygonum japonicum*,
Agrostis sp., Alliaria officinalis
In her novel *Summer*, Edith Wharton captures the co-mingling essence of nature—"Every leaf and blade seemed to contribute its exhalation to the pervading sweetness in which the pungency of pine-sap prevailed over the spice of thyme and the subtle perfume of fern, and all were merged in a moist earth-smell"

54. CYCAD, *Zamia sp.*
The botanical name *Zamia* is a corruption of the Roman word for pinecone. These primitive seed plants have cone-like reproductive structures and hard leathery leaves.

55. HARDY GERANIUM, *Geranium sp.*
"When I go to a perennial nursery in search of a geranium and I am shown a pelargonium [an annual bedding geranium], I know I'm dealing with horticultural ignorance and I leave."—Elsie Smith, gardener.

56. TREE PHILODENDRON, *Philodendron bipinnatifidum*
This genus of tropical plants contains many shrubby and climbing plants that are easily grown in homes without much sunlight. The name is derived from the Greek *philo*—love, and *dendron*—tree, perhaps referring to the climbing types that ramble up trees.

57. RHODODENDRON, *Rhododendron catawbiense* cultivar
In Christopher Lloyd's classic, *Foliage Plants*, he writes that he prefers particular rhododendron cultivars not for their flowers, but for the felted undersides of their leaves, known as indumentum. Lloyd describes one shrub from a friend's garden as "a real beauty, especially when the pale young leaves are expanding in the spring."

58. RIBBON PLANT, *Dracaena sanderiana*
Dracaenas belong to the lily family and are planted outdoors in subtropical and tropical climates. Gardeners in temperate climates have to be content with growing them as houseplants where their bold, ornamental foliage is highly valued.

59. HARDY GERANIUM (Reverse of Leaf), *Geranium sp.*
In his book *Hardy Geraniums*, Peter Yeo describes the geranium leaf—"Little is known about the ways in which the varied attributes of the leaves function, but there is a clear correlation between leaf-type and habitat. The shadier the habitat the more likely is the leaf of *Geranium* to have shallow divisions and lobes and numerous small teeth; the texture tends to be wrinkled"

60. YELLOW SPURGE, *Euphorbia myrsinites*

This native of Europe and Asia is close kin to the Mexican poinsettia. Yellow spurge is popular in the cut flower trade because of its manageable, arching stems and its long lasting, brightly colored bracts and flowers.

61. POKEWEED, *Phytolacca americana*

The name is derived from the Greek *phyton*—a plant, and *lacca*—lake, and refers to the color of the juice of the berries, which is a rich reddish-purple. In *The Iliad* and *The Odyssey*, Homer writes of "the wine dark sea," an apt description for a murky body of water.

62. FALSE ARALIA, *Dizygotheca elegantissima*

The specific epithet (secondary name) of this South Pacific native means "most elegant", describing the refined, graceful beauty of its delicate leaves.

63. LISIANTHIUS, (Flower Bud), *Eustoma grandiflorum* cultivar

The plants of the genus *Eustoma* are native to North and South America, and the West Indies. The name translates from Greek as "good mouth," alluding to the wide-mouthed flowers.

64. DAHLIA, (Flower Bud), *Dahlia* sp.

"The force that through the green fuse drives the flower Drives my green age. . . ."
—Dylan Thomas.

65. SYCAMORE MAPLE, *Acer pseudoplatanus*

"The leaf's purpose in life is to bask in the sun—dendrologist Brayton Wilson compares a tree to 'a tower bearing many solar collectors'—the arrangement of leaves on trees is more than a matter of sheer luck. Trees are intimidatingly mathematical constructs, branches, twigs, and leaves positioned at precise intervals and extended at consistent angles such that the leaves—like the sun bunnies—end up with the greatest possible number of bodies soaking up the highest possible concentration or rays."—Rebecca Rupp, *Red Oaks and Black Birches*.

66. SPIDER PLANT, *Chlorophytum* sp.

Spider plants are native to Africa, South America, Australia, and Asia. They are nondemanding houseplants, needing bright but indirect light and moderate temperatures to thrive.

67. COSMO LEAFS, *Cosmos bipinnatus* cultivar

Cosmos grow easily from seed—when planted in a garden they freely reseed themselves each year. Most grow four to five feet tall and come in white, shades of pink, and orange.

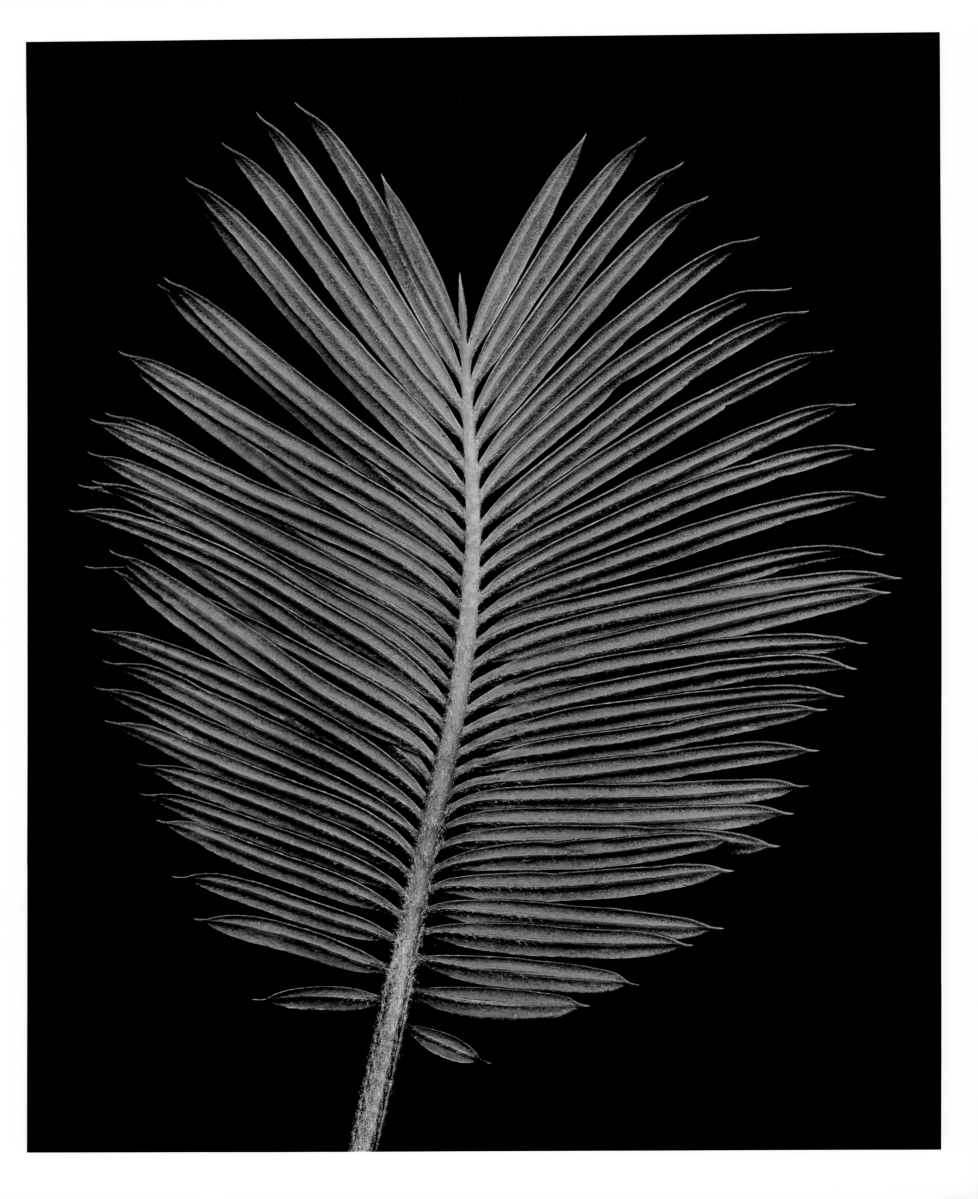

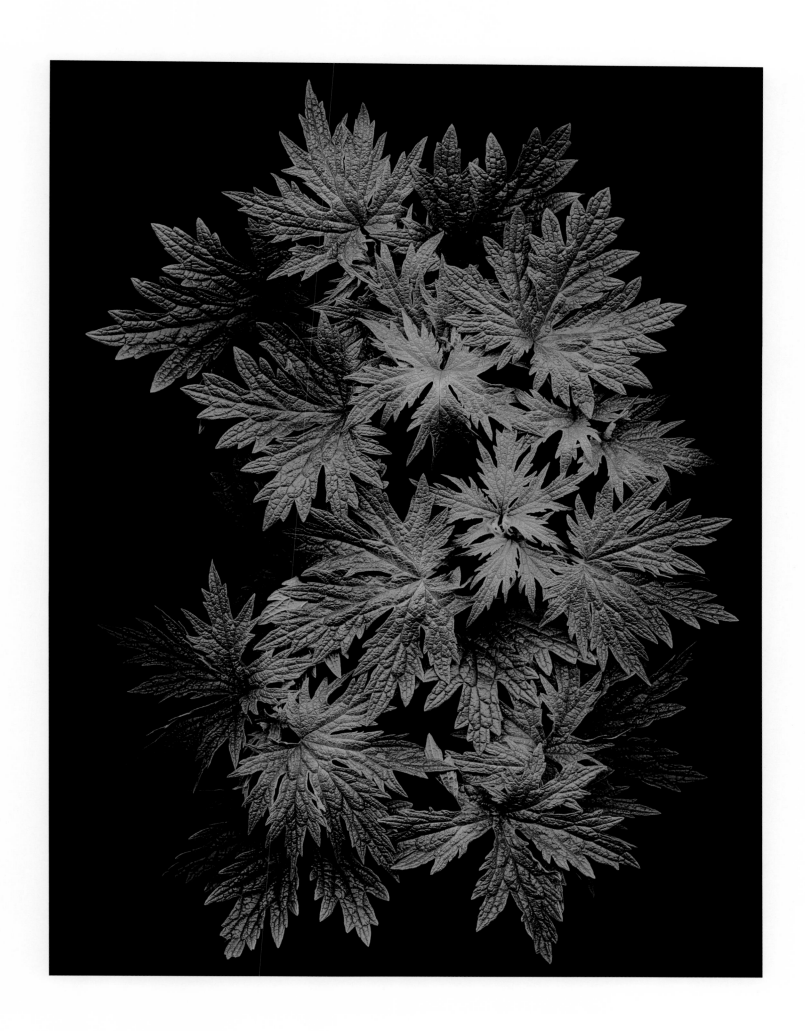

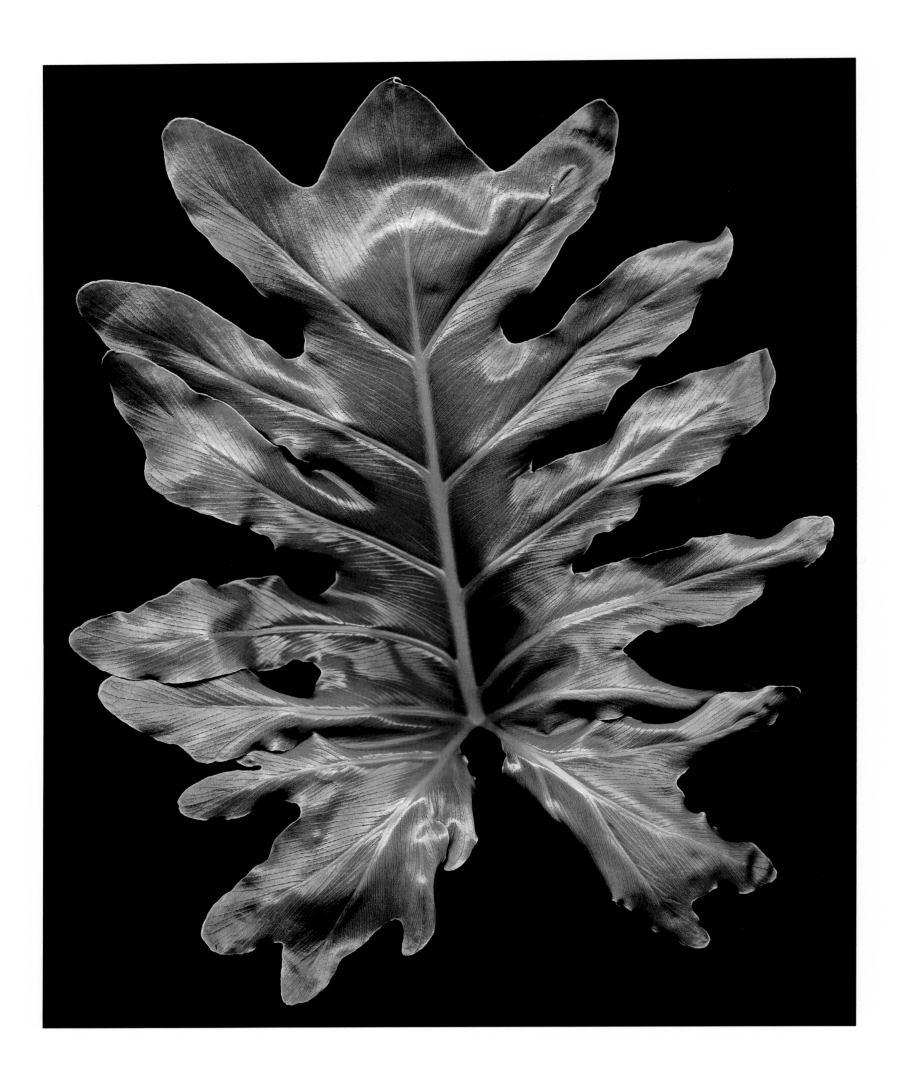

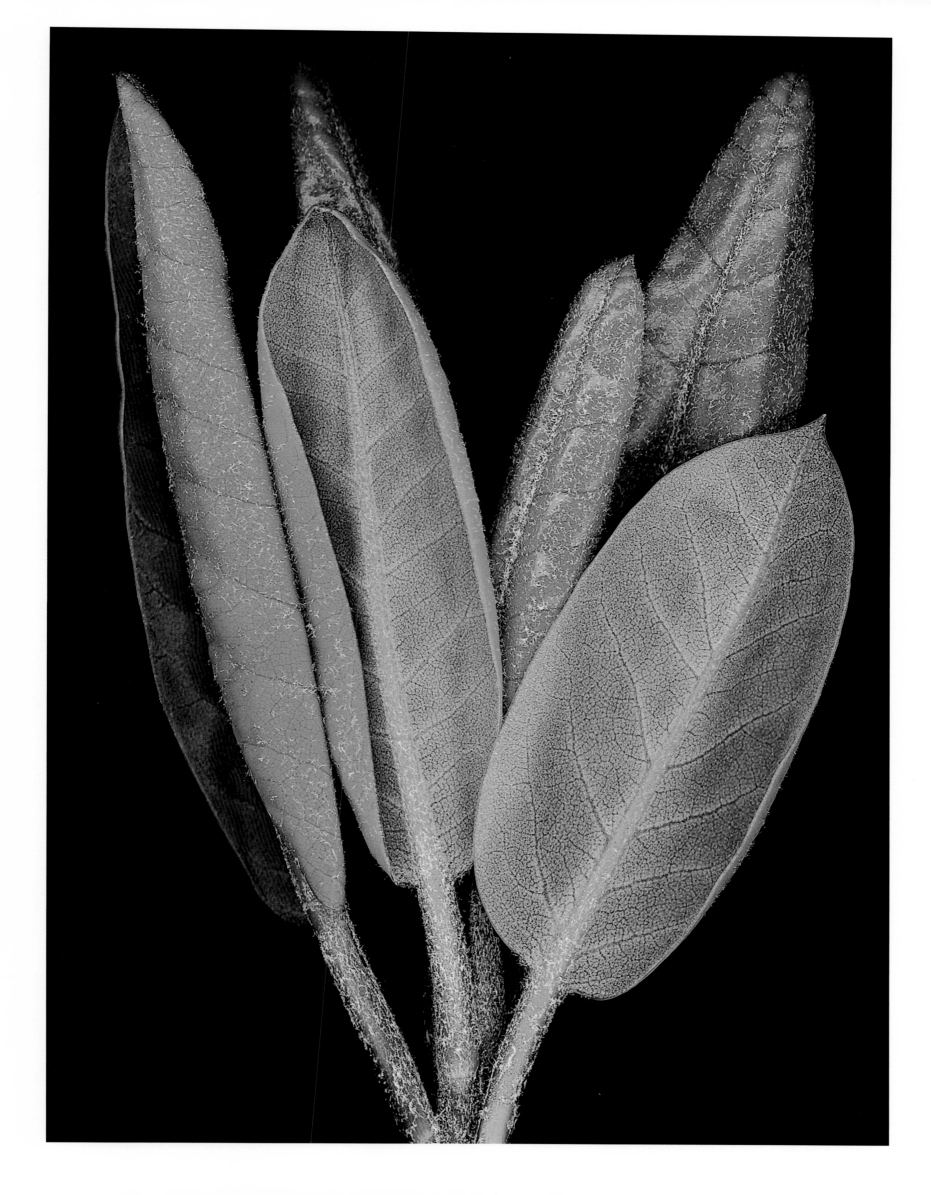

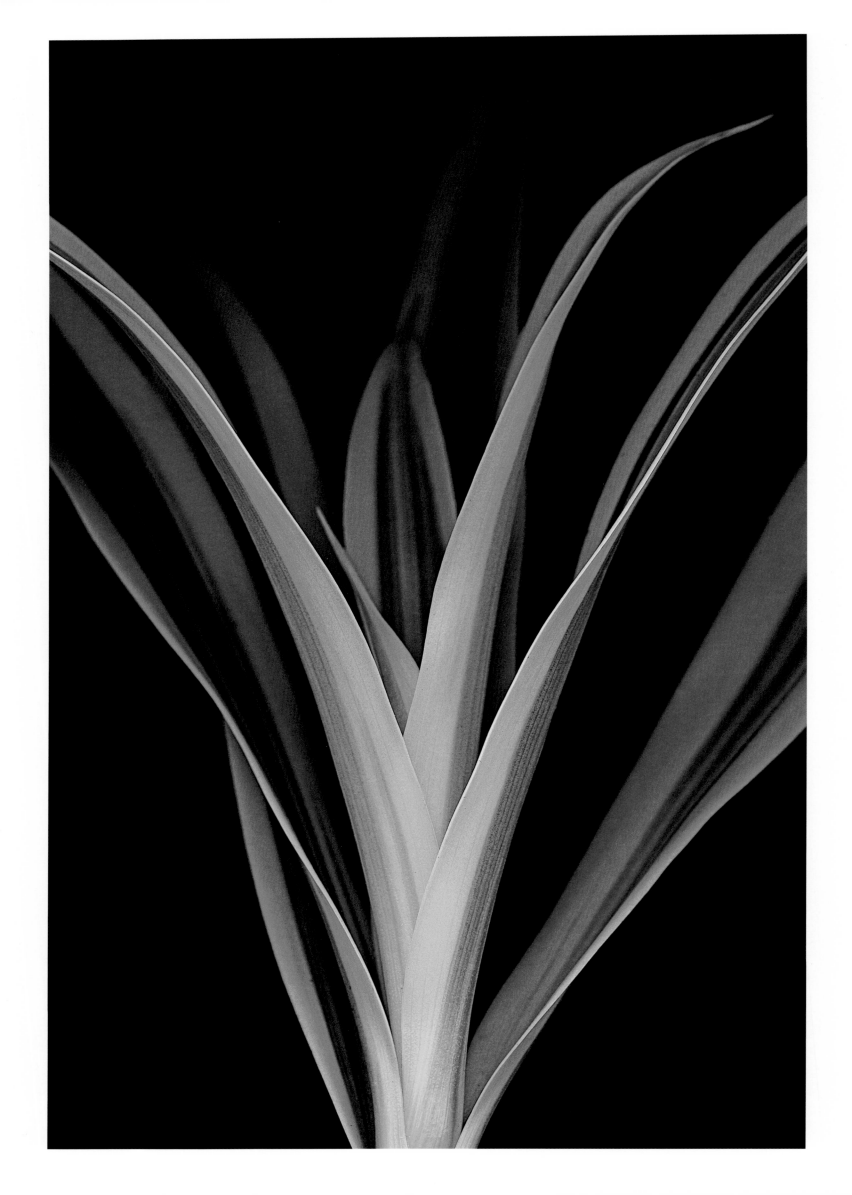

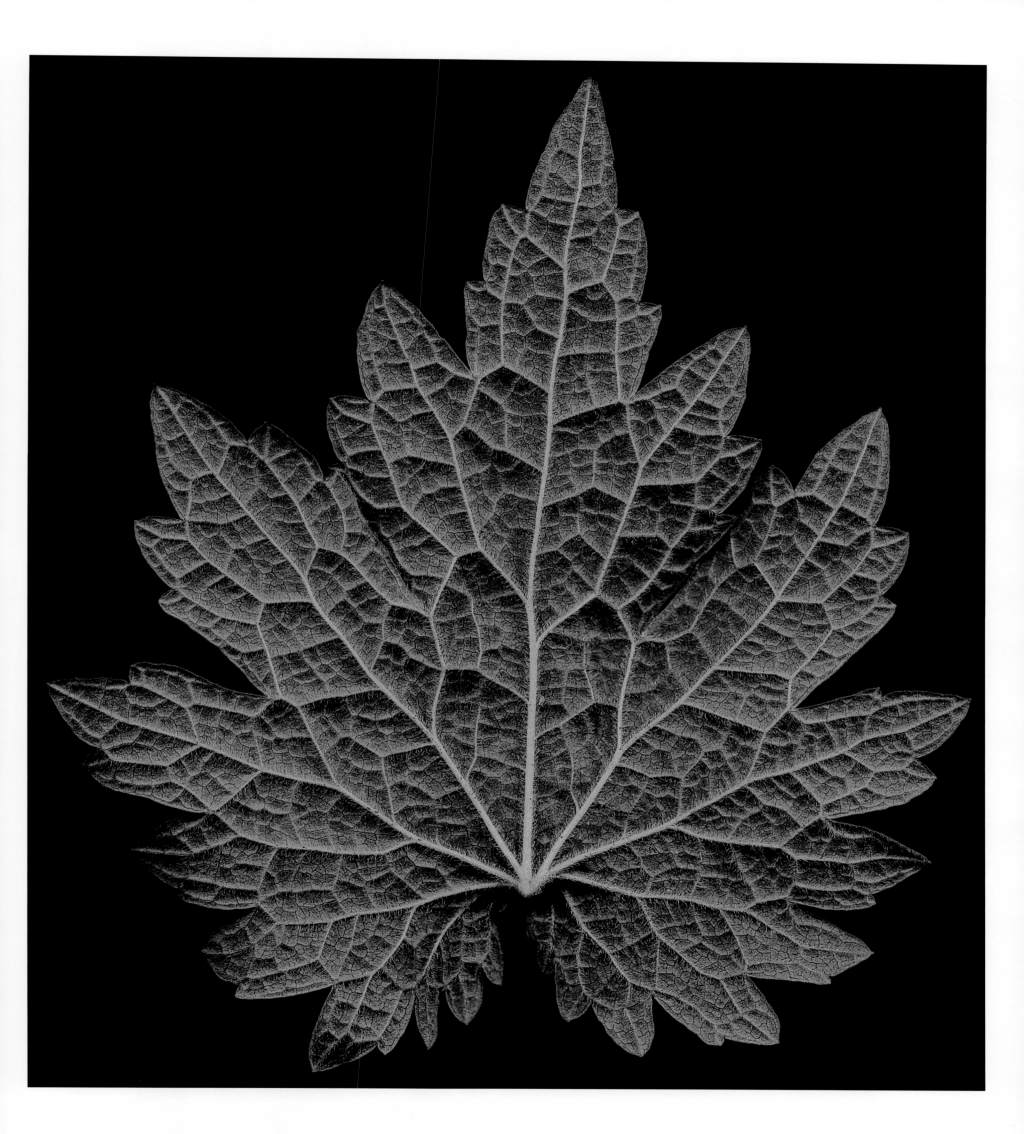

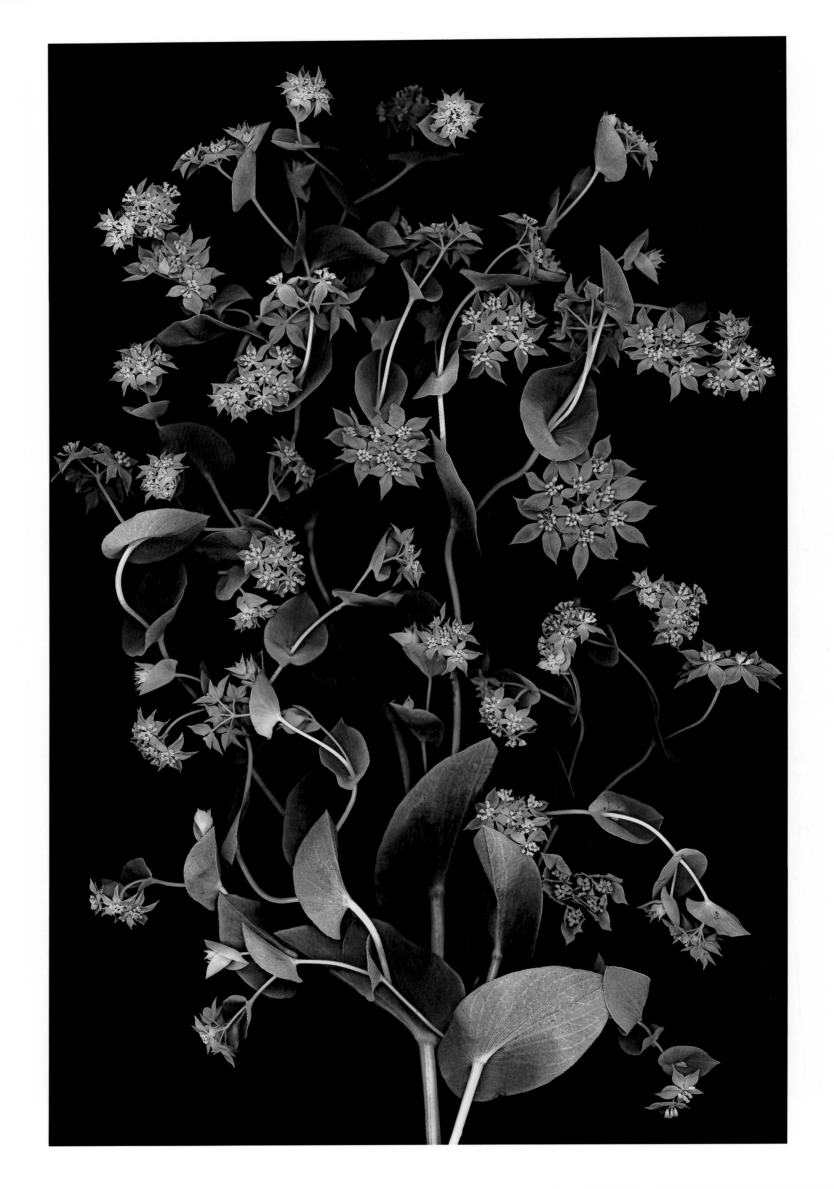

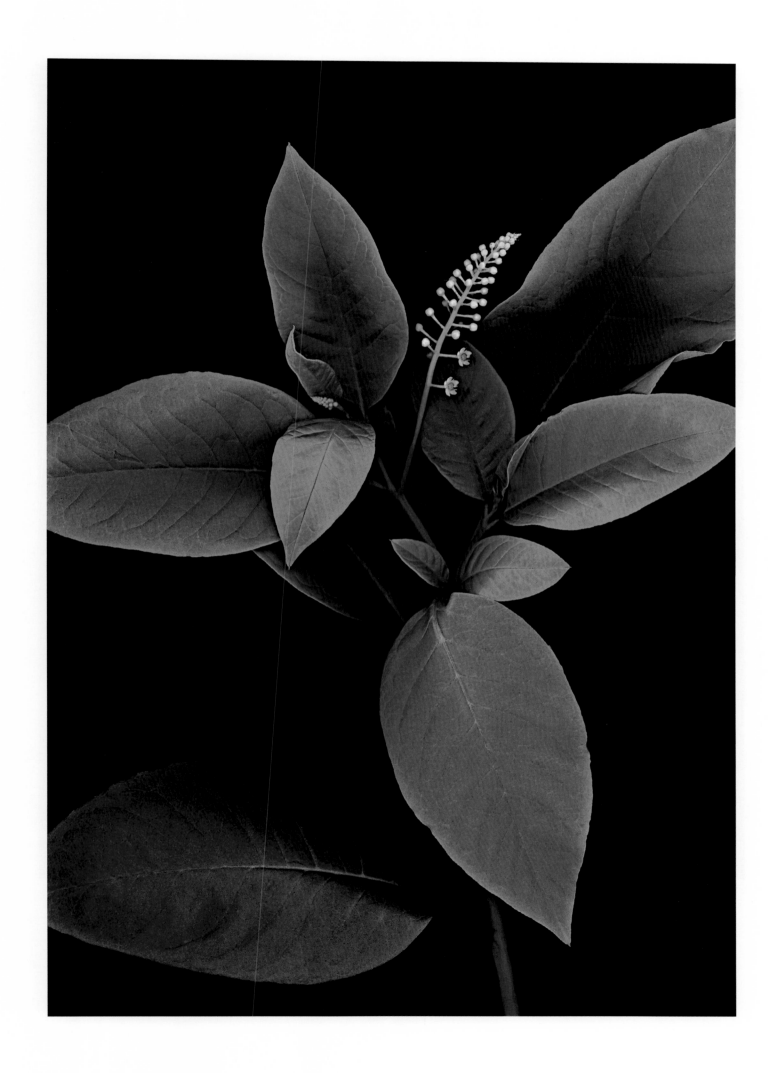

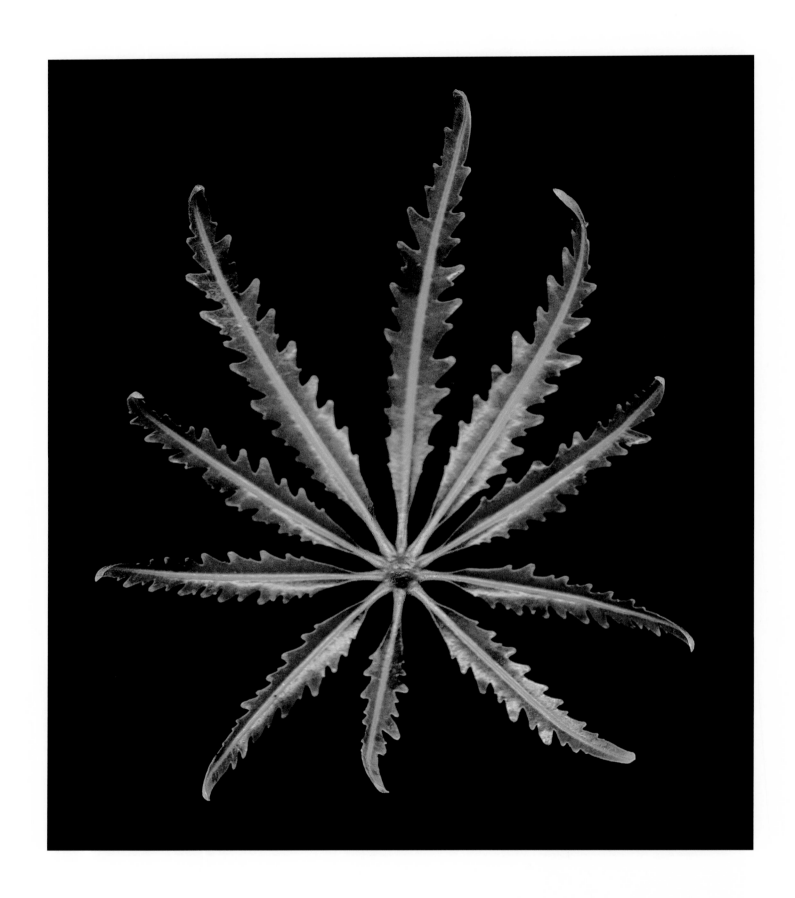

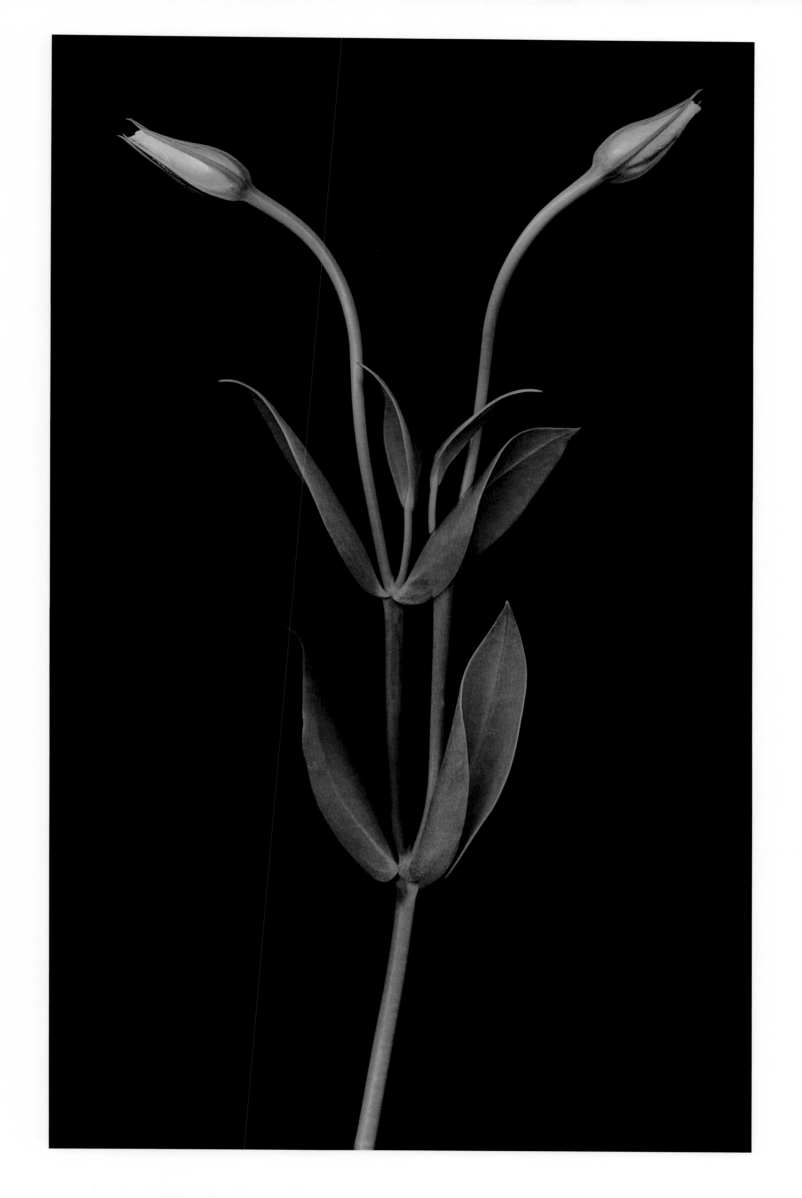

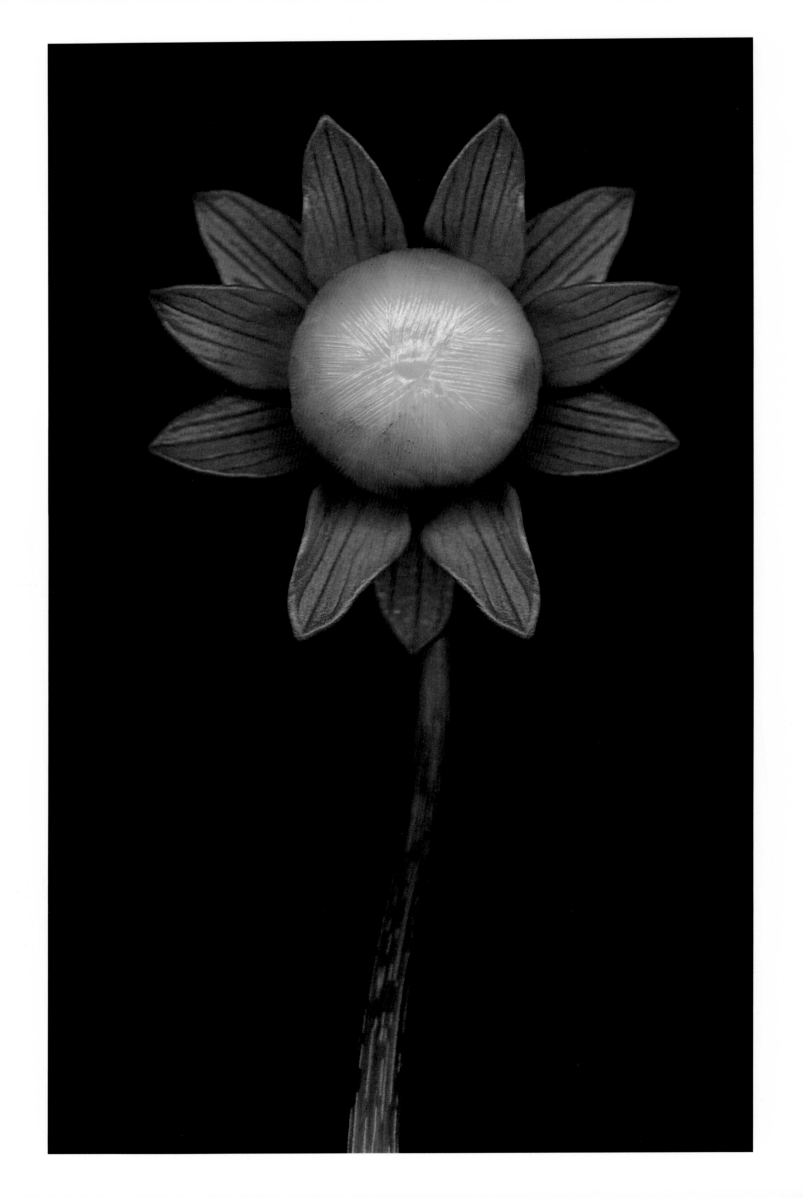

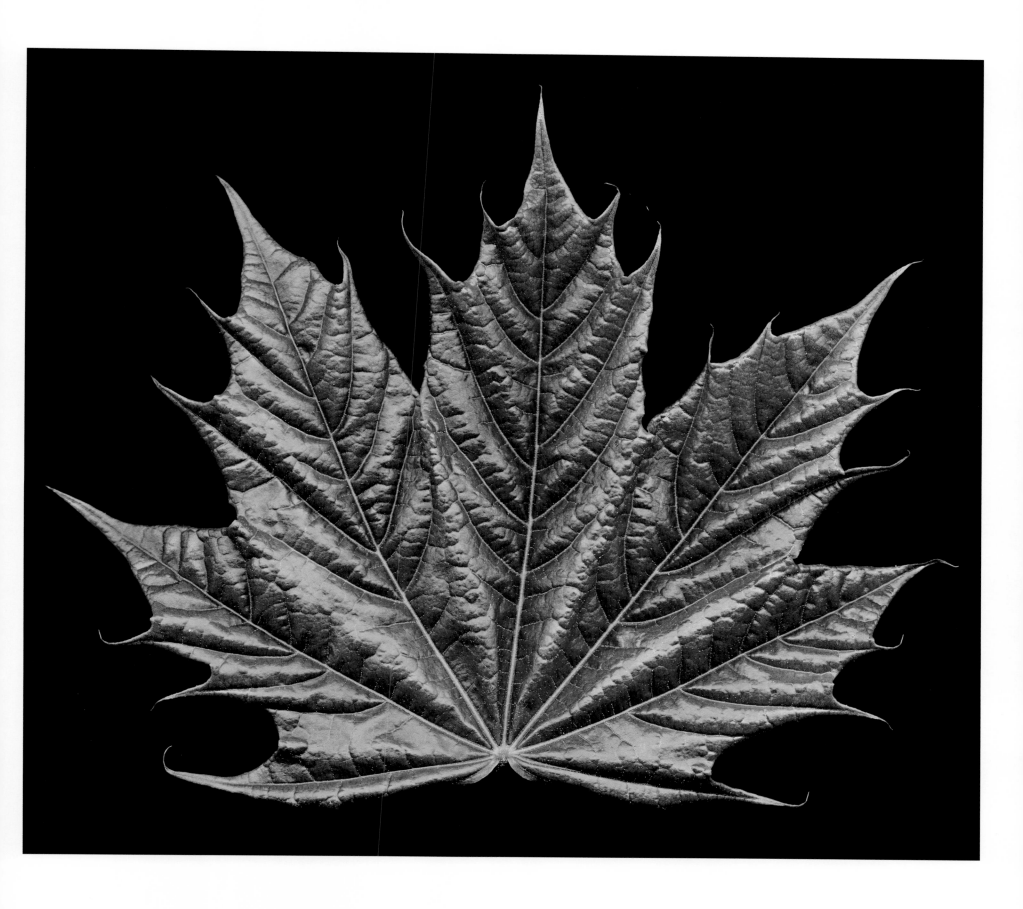

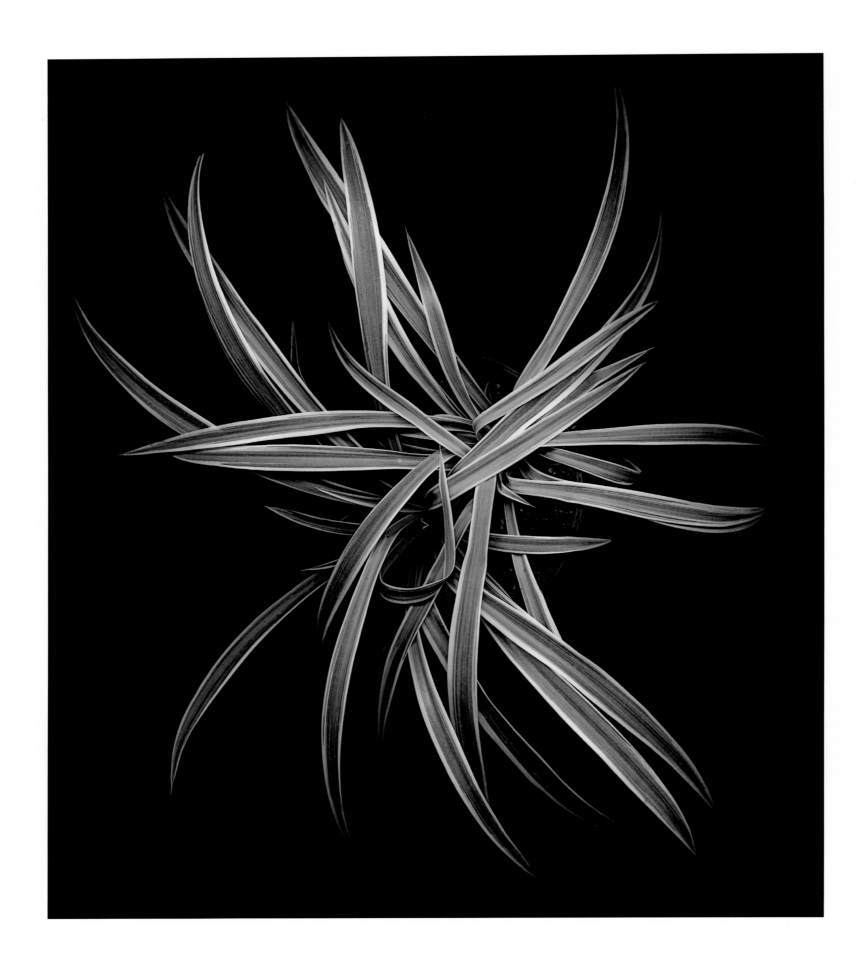

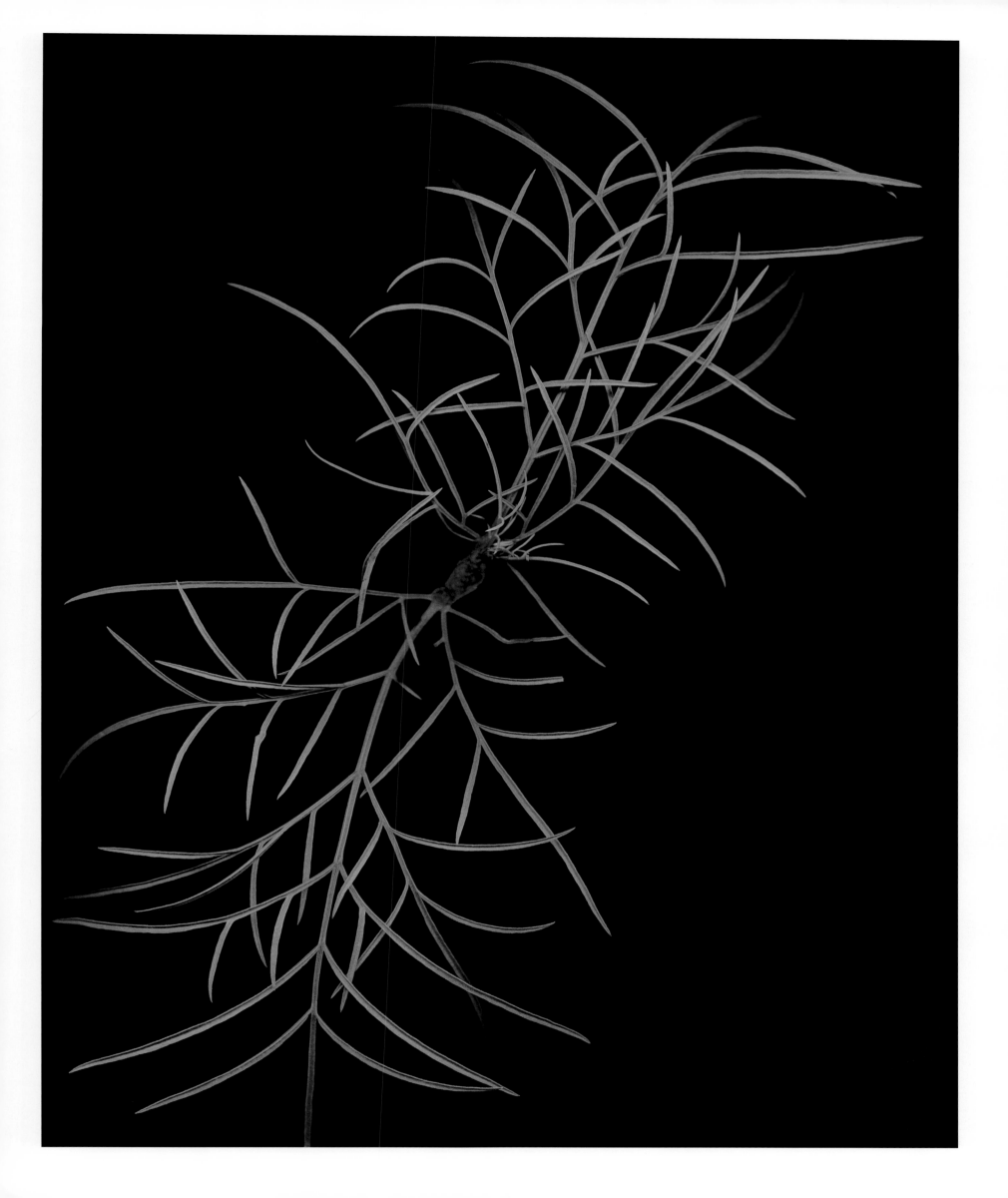

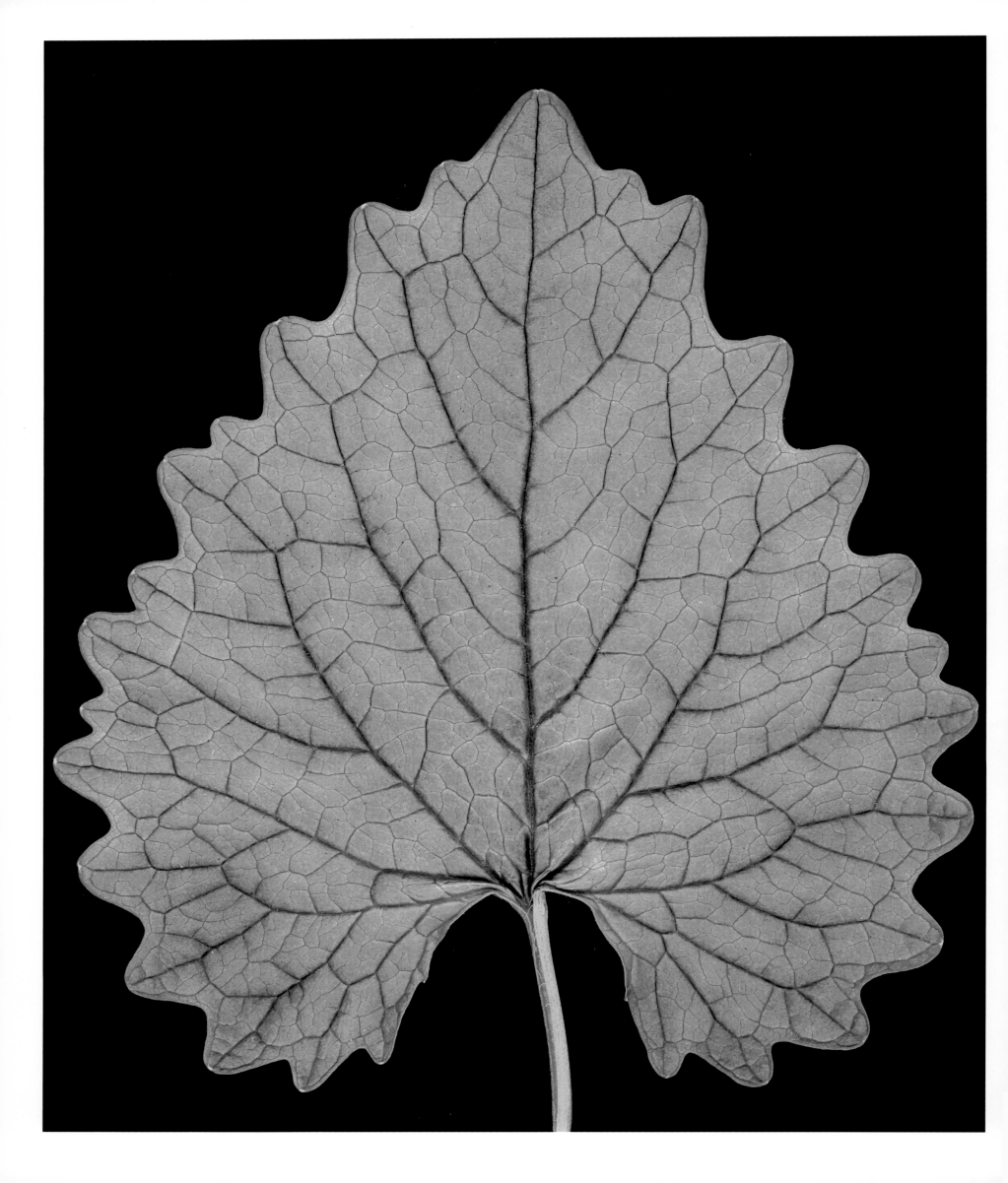

THE BENEFICIAL GREEN PLANT

Ever since the existence of life on the planet Earth, a natural cycle of birth, death, decay, and rebirth has ruled over all living things. The innumerable life forms embroiled in the cycle exist because of the relationship between the planet and the sun—closer to, or farther from the sun, and the flora and fauna of earth would be very different than it is. The sun has guided the development of life on earth, and the life form that takes advantage of the sun's energy—the photosynthetic plant—is the one on which all others depend. The beneficial green plant transforms the sun's energy into nourishment for other living things.

By intervening in the food chain, humans reap the benefits of earth's natural energy cycle. Fats, carbohydrates, and proteins are nutrients that come directly or indirectly from plants, giving us energy—the capacity to move. Green plants are the first links in the chain, but the ties that bind humans and plants are a bundle of contradictions. We dominate and manipulate them, sometimes to the point of their extinction, while at the same time are overpowered by our dependence upon them.

By mistake or design, the technological advance of humans is rooted in our associations with plants. Converting the energy from dead and living plants, and using other earth-bound materials, we have manufactured the modern world. Beginning with wood—the energy source that fuels fires for warmth, illumination, and cooking—humans have devised or discovered gratifying ways to use fire and its emanating heat. One mythological version of the creation story tells how Prometheus and his brother Epimetheus fashioned the creatures of the world and gave humans the gift of fire. The name Epimetheus means afterthought, and living up to his title, he gave the best gifts to the animals. Acting on first impulse, Epimetheus endowed the beasts of the world with strength and speed, courage and cunning, with fur and feathers, wings and shells—all the while not thinking that these gifts might benefit humans. Upon realizing his mistake, Epimetheus asks his brother for assistance and Prometheus—whose name means fore-thought—takes over the task of creating. He creates the humans, creatures that stand upright like the gods—and going up past the heavens, to the sun, he lights a torch, bringing back the fire to protect humans from the strength, swiftness, and cunning of the beasts. In the 8th century B.C. the Greek poet Hesiod wrote—"And now, though feeble and short-lived, Mankind has flaming fire and therefrom Learns many crafts."

Somewhere during the history of human existence, people did learn from fire, finding that its heat hardens clays and metals. Clay can be formed into vessels for eating and drinking or storing food, and once hardened, retains its shape. Stored food that stays dry can be transported, and that was important for two reasons—trade and exploration. The ability to traverse great distances with food enabled goods and ideas to be exchanged, and unknown lands to be explored. Since necessity inspired innovation, a system of record keeping also sprang from

commerce. Written characters were invented and used to document transactions; they were pressed onto soft clay tablets, and then hardened by fire. These and other tablets may have contained information essential to the townspeople of the day, or to serve as a record for future generations.

Even charcoal, the remains of heated wood, is technologically important. Charcoal acts as a reducing agent, and when—in the hands of a skilled artisan—it is heated with mineral ores, gaseous carbon dioxide and water are created and driven off, leaving behind valuable copper. Dissolving tin into molten copper results in bronze—stronger than copper by itself, bronze is easy to cast and can be hammered to a hard, sharp edge—ideal for tools, weapons, and farm implements. Iron is derived from a similar process—it and bronze are superior to stone, clay, wood, or bones because they are easier and quicker to fashion into useful objects and to keep sharp. Animals became more manageable with metal harnesses and mouthpieces, resulting in greater crop yields and easier maneuverability during battles. The desire to obtain more metals provoked conflicts over mineral rich lands, and societies possessing metal weapons and hammered metal body armor were usually victorious in battle.

The vitality and growth of cities increased because of innovations with metals. Better farm tools increased crop productivity—surplus could be stored or traded—and craftspeople had the equipment to create works that were more intricate and specialized than before. Wood and fire combined to propel humanity into the age of metals, leading to steam power and the age of industry, which has rapidly depleted the Earth's natural resources. In *The Substance of Civilization*, Stephen Sass writes—"History teaches us that the depletion of one source of a substance leads to the discovery of a new source. Nature is bountiful in wood, coal, and oil, the sources of materials and energy. Just as the peoples of the 17th and 18th centuries turned increasingly to coal as a substitute for wood, so it will soon be time for us to look for a replacement for oil, the reserves of which will run out sometime this century."

In nature, plants that disperse their seeds ensure the success of their species through continued generations. It was a lucky chance that hunter-gatherers found an anomaly among grain plants—some of which did not disperse their seeds, but held onto them. This meant the grain didn't fall to the ground, nor was it carried off by the wind; it remained on the stem until it was physically removed. Along with domesticated animal power, this plant discovery contributed to the concept of farming. Plowing the land, planting it with one crop, and most importantly, being able to harvest it all at once, became an important building block in the history of many civilizations. Evan Eisenberg writes in *The Ecology of Eden*, "The alliance of grass and man has conquered the world about as thoroughly as any previous alliance, and in record time. The genus *Homo* has struggled for two million years to reach a population of five million; once the marriage with annual grasses was solemnized, it took only ten thousand years to reach the present level of almost six billion."

68. POPLAR, *Populus* sp.

"The genus name *Populus* is said to derive from the Roman use of the trees as the sites of public meetings—hence *arbor populi*, or 'people's tree.'"
—Rebecca Rupp, *Red Oaks and Black Birches*.

72. HONEY LOCUST, *Gleditsia triacanthos* cultivar

"The year was quietly dying. Leaves drifted unprotestingly from their source of life. The harvest had been gathered, and all sense of urgency had gone from the landscape. It was odd That in what approximated to late middle age in the year, the earth should become fruitful Perhaps if human beings were more like the earth and less like the animals, they might die with similar grace."—Alice Thomas Ellis, *The Other Side of the Fire*.

73. LINDEN LEAVES AND ACORNS, *Tilia* sp. and *Quercus* sp.

"I raked a lot of autumn leaves today;
They made a heap of scarlet, brown and gold.
I layered them in with rays of shimmering sunlight
And left them there for Mother Earth to hold.

But really I was raking up some dreams;
Some still gleamed with bits of gold—but some were brown.
I layered them in with gentle thoughts and love.
They had their day but now I've dropped them gently down."
—*Autumn Thoughts*, Edith Stratton.

74. JAPANESE KNOTWEED (Reverse of Stem), *Polygonum japonicum*

The jointed stalks of this tall growing eastern Asian native look like bamboo, but the large leaves and small clusters of creamy-white flowers disprove that assumption. The name *Polygonum* comes from two Greek words, *polys*—many, and *gony*—a knee, referring to the many joints, or "knots" in the stem.

75. ASH LEAVES, *Fraxinus* sp.

"When Henry L. Aaron, known to baseball fans as Hank, hit his all-American lifetime record of 755 home runs, he did it with a stick of ash."—Rebecca Rupp, *Red Oaks and Black Birches*.

76. MAPLE SAMARAS, *Acer* sp.

"The airborne winged seeds of the maple are lovely in form and color. Their propeller-like shapes aid the lively whirl of their wind dispersal."—D. B. Thorp, artist and gardener.

77. INDIA QUASSIAWOOD, *Picrasma ailanthoides*

"Flowers are lovely; love is flower-like; Friendship is a sheltering tree."
—Samuel Taylor Coleridge, *Youth and Age*.

78. BROMELIAD, *Guzmania* sp.

Bromeliads are mostly epiphytic plants—they grow on trees for support, but not for nourishment. The rosette of leaves, clasping tightly to one another, catches rainwater, leaves, and insects that decay and nourish the plant.

79. YEW, *Taxus* sp.

In Britain, yew trees live for hundreds, even thousands, of years. The wood of the Old World species, *Taxus baccata*, is exceptionally hard and used to make furniture and archery bows.

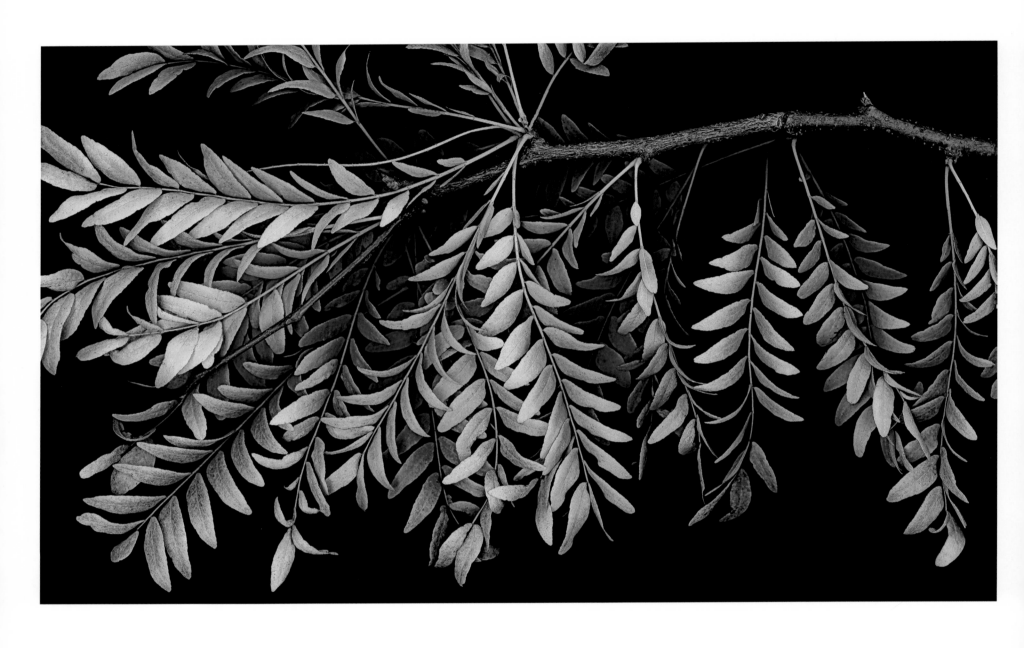

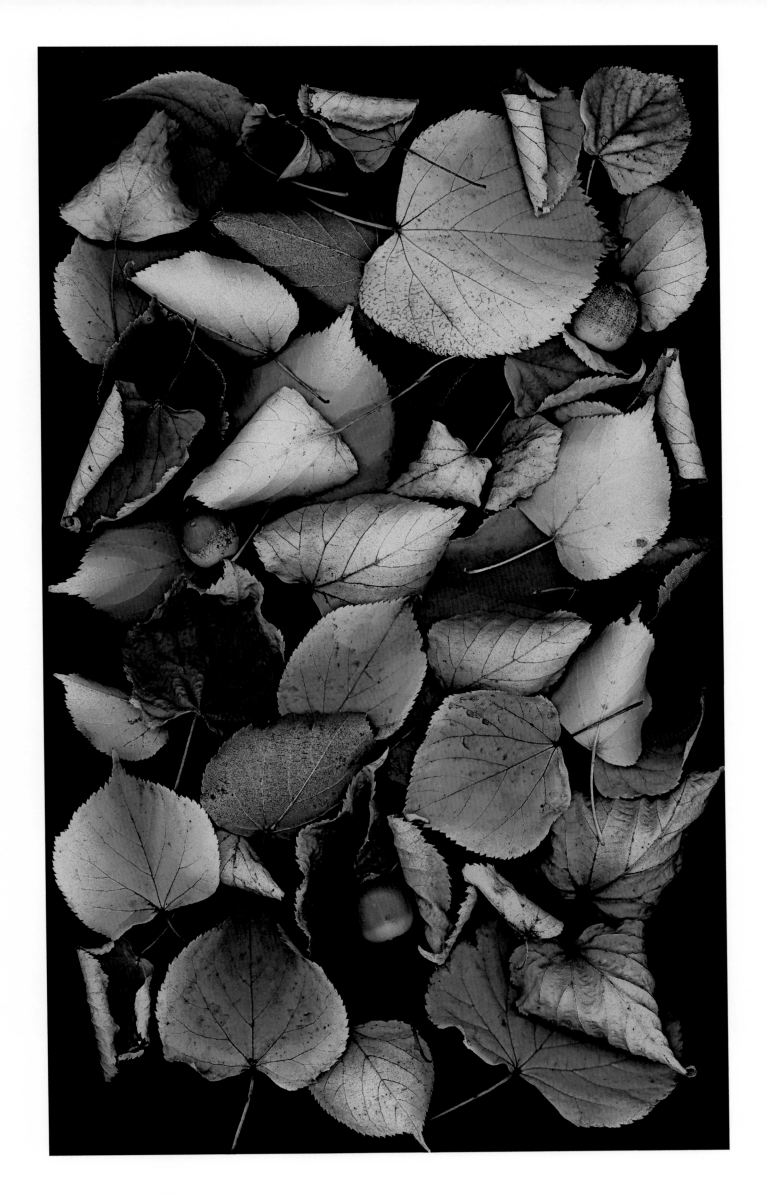

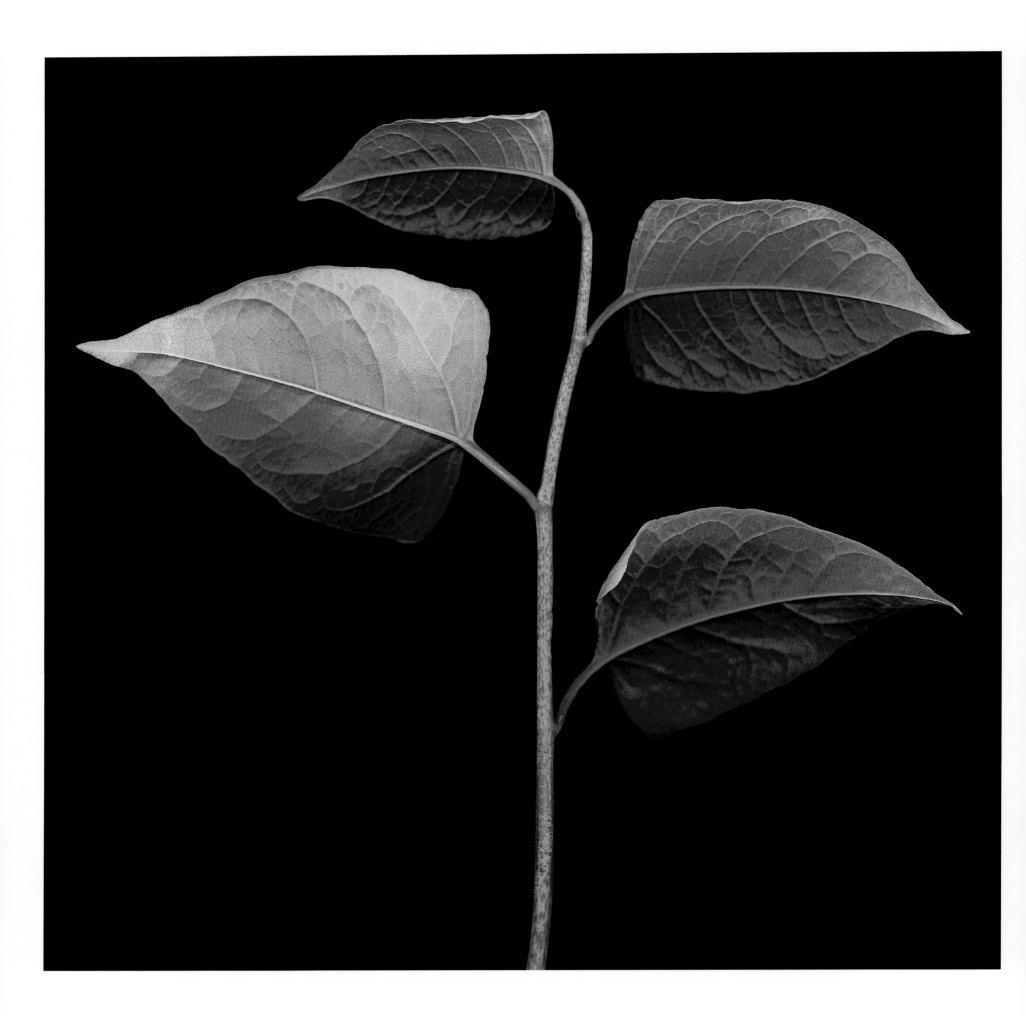

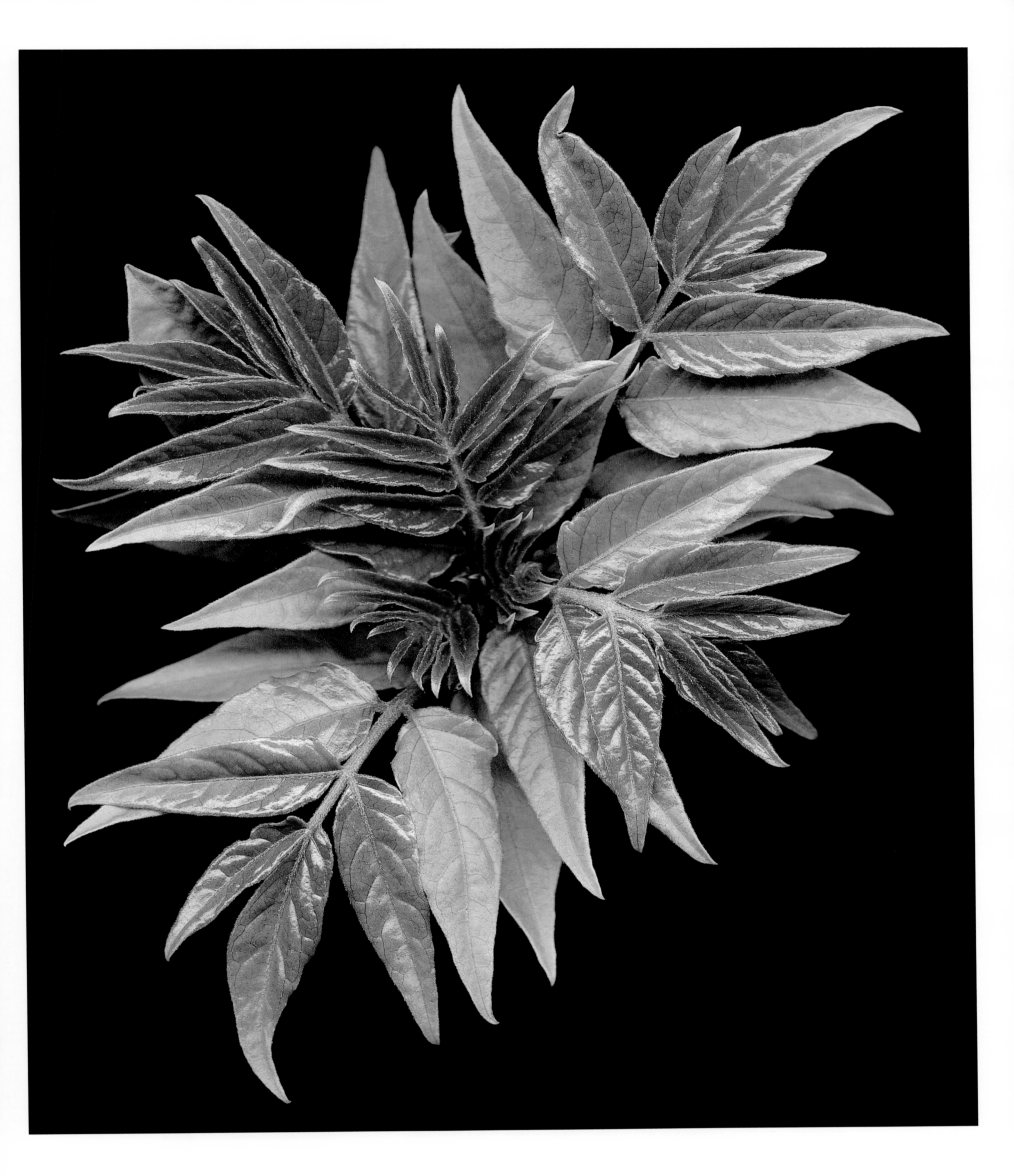

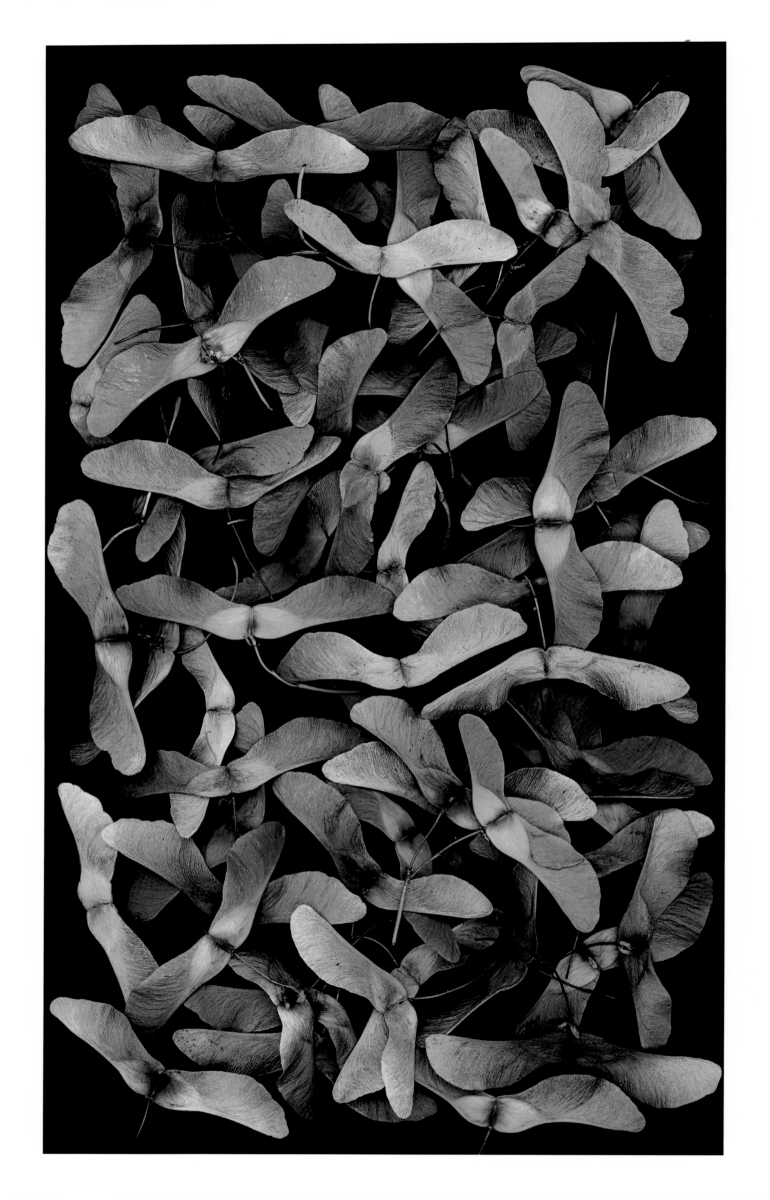

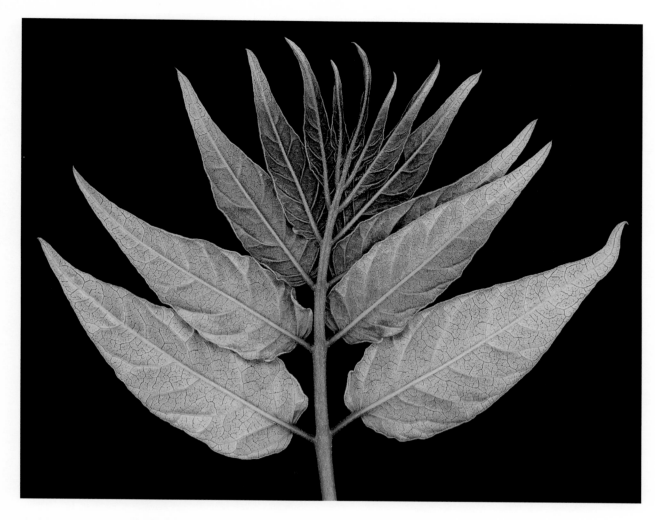

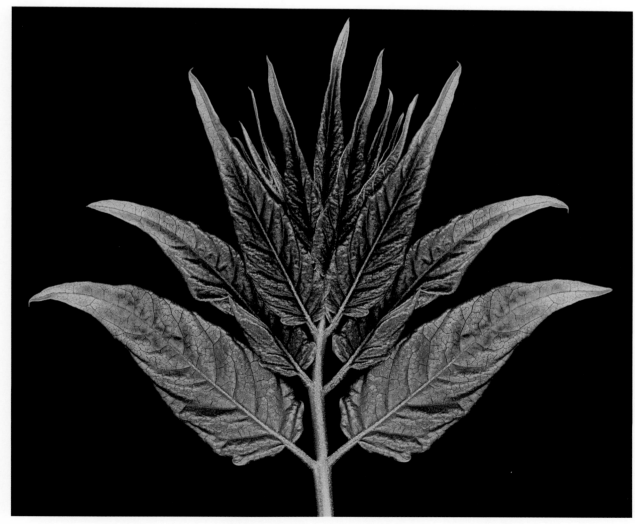

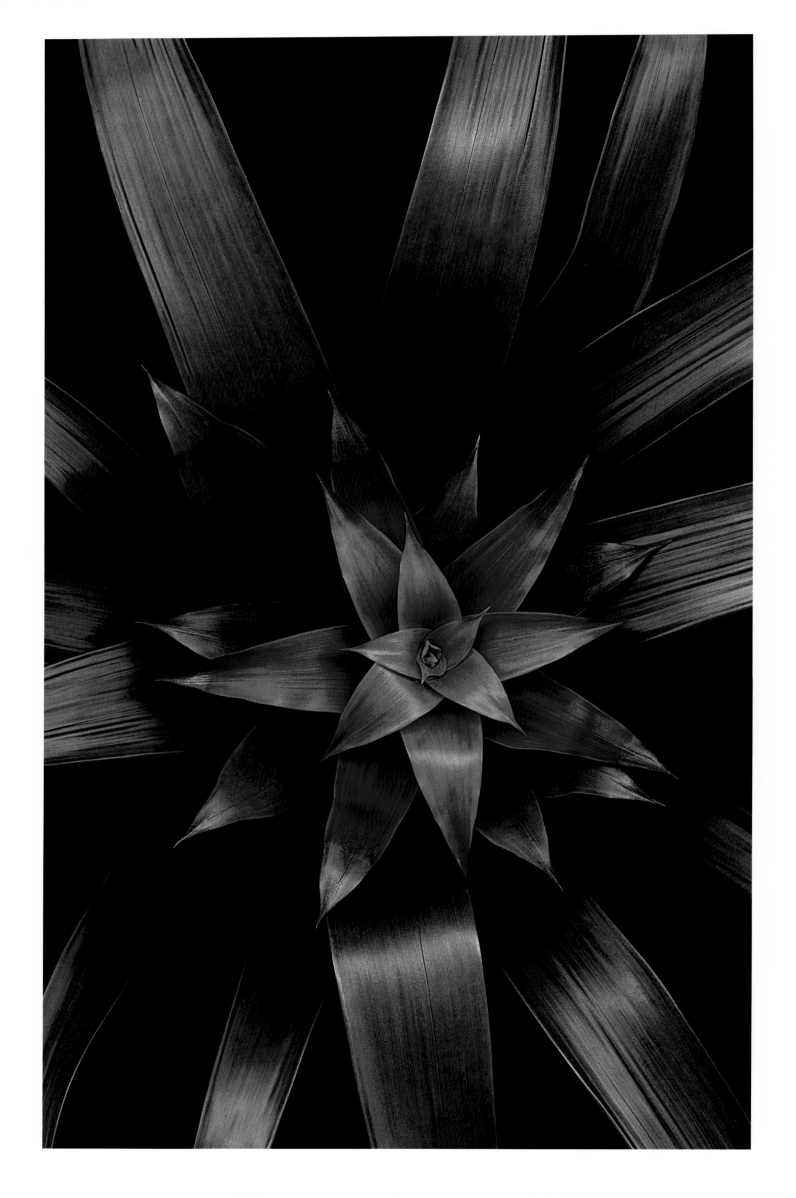

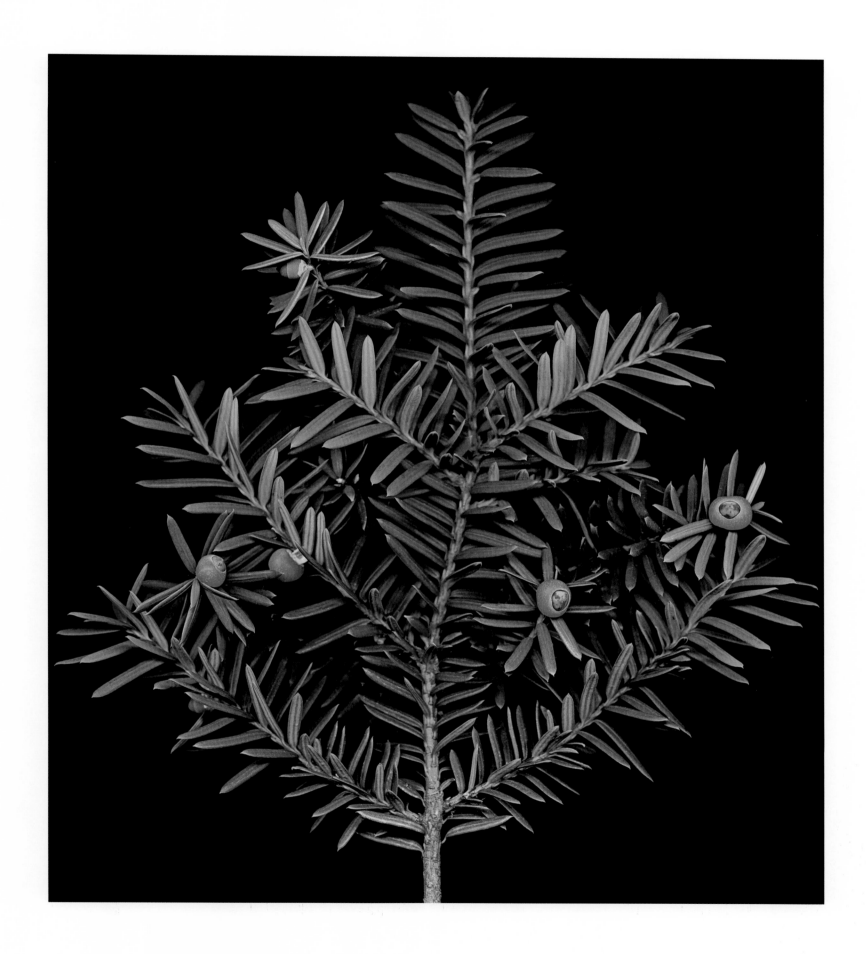

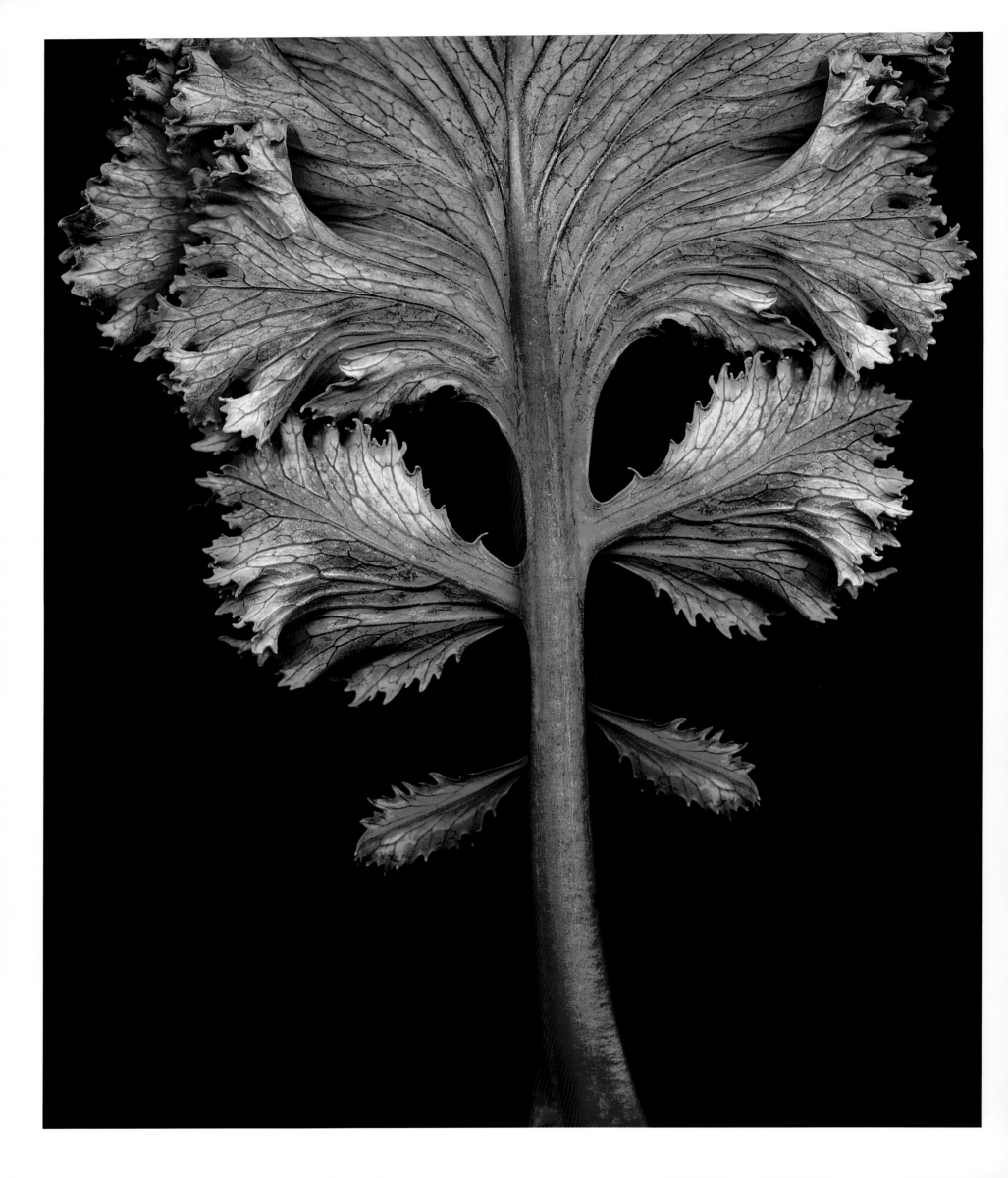

LEAF COLORATION

Whether adorning the branches of trees and shrubs, hanging from climbers, or hugging the ground, leaves in all their guises, serve a purely functional purpose. They make food by photosynthesizing; upon being shed, they fall to the ground where countless organisms benefit from food and shelter, and the surrounding soil is enriched as they decay. An excerpt from the first chapter of Christopher Lloyd's book *Foliage*, tells us how valuable leaves are in the garden. "One of the most obvious attributes of the average leaf is that it is with us for much longer than the flower. . . . It provides a satisfying and sustaining diet." Mr. Lloyd continues by asserting his views on the shapes, colors, sizes and textures of leaves.

Most leaves look green because that's the color of light reflected by their surfaces—being full of green chlorophyll, they absorb all other colors. Leaves have layers of cells; some that are below the surface contain pigments of other colors, but are masked by the uppermost green layer. This becomes obvious during autumn in temperate climates as day length decreases. The top layers of green cells can no longer sustain themselves in the reduced amount of light, allowing the underlying colors to appear. Golden locusts, purple-leaved plums, and other plants with colored foliage in spring and summer, have cells dominated by nongreen pigments that do not interfere with photosynthesis. However, in variegated leaves, the cells of the nongreen portions have either no pigmentation, resulting in white variegation, or else they contain pigments of other colors that are not covered by green chloroplasts, giving the leaves striped, mottled, or spotted patterns.

Variegation arises when environmental changes or viral infections alter the genetic composition of plants. This is often referred to as a mutation or a chimera, because one new shoot usually emerges variegated from an otherwise green plant. Like Chimera of Greek mythology, it shows diversity or variability. These "oddities" are random events that get weeded out in nature because of their diminished vigor—plants with the reduced capacity for photosynthesis produce less food for themselves, eventually dying out. In nonwild plants—that is, plants that are cultivated—variegated mutations frequently show up and are valued for their uniqueness. These eccentric individuals would probably also die out if left to their own devices, but because gardeners prize them, they survive by being propagated, distributed, and pampered. Hostas are perhaps the one group of variegated plants that are most appreciated by gardeners. The southern gardener and writer, Elizabeth Lawrence, knew hostas as plantain-lilies, she writes—"A variety of tones in foliage is as important as bloom, and there is much variation in the leaf pattern of the plantain-lilies."

80. KALE, *Brassica oleracea* cultivar

The huge group of brassicas contains many edible plants—kale, cabbage, cauliflower, and broccoli are the most familiar. It is thought that these evolved from one variable plant species that diverged into many forms and was then selected and preserved by humans.

84. PAINTED LEAF BEGONIA, (Reverse of leaf), *Begonia rex* cultivar

The painted leaves of *Begonia rex* are among the most striking of all begonias. Of the thousands of begonias in existence, painted leaf begonias are easily grown in the house, preferring warm temperatures, moderately moist soil, and indirect light.

85. WORMWOOD, *Artemisia* sp.

A bitter extract is distilled from several aromatic plants in the genus *Artemisia* for use in absinthe, and to flavor certain wines. "For the lips of a strange woman drop as an honeycomb, and her mouth is smoother than oil: But her end is bitter as wormwood, sharp as a two-edged sword." *Proverbs*, 5: 3-4.

86. ZEBRA PLANT, *Aphelandra* sp.

A group of plants native to the tropical and subtropical Americas, zebra plants and their kin are easy ornamental plants for the house. They enjoy warm temperatures and bright light, resting after they bloom.

87. MADAGASCAR DRAGON TREE, *Dracaena marginata*

Dracaena is from the Greek *drakaina*, a female dragon, and alludes to the stems of *Dracaena draco*, said to resemble dragon's blood.

88. SNAKE PLANT, *Sansevieria trifasciata*

This long-lived member of the lily family is native to South Africa. Its pointed leaves are stingingly sharp and never seem to die, attributes that inspire some to call it Mother-in-law's tongue.

89. CANDLE PLANT, *Plectranthus oertendahlii*

Like other members of the mint family, candle plants have square stems and spurred flowers. They are easy-to-grow houseplants, preferring moderate temperatures and bright, but indirect light. The candle plant, and its cousin Swedish ivy, have long trailing stems and make excellent specimens when planted in hanging baskets.

90. HOSTA, *Hosta* sp.

Hostas are native to China and Japan, but many hybrid cultivars have arisen from all parts of the world. These are tufted perennials grown for their handsome leaves and white, lilac, or blue flowers.

91. SILVER NERVE PLANT, *Fittonia verschaffeltii* var. *argyroneura*

As the empires of nations rapidly expanded in the 18th and 19th centuries, finding, collecting, and growing unknown plants became an obsession. Among the amateur and professional botanists rising to prominence were Elizabeth and Sarah Fitton who wrote *Conversations on Botany* in 1817. The genus of tropical plants, *Fittonia*, is named to honor them.

92. PEACOCK PLANT, *Calathea* sp.

Peacock plants are clump-forming perennials from the tropics. As houseplants, they are easy to care for, preferring warm temperatures and partial shade.

93. POINSETTIA, *Euphorbia pulcherima* cultivar

In their native country of Mexico, brightly colored poinsettias are shrubs grown outdoors and are known as "Flowers of the Holy Night." These beautiful plants are members of the spurge family and are somewhat toxic if ingested.

94. TEASEL, *Dipsacus fullonum*

This coarse, thistle-like plant is native to the Old World but has naturalized in many parts of North America. Growing in fields and along roadsides, it flowers in summer and has unique, prickly seedheads in autumn.

95. POPPY, (Flower Buds), *Papaver sp.*

Martin Booth writes in *Opium—A History*, "To every discovery mankind has ever made, from the lighting of the first fire to the splitting of the atom, there has been a good side and a bad side. Opium is no different. It can stop pain and, as Thomas Sydenham observed over 300 years ago, few doctors would be hard-hearted enough to practise medicine without it."

96–97. MAPLE, *Acer sp.*

"The scarlet of the maples can shake me like a cry of bugles going by."
William Bliss Carman, *A Vagabond Song.*

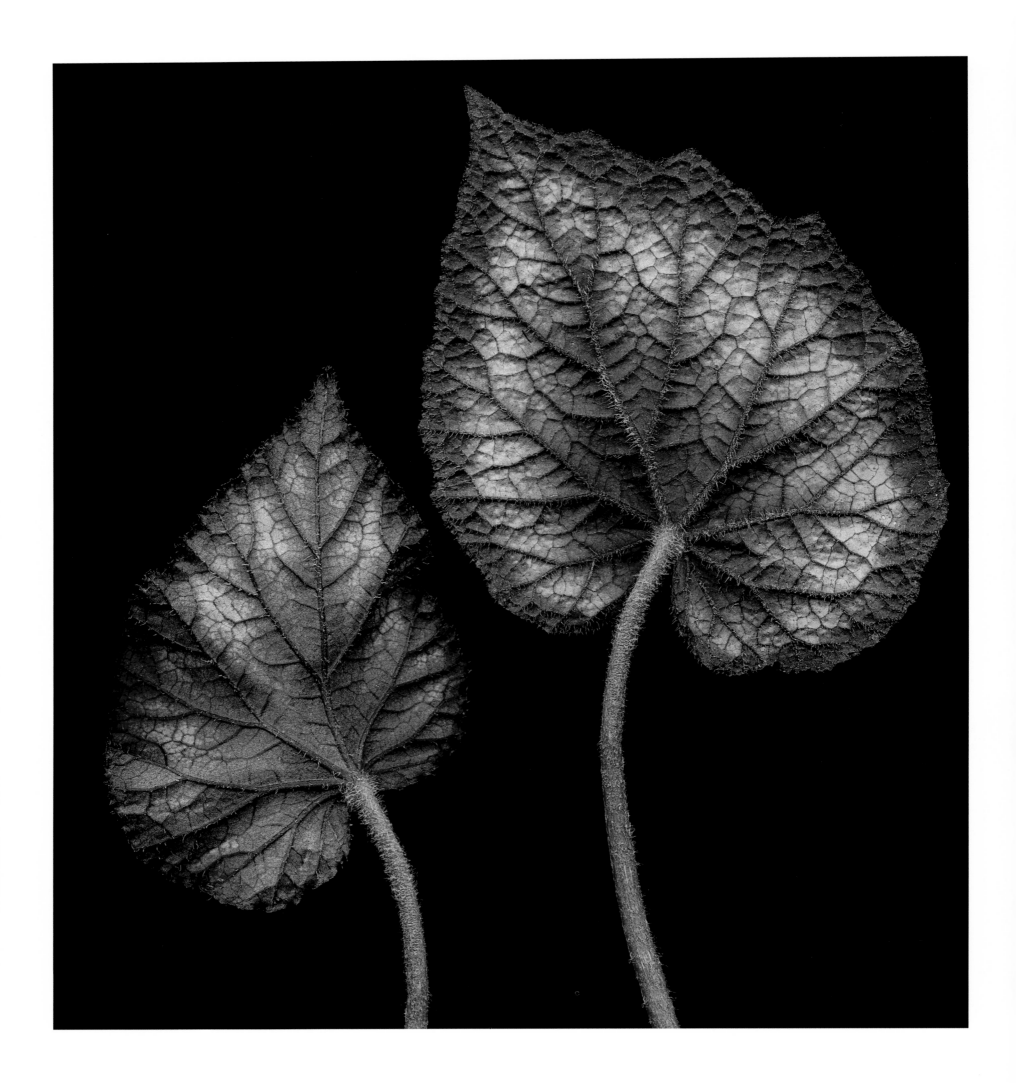

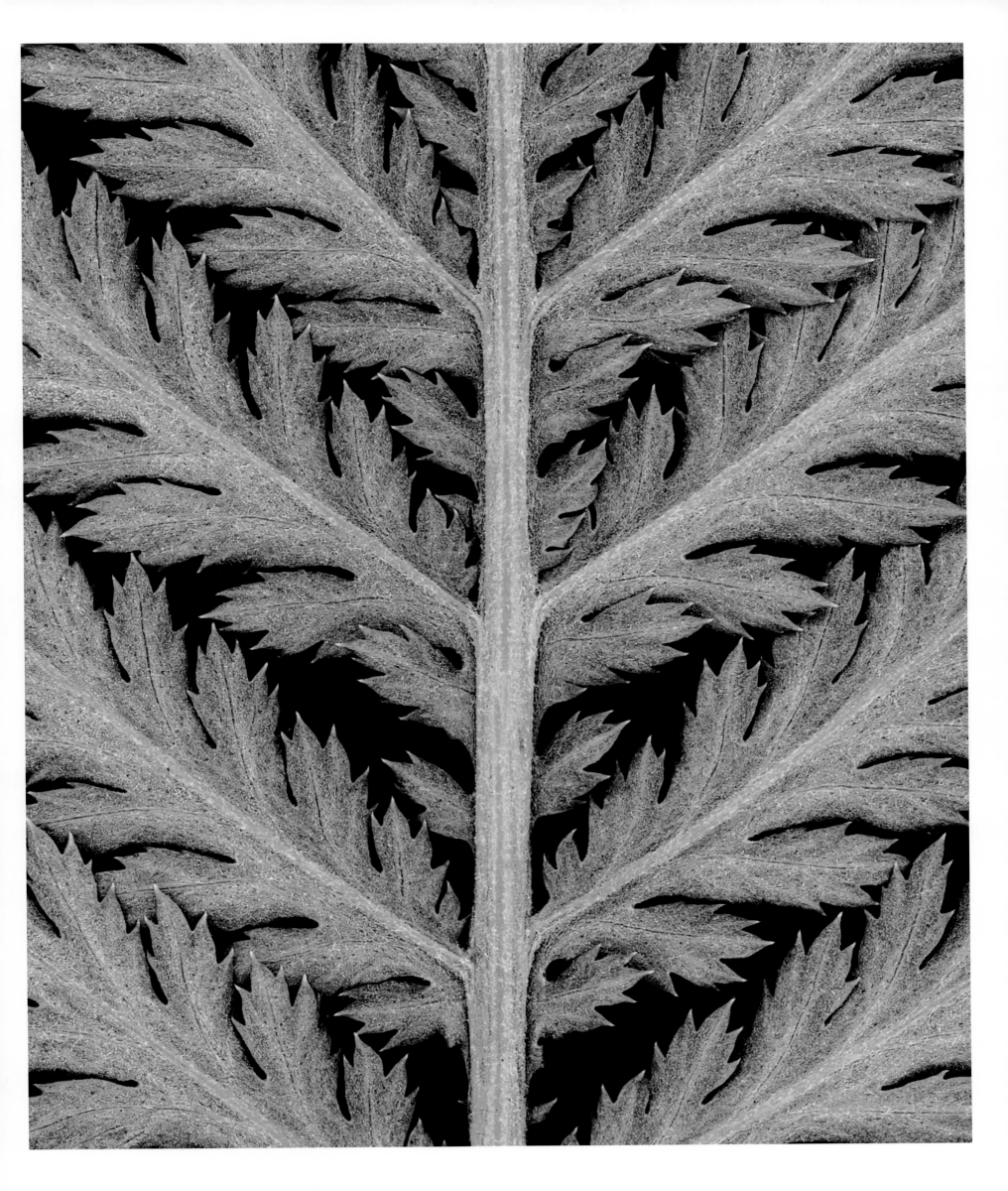

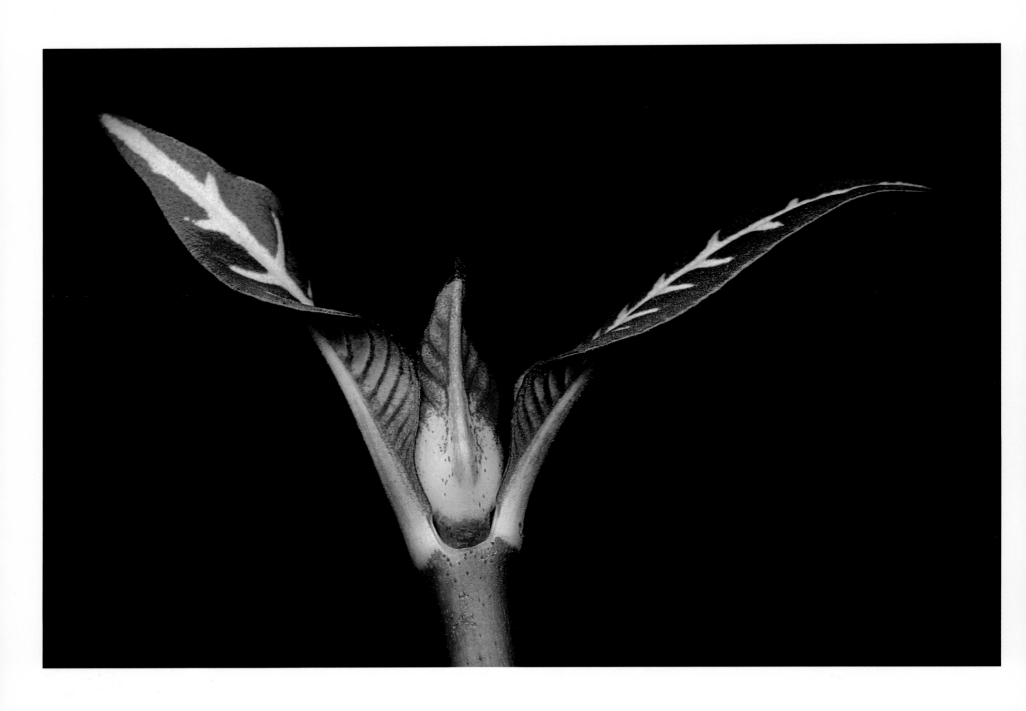

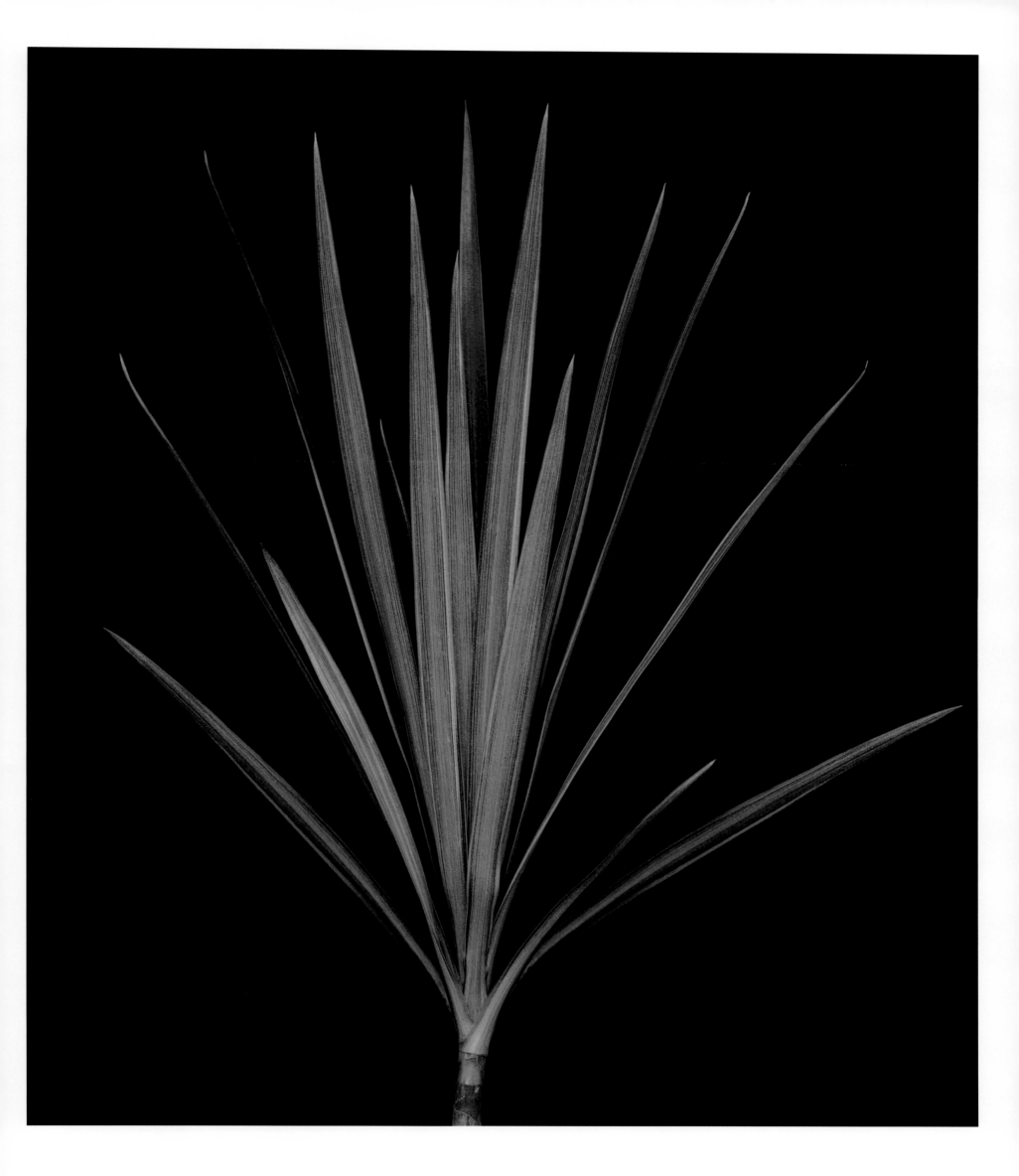

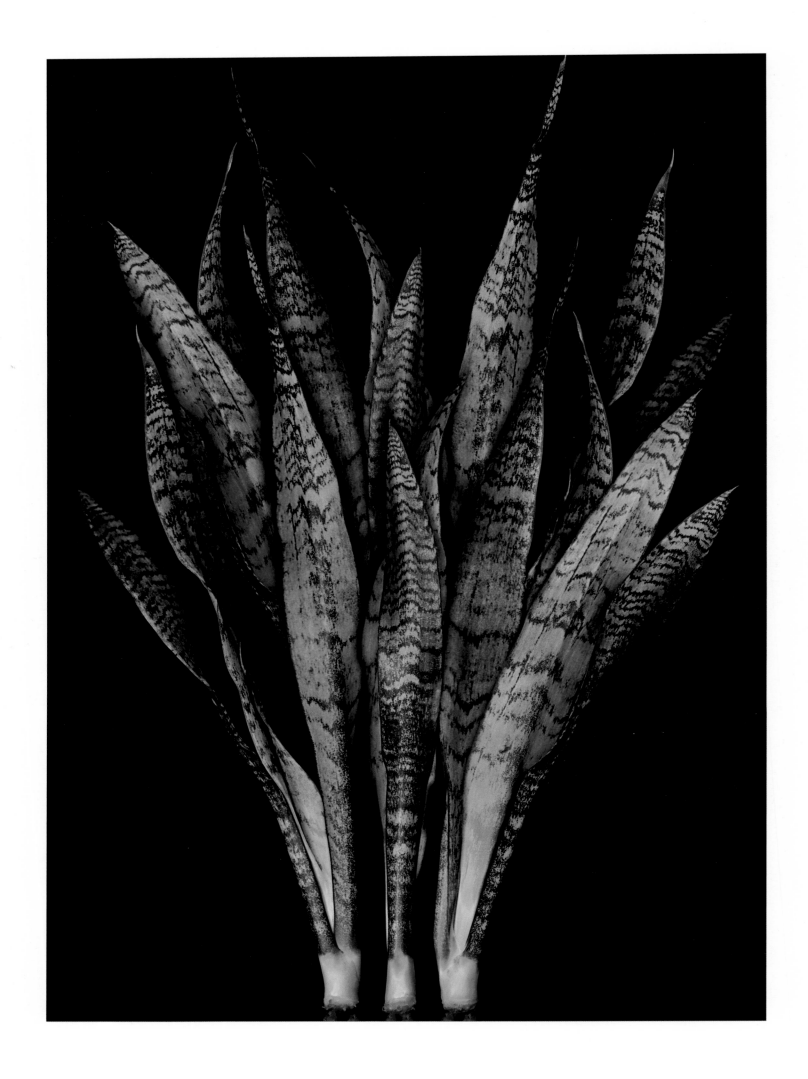

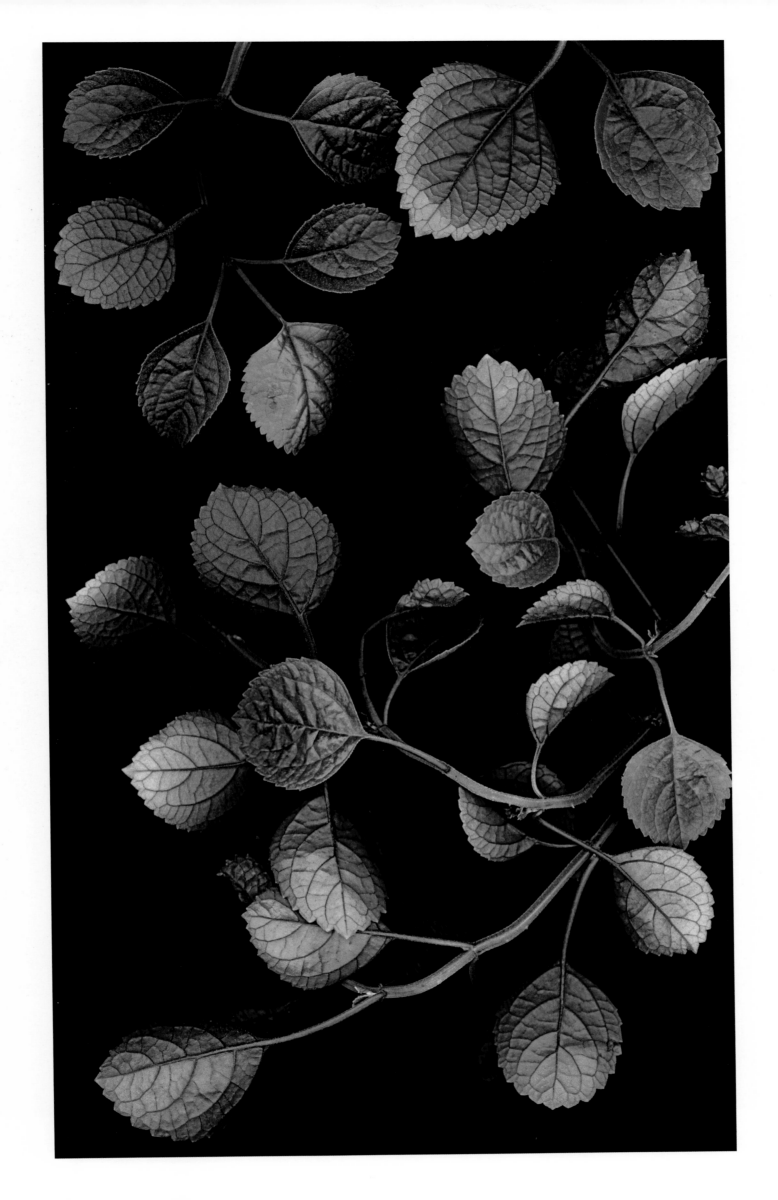

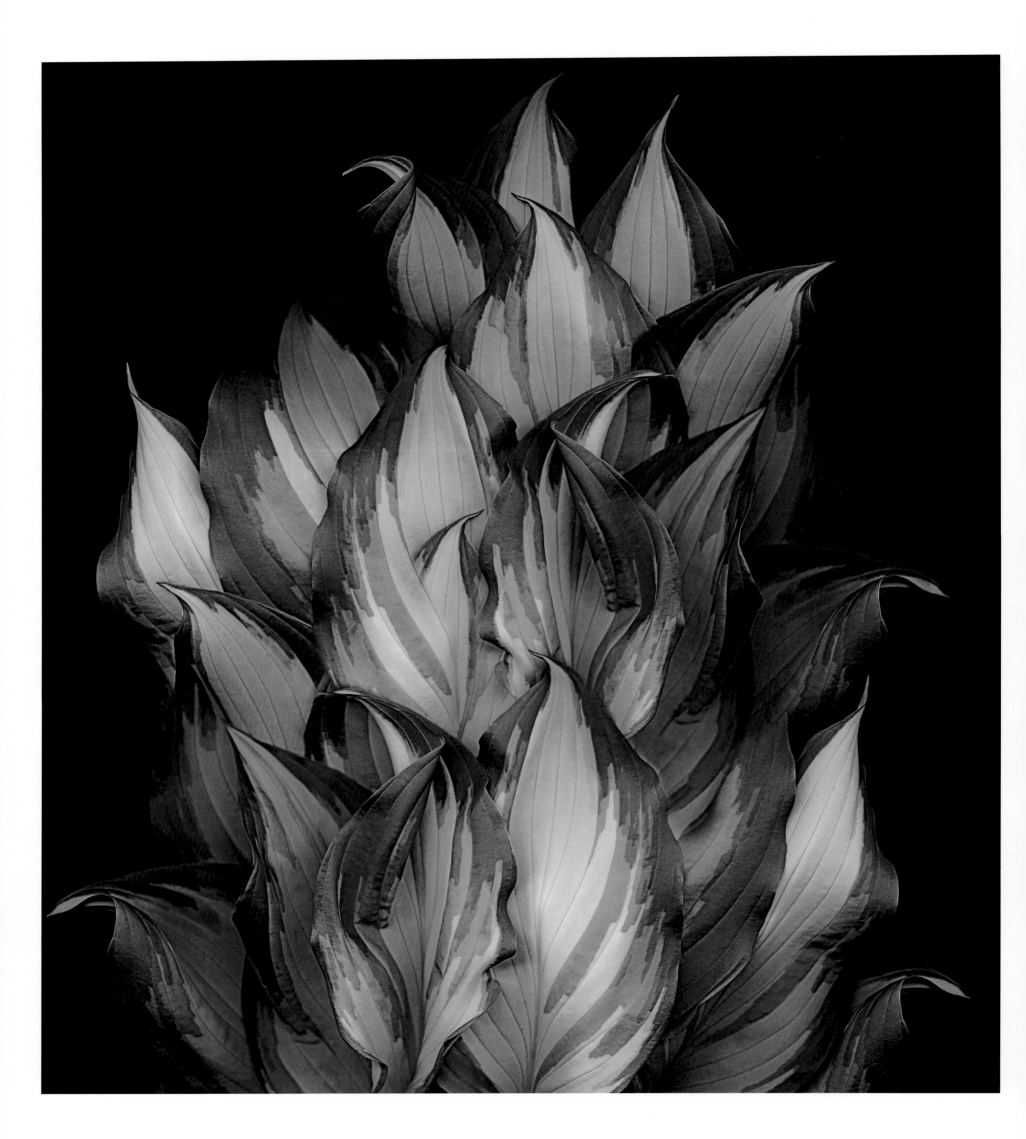

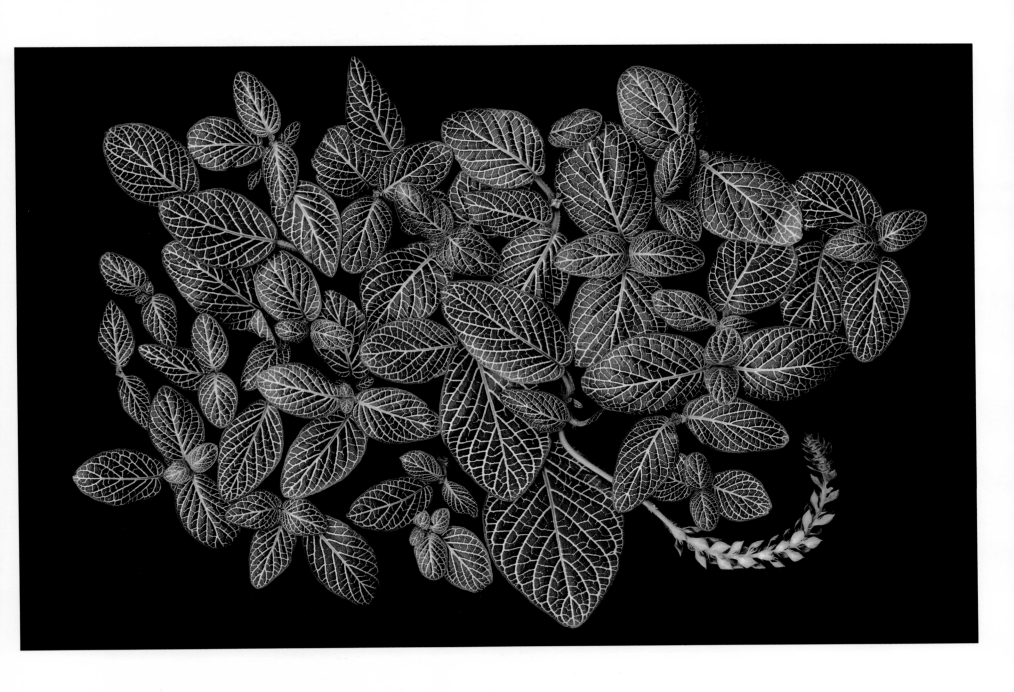

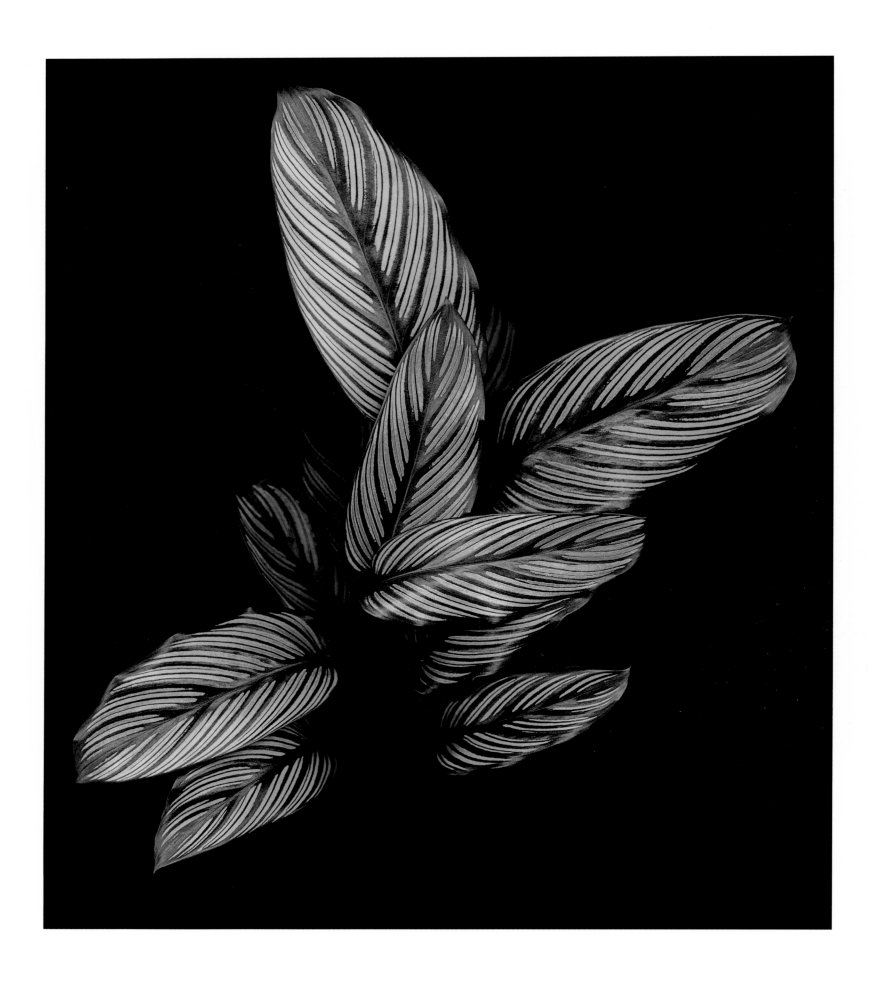

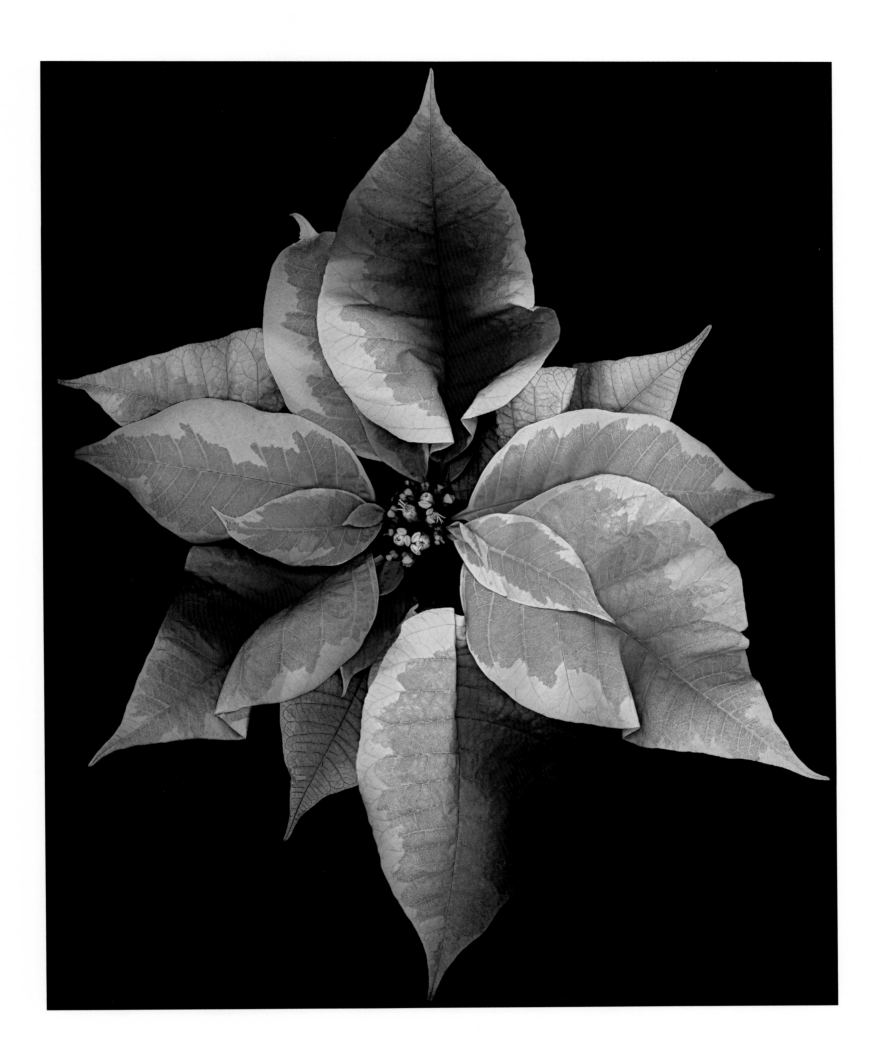

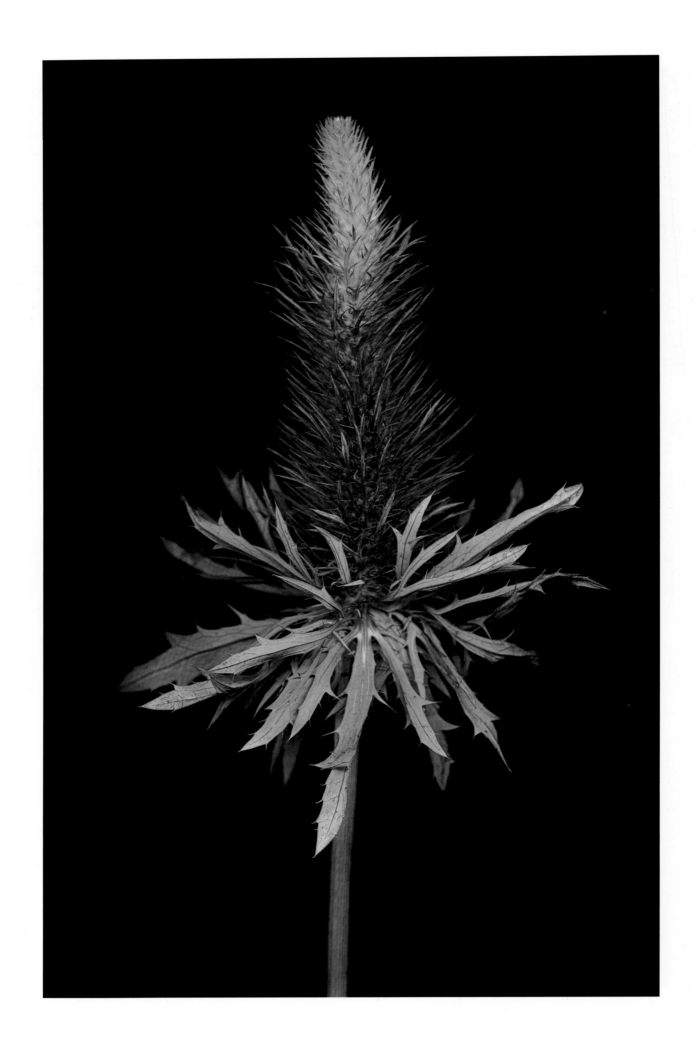

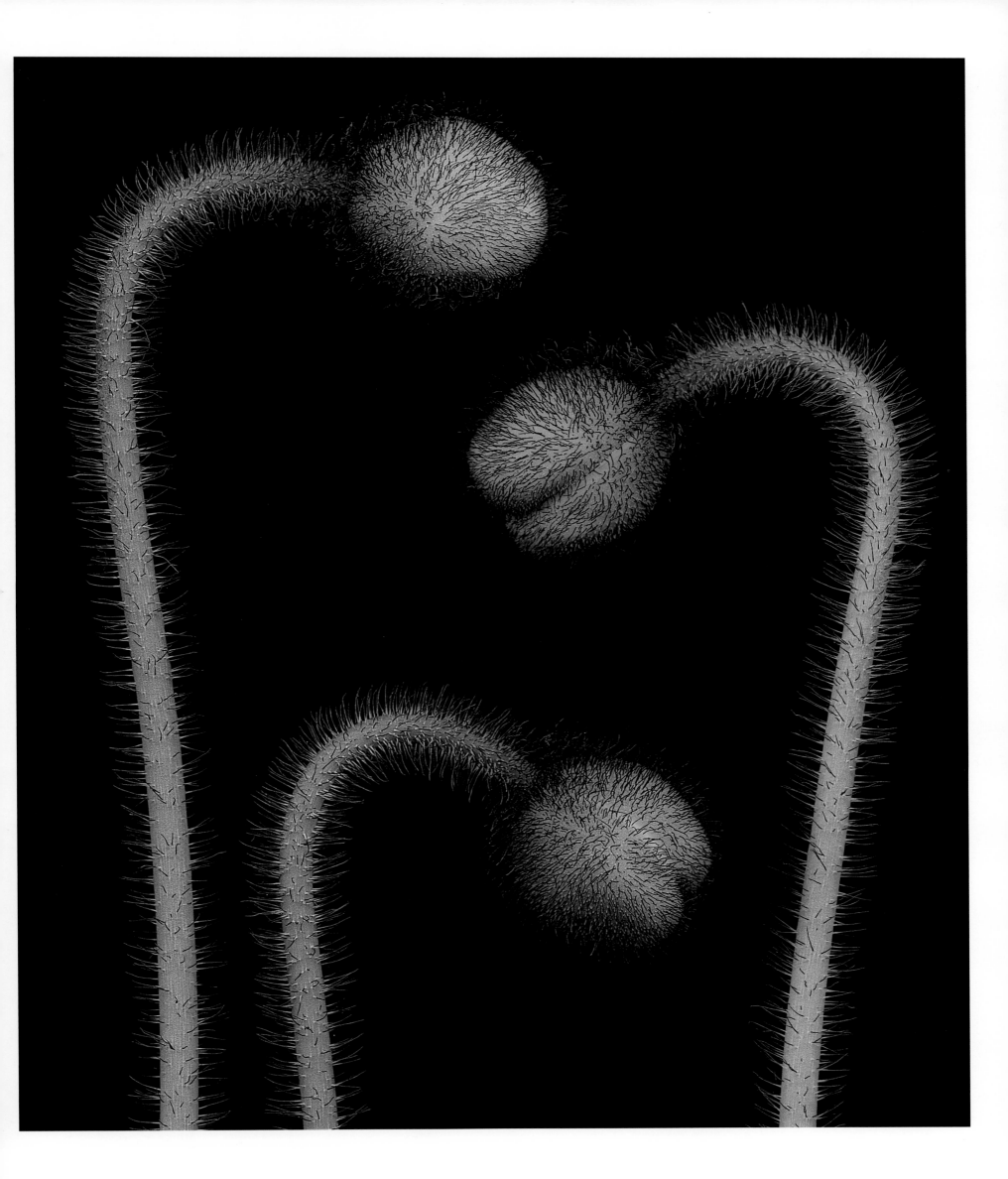

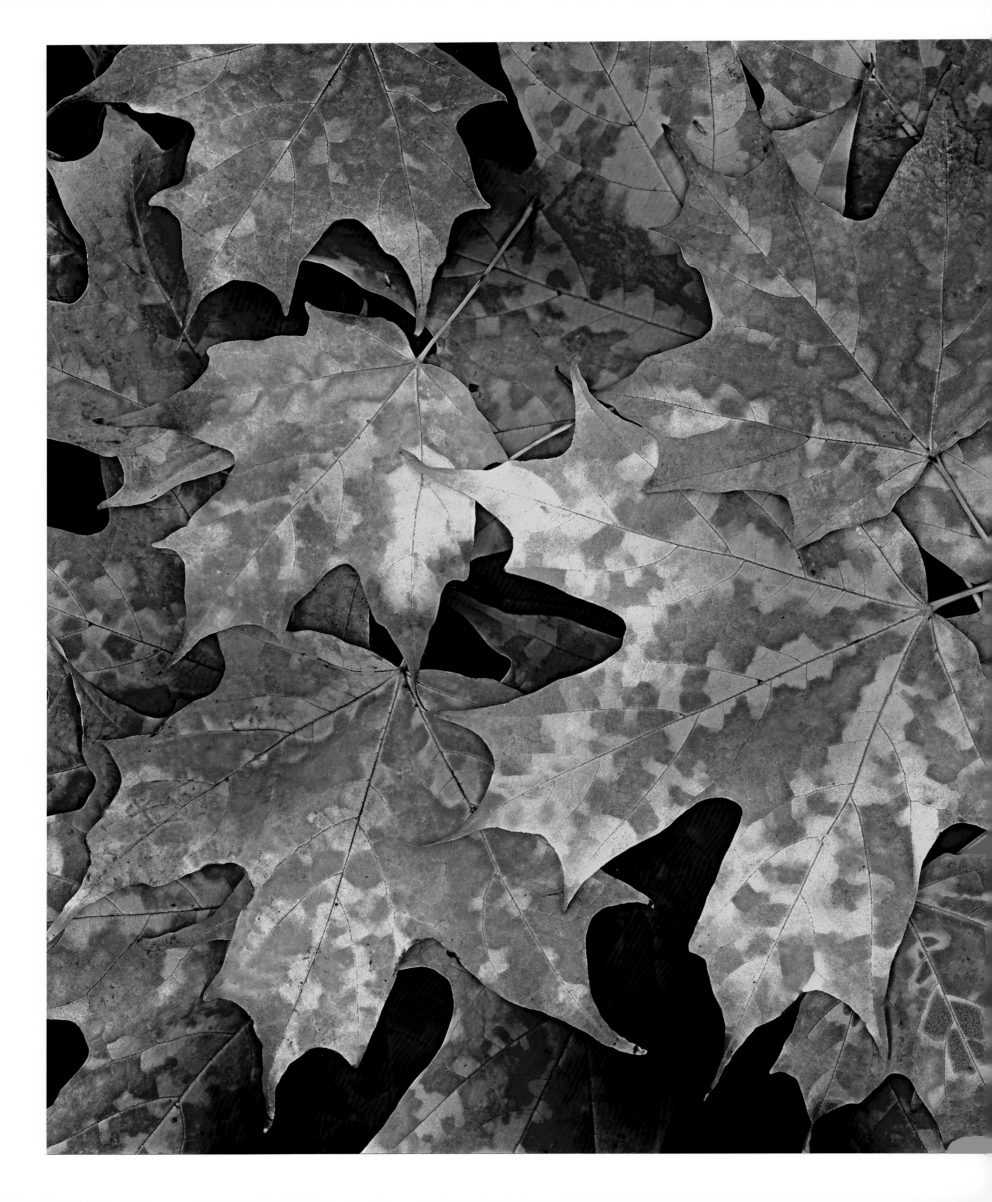

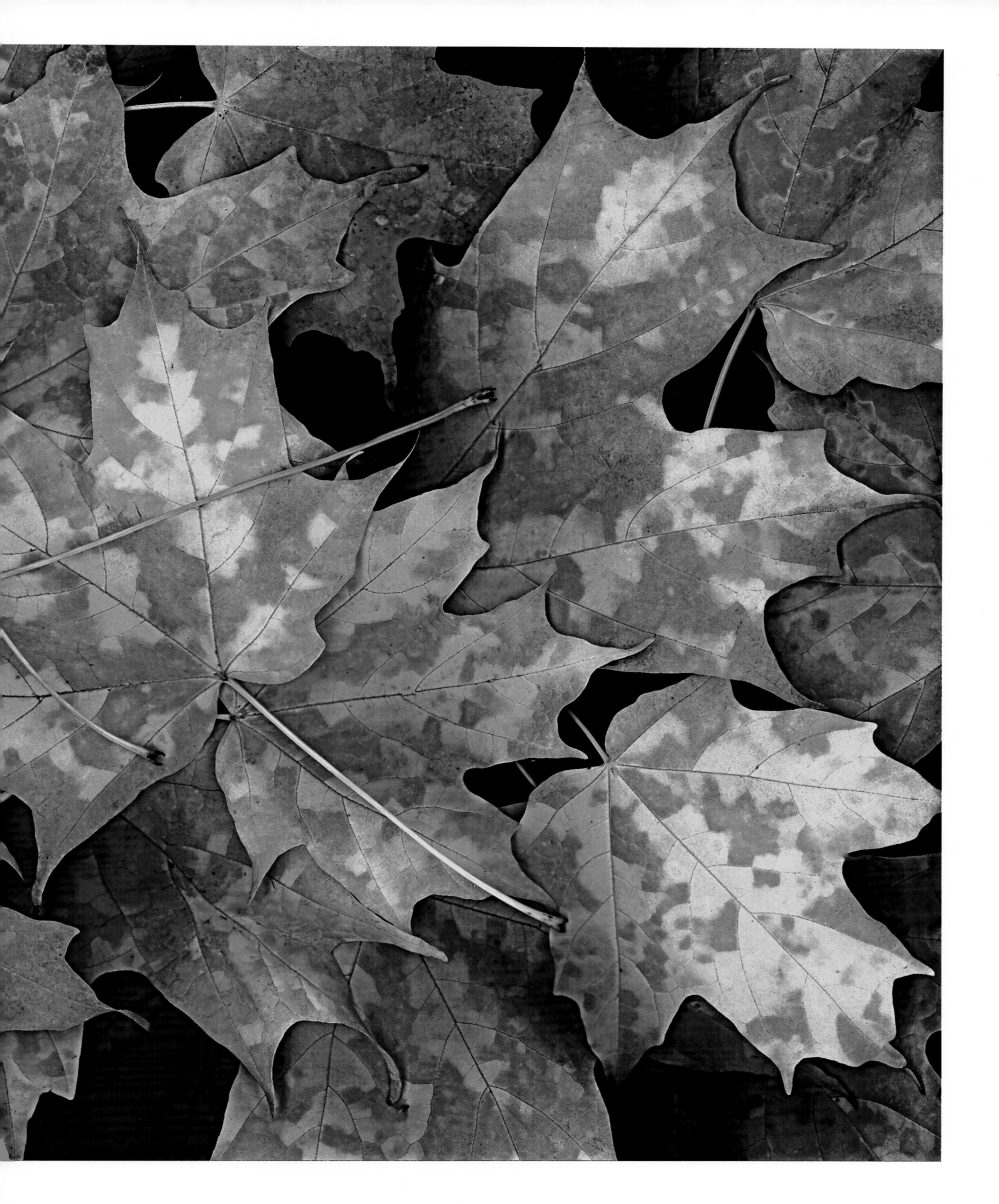

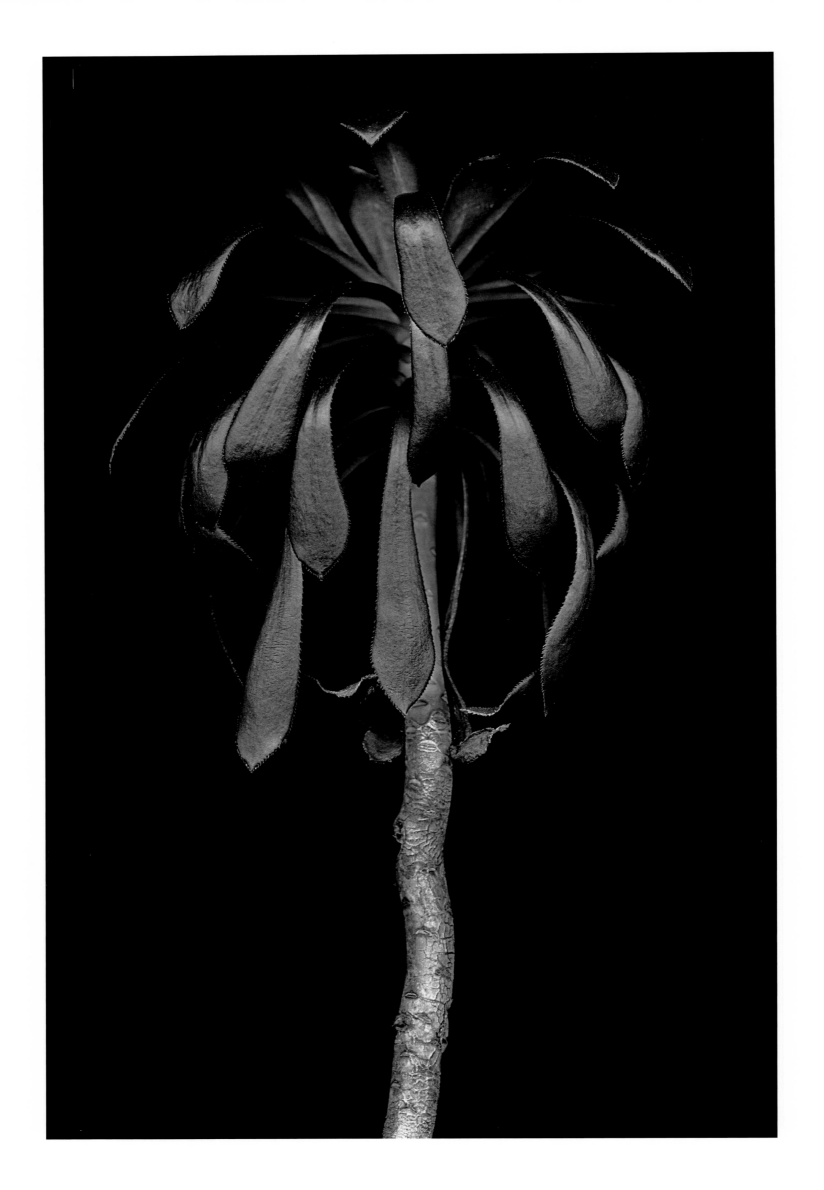

CACTUS AND SUCCULENTS

Cacti and succulents are often grouped together as desert plants—or xerophytes, though not all are native to arid parts of the world. Some grow in tropical and subtropical forests—these are mostly epiphytic succulents—they grow on trees for support, but do not receive nourishment from them. Botanically, succulents are plants with thick, fleshy organs—leaves, stems, or roots—used to store water. Because of their prickles and barbs, cacti are viewed as a distinct group—but they are succulents too. Most cacti are spiky and don't have leaves; their stems are ribbed and swollen, expanding and contracting as their water supply fluctuates. Conversely, leafy succulents have thick, fleshy leaves and short, almost nonexistent stems. These seemingly odd arrangements of anatomy help succulents survive hostile climates.

All plants are unique because of their self-sufficiency—they make their own food by the process of photosynthesis. Most rely on the chlorophyll in their leaves to make this happen, but any part of a plant that is green contains chlorophyll, and will photosynthesize. Sunlight is the force that drives photosynthesis; plants get their energy from carbohydrates made from carbon dioxide and water in the presence of sunlight. The movement of moisture and gasses in and out of the green tissue is crucial to this self-sustaining process. It is controlled by tiny pore-like openings called stomata. Stomata open during the hours of daylight, allowing carbon dioxide into the plant, and releasing moisture. This method works well for most plants, but the moisture lost through the stomata from evaporation would be certain death for those growing in hot, dry climates. Succulents have overcome this dilemma; they still perform the life-sustaining process of photosynthesis—they must to remain alive—but they do it without opening their stomata during the hottest part of the day. Their stomata open at night when temperatures are cool; gathering carbon dioxide, then storing it to be use in photosynthesis the next day.

Evolution has taken plants in many distinct directions and has provided succulents with features that may look unusual, but are essential to their survival. Since moisture conservation is important to plants living in harsh climates, succulents avoid the direct rays of the sun by covering their stems or leaves with spines, hairs, or waxy coats. These coverings buffer drying winds and provide an appreciable amount of shade. Hairs and spines gather water by being arranged in a fashion that collects dew or rain, channeling it to the roots. Spines and prickles also prevent fleshy, moisture-laden stems and leaves from being eaten by animals. In *The Sensuous Garden*, Montagu Don describes the visual sensation of cacti, "While most plants positively invite touch, there are those that have evolved means of defending themselves against it. Some plants openly display their aggression like a cornered street fighter. No one comes off better in a brush with any cactus, holly, yucca, spear grass, or prickly pear." One group of succulents, called stone plants, have camouflaged leaves that fool predators. The plants bury themselves below ground where they stay shaded and cool. Only the surface of their thick, fleshy leaves remains

exposed, looking like pebbles or stones on the surface of the soil. To take advantage of sporadic moisture from rain and dew, succulents have shallow, but extensive root systems covering large areas to absorb water before it evaporates. When rainfall is plentiful, succulents jump into action; some species are capable of forming leaves, flowers and seeds in less than one month. Having a short growing season is advantageous in inhospitable climates—being dormant during the hottest part of the year ensures survival.

98. VELVET ROSE, *Aeonium arboreum*

Aeonium's origins are exotic: Arabia, Ethiopia, the Mediterranean region, and the north Atlantic islands. In five to seven years, plants reach maturity, bloom, set seed, and then die.

102. RED ALOE, *Aloe sp.*

"I went along the seventh circle's margin alone, and passed to where those doleful people sat. Their woes burst from their eyes, their hands were doing their best to shield them from the torments, shifting place from here to there—one moment falling flames, the next, burning ground: just like the ways of dogs in summer when they scratch, sometimes with paw and others with muzzle, they behaved as though fleas or flies or gadflies bit their limbs."—*The Inferno of Dante*, translated by Robert Pinsky.

103. ORANGE MAMMILLARIA, *Mammillaria sp.*

"Here hangs in shades the orange bright, Like golden lamps in a green night."
—Andrew Marvell, *Bermudas*.

104. PINCUSHION CACTUS, *Mammillaria sp.*

In *The Gardener's Essential Companion*, Dora Galitzki advises, ". . . that the most common mistakes that people make are watering too little and too infrequently during the active growing season and thinking that cacti prefer infertile growing media."

105. PRICKLY PEAR, *Opuntia sp.*

The reason behind using the botanical name *Opuntia* for this group of plants is somewhat mysterious. The genus consists of over 200 species, all native to the Americas, yet the name is based on a plant that grew near the Greek city Opus.

106. CRASSULA, *Crassula sp.*

Members of the crassula family have the widest range of habitats—from desert to marsh, putting them in very diverse climates. Some are shrubby, but most are perennial with succulent leaves that have hairy or waxy coverings protecting them from sun and wind.

107. PINCUSHION CACTUS, *Mammillaria sp.*

"In the rain forests, epiphytic orchids, bromeliads and ferns live high on the trees, with a high degree of organic humus and very little mineral supply at all; cacti and succulents, by contrast, inhabit semi-deserts where the proportion of humus is minute, but the quantity of minerals is large. Plants, it seems, can grow anywhere; no matter how impoverished, imbalanced, or toxic a soil "—Anthony Huxley, *Green Inheritance*.

108. ECHEVERIA, *Echeveria sp.*

In flowerbeds and containers, echeverias make handsome specimens during the warm summer months. These tender plants cannot survive cold temperatures. However, they make suitable houseplants in winter, preferring cool temperatures and bright light.

109. ALOE, *Aloe* sp.

The aloe symbolizes bitterness, but also integrity and wisdom. It was sacred to Zeus and to practitioners of folk medicine as a burn remedy.

110. GRAFTED CACTUS, *Echinopsis* sp.

Colored cacti are novelties and usually have a short life span. Their nongreen coloration means they do not photosynthesize and need to be grafted on to a green "host" to provide nourishment. However, the two portions are rarely compatible, and the top usually succumbs from lack of food.

111. ECHEVERIA, *Echeveria* sp.

Echeverias are succulent-leaved, tender plants from Central and South America. Their rows of fleshy leaves overlap each other to form tight rosettes that look like flowers.

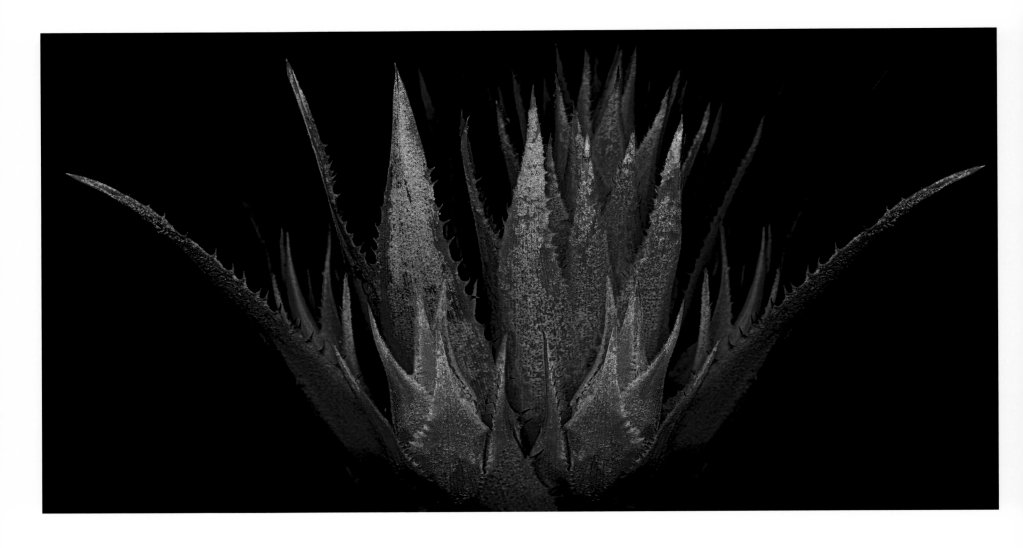

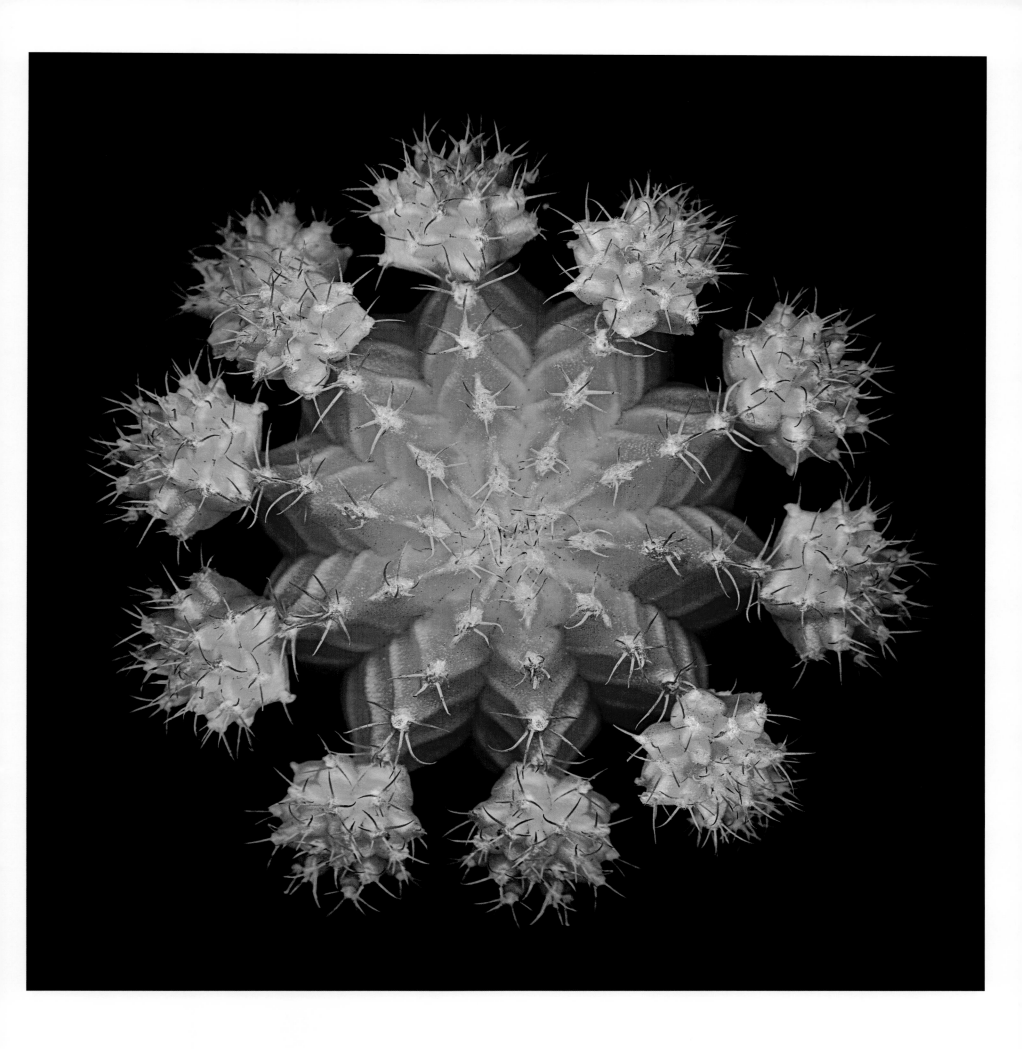

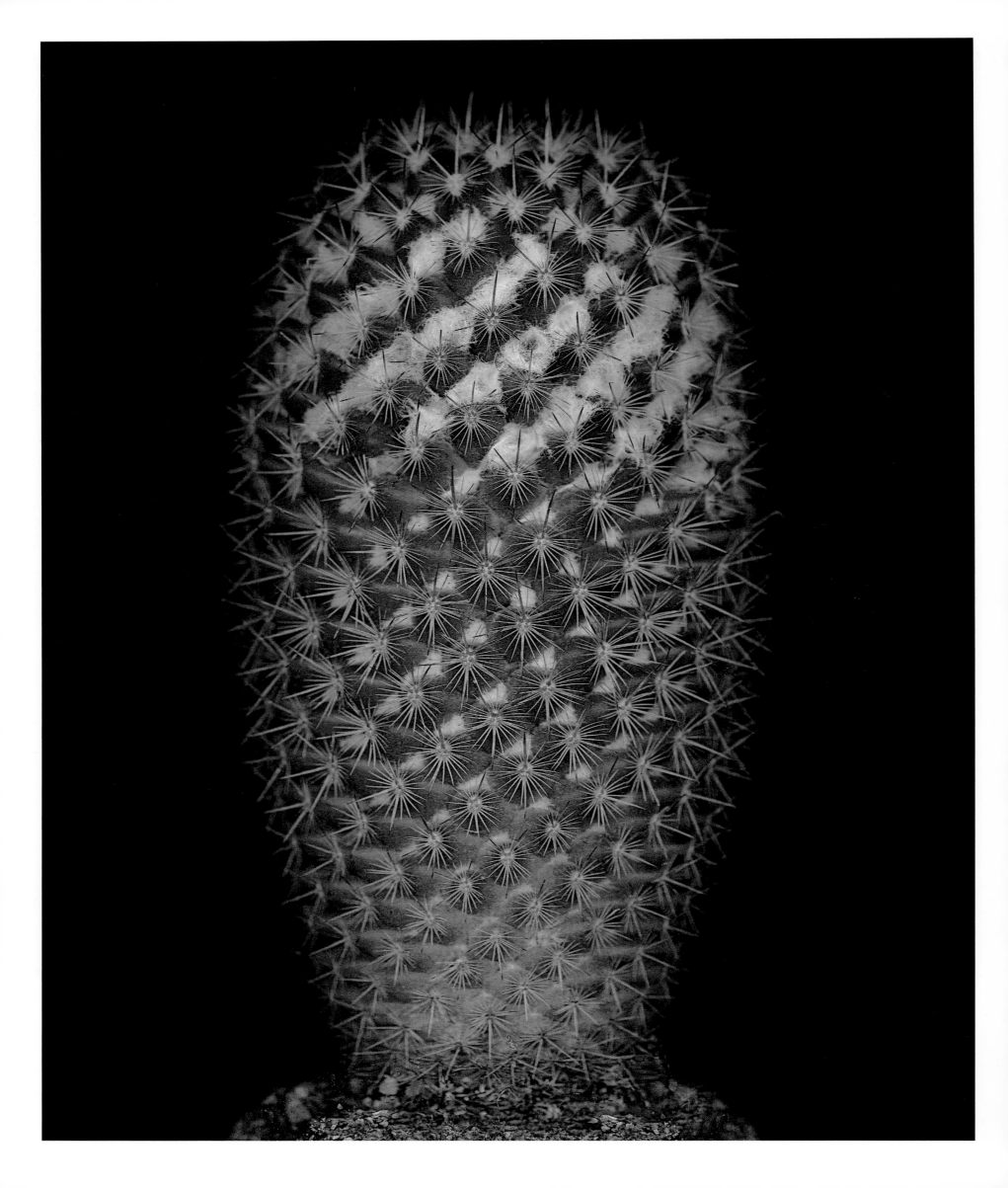

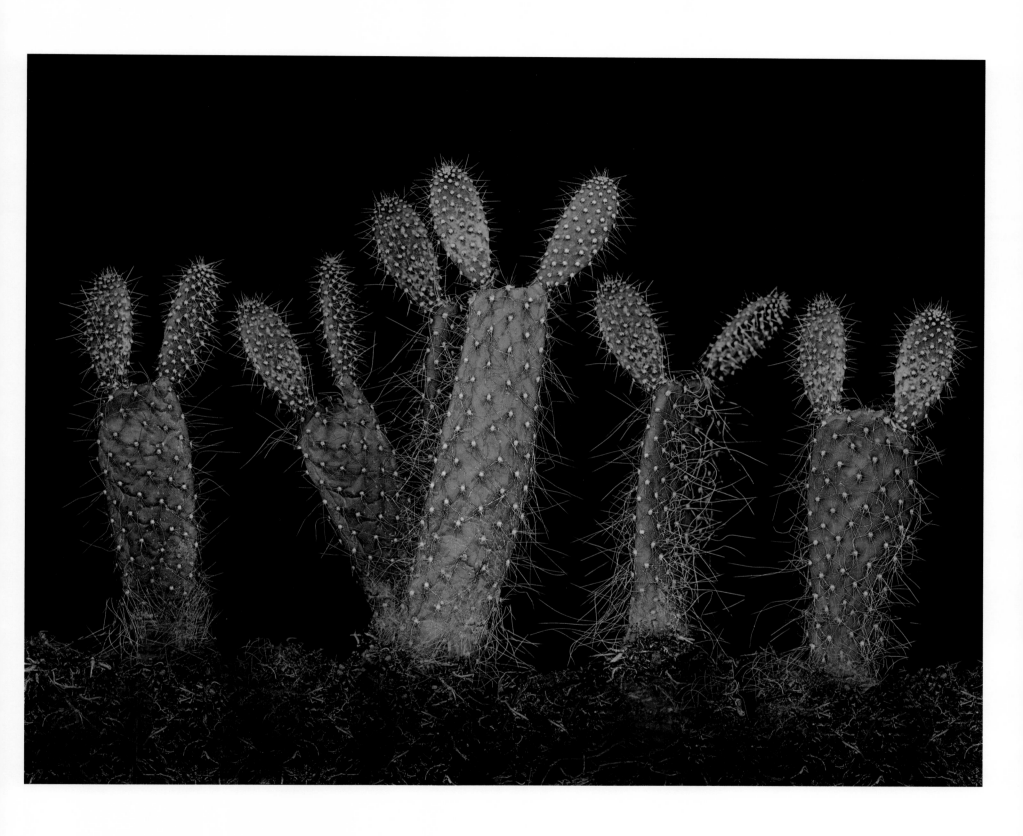

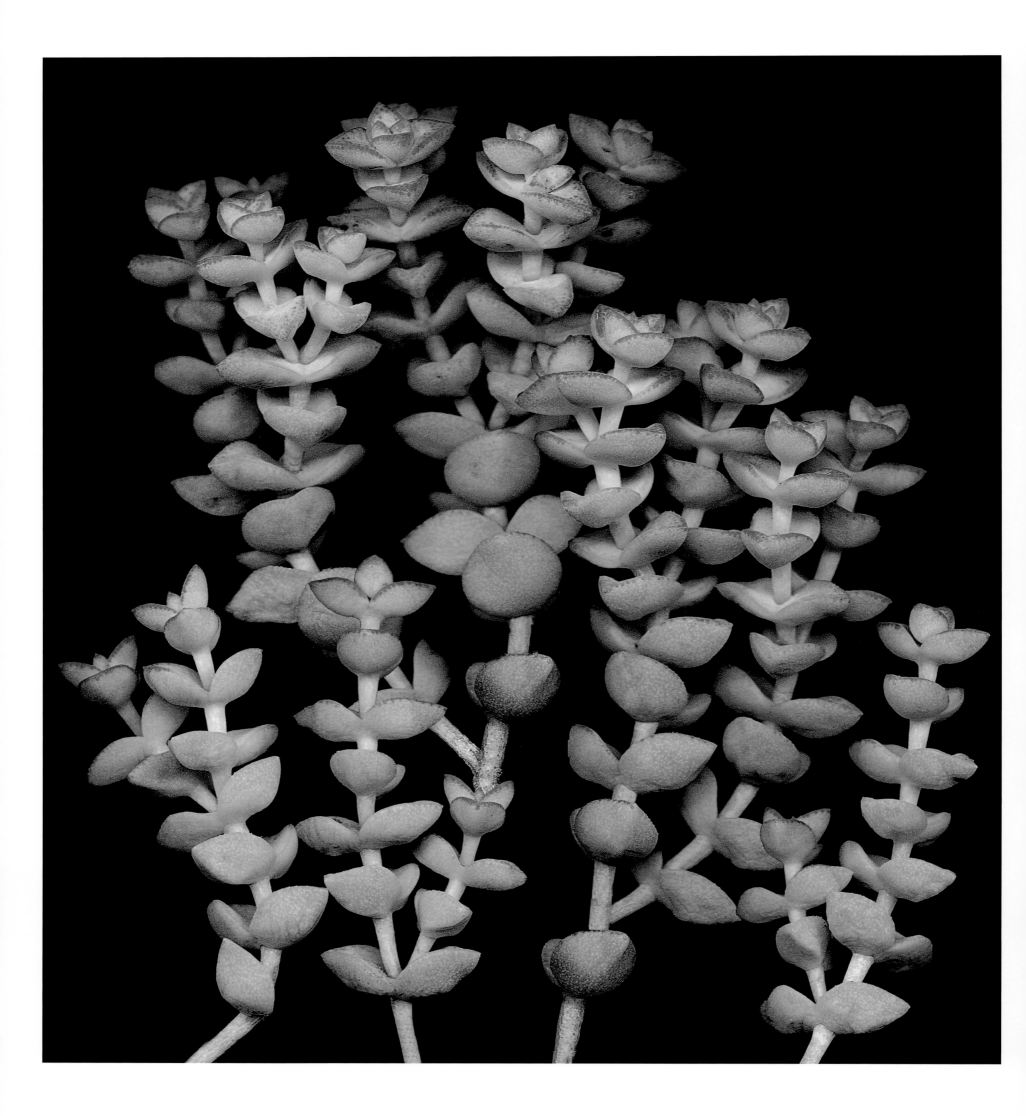

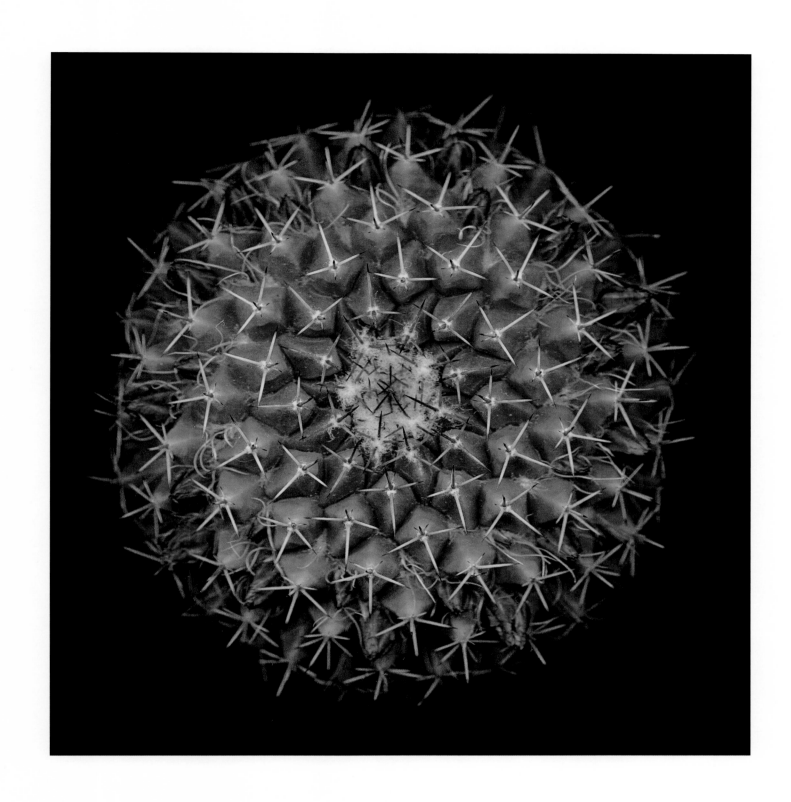

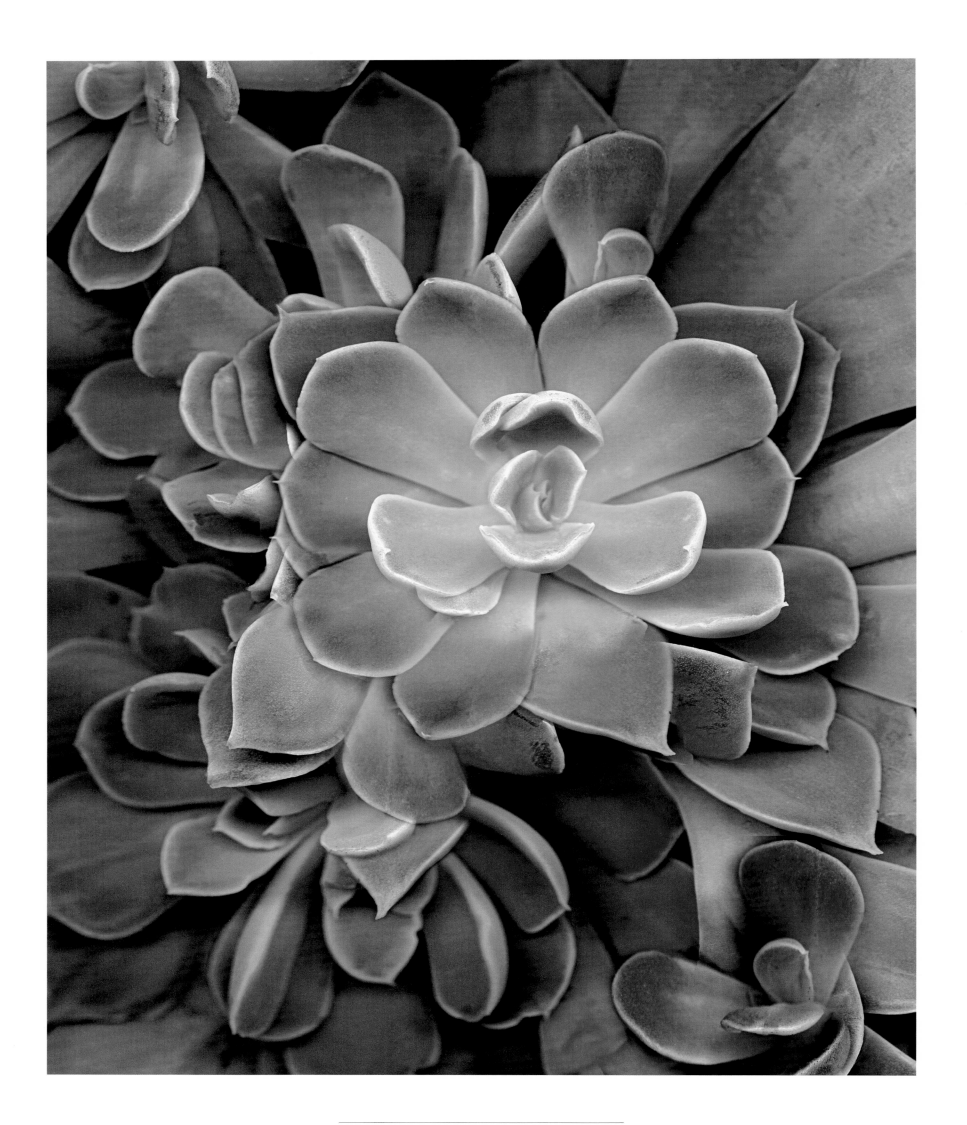

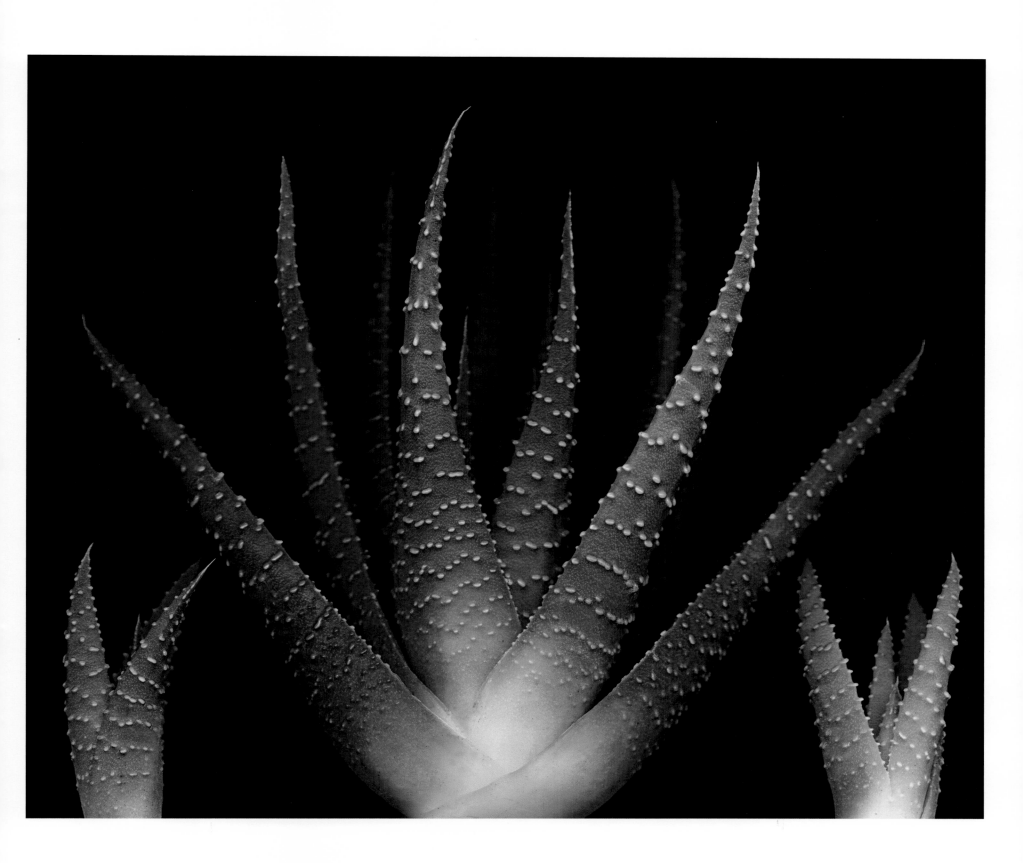

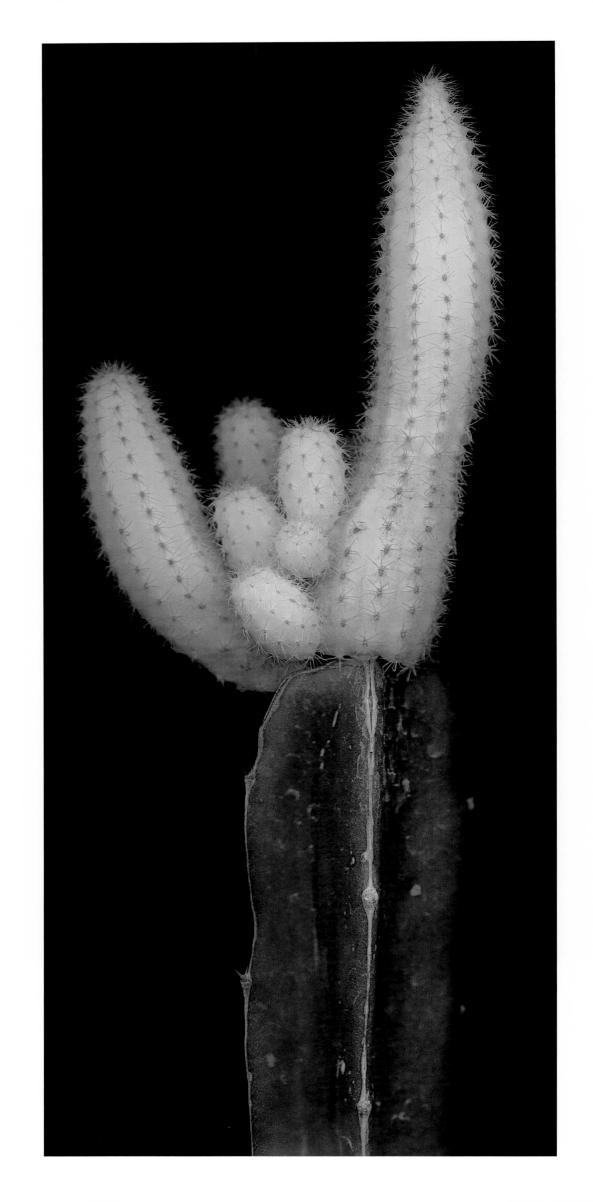

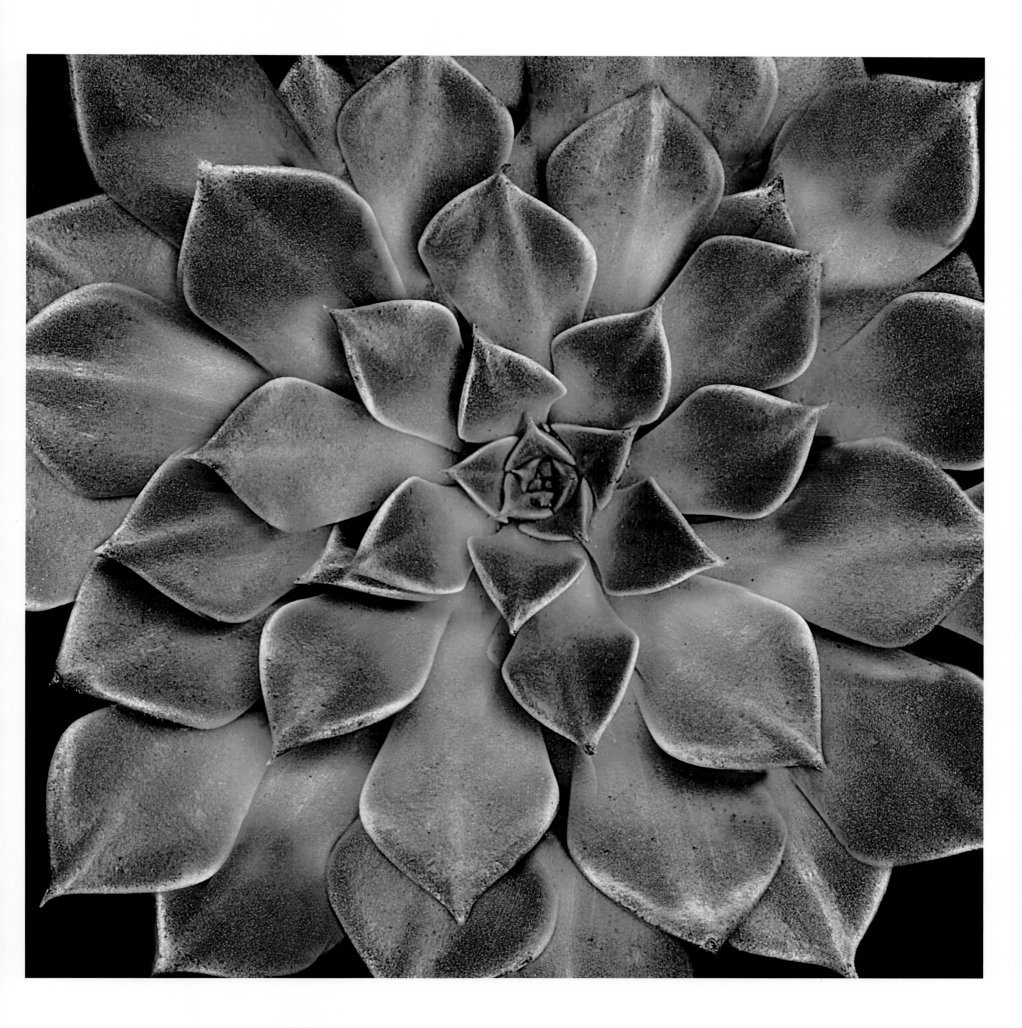

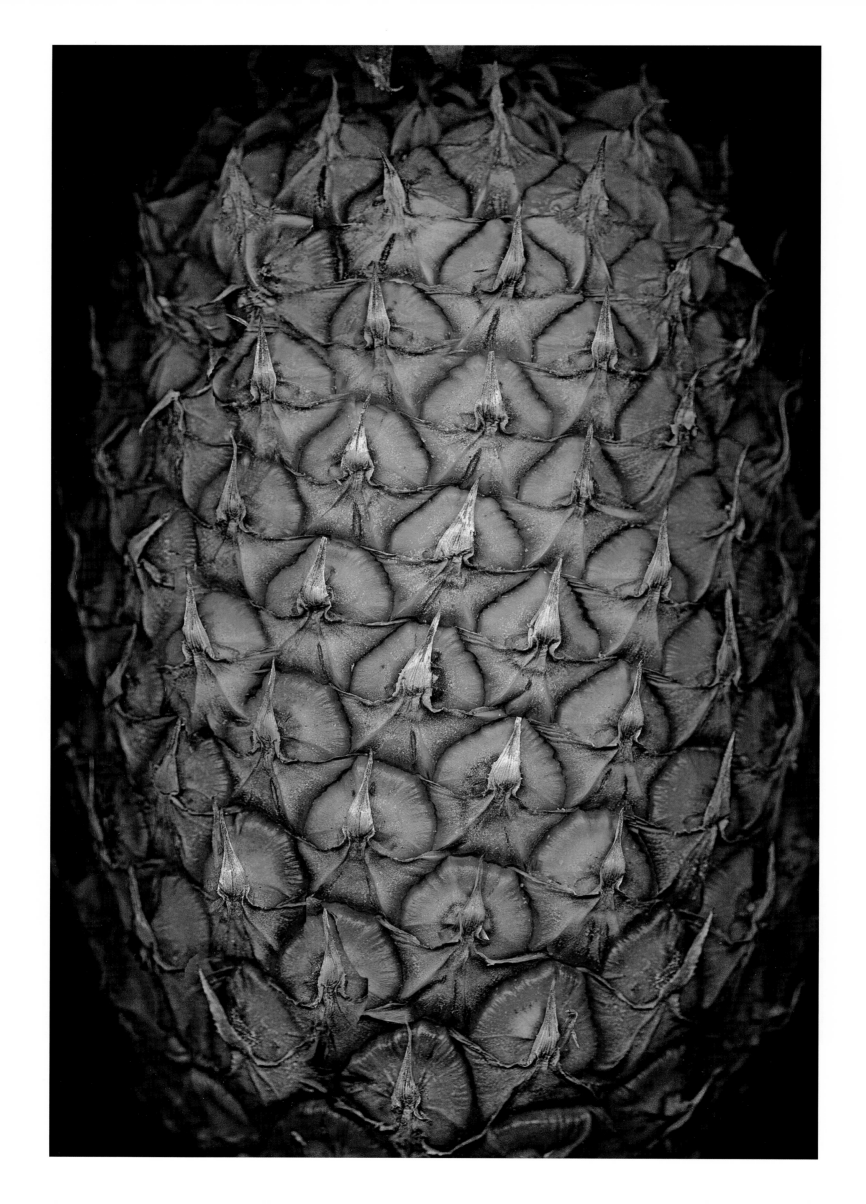

SEEDS OF CHANGE

In the wild, and in cultivation, plants have an innate desire to survive. They evolve and adapt to new situations by reproducing—most do this by sexual propagation, resulting in seeds. Two types of seed-bearing plants exist—gymnosperms (meaning "naked seed") such as conifers; and angiosperms, which enclose their seeds in protective coverings called fruits. Gymnosperms are nonflowering plants—their reproductive organs are the evolutionary precursors to flowers, and lack ovary walls. Only angiosperms (meaning "housed seed") produce true flowers, and when pollinated and fertilized, their ovary walls enlarge to become fruits.

The fruit that develops from a flower can be one of many kinds—a berry, a nut, a capsule, or one of a dozen others that is either dry or succulent. Fruits protect developing seeds, and when ripe, help disperse them. Dry fruits might burst open, propelling the seeds with explosive force, or they may simply crack, releasing seeds to the ground or the wind. Other dry fruits don't open until their outer coverings are either weathered away, or the germinating seed cracks them from within. Many of these fruits try to travel great distances from their parent—they have hooks or hairs, enabling them to catch a ride as passersby brush against them; they have wings, or umbrellas of hair-like filaments, to float on the breeze. The succulent fruits have appealing outer coverings and good-tasting flesh that attracts and rewards the hungry. In the wild, this prize comes with string attached; as predators eat the fruit, they unwittingly become dispersal agents to a new generation of seeds.

With creative intuition, the concept of bearing fruit is transferred to objects and theories. By this interpretation, productive ideas, land, and labor are considered fruitful or fertile. Strangely, these two words are synonymous; they both imply prolific or abundant productivity, yet fruitfulness cannot happen without fertility, it is dependent upon it. Fruition is similar, but it infers accomplishment without signifying abundance.

A symbol of fruitfulness and fertility—the horn of plenty, or cornucopia—expresses the abundant and bountiful harvest of the earth's goodness. It is linked to the mythological god and goddess of the earth—Demeter, goddess of corn and Dionysus, the god of wine. These two are unlike other immortals in their attachment to the earth and its cycles. Demeter champions all grain-bearing plants, but is called goddess of the corn because corn in the archaic word for grain. Dionysus—called Bacchus by the Romans—is the god of the grapevine, and together with Demeter, bestows the gifts of bread and wine on humanity. Bloody sacrifices were not offered to honor these deities. Instead, they were celebrated with every act that nurtured grains and grapes, and by making and consuming bread and wine. In *Mythology*, Edith Hamilton writes, "It was natural that they should be worshiped together, both divinities of the good gifts of earth, both present in the homely daily acts that life depends on, the breaking of bread and the drinking of wine." The cycles of the earth reflect the temperaments of Demeter and Dionysus.

When afflicted with tragedy, they grieve and withhold their fertile gifts of the soil, the earth becomes lifeless, sorrowful, and cold, no longer producing. The myths support the presence of aging, mortality, and change upon all earth-bound life. The principles of physical and spiritual alchemy are also guided by the process of change and strive to cooperate with it. Since nothing remains constant, acknowledging and preparing for an end—or even a change—embraces maturity, ripeness, and death as essential parts of life.

Every blade in the field,

Every leaf in the forest

Lays down its season

As beautifully as it was taken up

—Henry David Thoreau

112. PINEAPPLE, *Ananas comosus*
"Pineapples are consumed fresh, canned and processed to give juice. The juice may be fermented for vinegar or further distilled to give an alcoholic spirit."
—*The New Oxford Book Of Food Plants.*

117. PINEAPPLE, *Ananas comosus*
The pineapple was "domesticated in tropical South America in pre-Columbian times. It was first seen by Europeans on the island of Guadeloupe during the second voyage of Columbus (1493–96)."—*The New Oxford Book of Food Plants.*

118. KIWI, *Actinidia deliciosa* cultivar
Kiwis are the fruits of a climbing woody vine native to southwestern China. In the early 1900s seed was taken to New Zealand where it was developed into a fruit of international importance. Kiwis contain high amounts of B and C vitamins.

119. TURBAN SQUASH, *Cucurbita mixta* cultivar
"There are numerous varieties of squash, from Acorn to Zucchini, with strikingly different size, shape and colored fruits. Scientists are investigating how they evolved and were domesticated—they are basically a legacy of Native Americans.
—Michael Nee, The New York Botanical Garden.

120. HORSE CHESTNUT, *Aesculus hippocastanum*
"Though I do not believe that a plant will spring up where no seed has been, I have great faith in a seed. Convince me that you have a seed there, and I am prepared to expect wonders."—Henry David Thoreau, *Faith In a Seed.*

121. CORN, *Zea mays*
"I believe in the forest, and in the meadow, and in the night in which the corn grows."
—Henry David Thoreau, *Walking.*

122. STRAWBERRIES, *Fragaria ananassa* cultivar
The technology of genetic engineering has inspired many theoretical gene combinations. One idea is to create strawberry plants with flowers capable of withstanding frost by combining them with cold hardy genes from a northern Atlantic fish.

123. GRAPES, *Vitis vinifera* cultivar

"The native American summer grape belongs to the same distinguished family as the ancient biblical 'vine,' which according to that record was the first plant cultivated by humans. Grapes have been grown for so long by the human race—for seven to nine thousand years—that the original home of the vine cannot be determined with certainty."
—from *Leaves*, Alice Thoms Vitale.

124. SPRUCE CONE, *Picea* sp.

"The Norway spruce, *Picea abies*, is generally planted for ornament and windbreaks. It is a very rapid grower and soon becomes an attractive object on the lawn."
—Liberty Hyde Bailey, *The Cultivated Conifers*.

125. CARDAMOM, *Elettaria cardamomum*

"Spices and herbs have served many purposes according to their historical period such as embalming, the masking of body odor or bad food and the enhancing of flavor in food. Modern methods of food preservation, such as refrigeration, have eliminated the need for herbs and spices to disguise the unpleasant taste of decaying food."
—*The New Oxford Book of Food Plants*.

126. BITTERSWEET, *Celastrus* sp.

"Season of mist and mellow fruitfulness,
Close bosom-friend of the maturing sun. . . ."—Keats, *To Autumn*.

127. CHINESE LANTERN, *Physalis alkekengi*

"In northern climes, when Halloween, Thanksgiving or Guy Fawkes Night come around annually there are all sorts of autumnal or fall ingredients available in warm shades of yellow, orange, red, russet and brown. This is a perfect time of the year to construct a wreath or a welcome ring to hang on the door. . . . "—Paula Pryke, *Flowers, Flowers!*

128–129. CHERRY, *Prunus* sp.

"Cherry ripe, ripe, ripe, I cry
Full and fair ones; come and buy!
If so be you ask me where
They do grow, I answer, there
Where my Julia's lips do smile;
There's the land, or cherry-isle."
Cherry Ripe—a poem by Robert Herrick about the mythological garden of Hesperides.

130. RHODODENDRON (Flower Buds and Fruits), *Rhododendron catawbiense* cultivar

In *Growing and Propagating Showy Native Woody Plants*, Richard Bir writes about the American native, *Rhododendron catawbiense*—"Festivals are scheduled to view the splendor of acres of natural rhododendron gardens in the southern mountains. In the home landscape the effect of this neat, large-leaved shrub in full flower is rich and lush while orderly."

131. RED BARBERRY, *Berberis thunbergii* 'Atropurpurea'

"*Berberis thunbergii*, a Chinese kind, is particularly beautiful because of the rich scarlet and orange coloring of the leaves in autumn. It grows five to six feet high and bears yellow flowers and red fruits. The variety 'Atropurpurea' has purple foliage."
—*New Illustrated Encyclopedia of Gardening*.

132. NORWAY MAPLE LEAVES AND FLOWERS, *Acer platanoides* cultivar

Many maples have attractive summer leaves changing to brilliant yellows and reds in autumn. Some also have appealing bark that peels or flakes from the trunk and branches, adding interest once the leaves have fallen. Although few have noticeable flowers, they do have flowers—they must to produce the typical "propeller-like" fruits.

133. ASH (Foliage and Fruit), *Fraxinus sp.*

"On Walpurgis Night, witches were said to nibble the buds of the ash tree as a prelude to their annual supernatural bash; conversely, in the superstitious sixteenth century, ash keys—the crispy single-winged samaras that comprise the ash fruit—were held to ward off witches and serpents."—Rebecca Rupp, *Red Oaks and Black Birches*.

134. SOURWOOD FRUITS, *Oxydendrum arboreum*

"Its miniscule white blossoms, standing in rows on slender, drooping stems, earned it the name, lily of the valley tree. And the fragrant honey that bees distill from these small, perfumed flowers is the most prized in the south because of its light color, heavy body, and unique, tangy taste."—from *Leaves*, Alice Thoms Vitale.

135. TEASEL, *Dipsacus fullonum*

Up until a few years ago, the spiky seed heads of teasel were found to be the best way for fabric mills to raise a nap on woven fabrics. This native of Europe and Asia has become naturalized in North America, and when dry, is favored by flower arrangers.

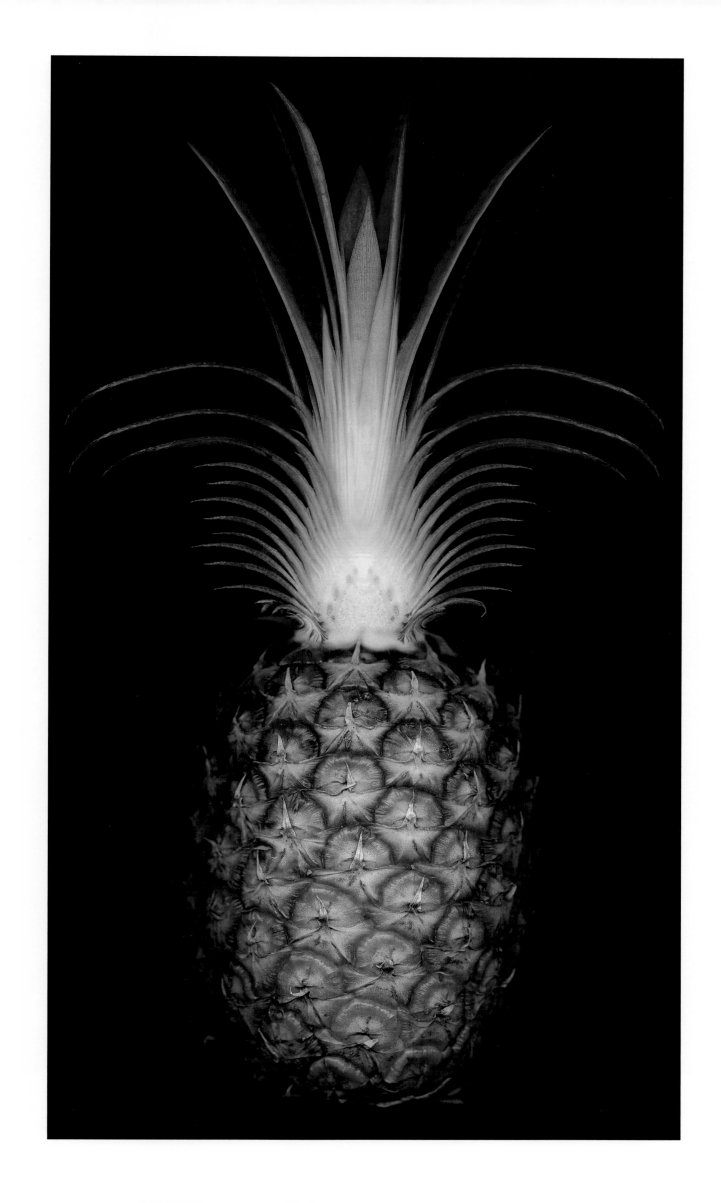

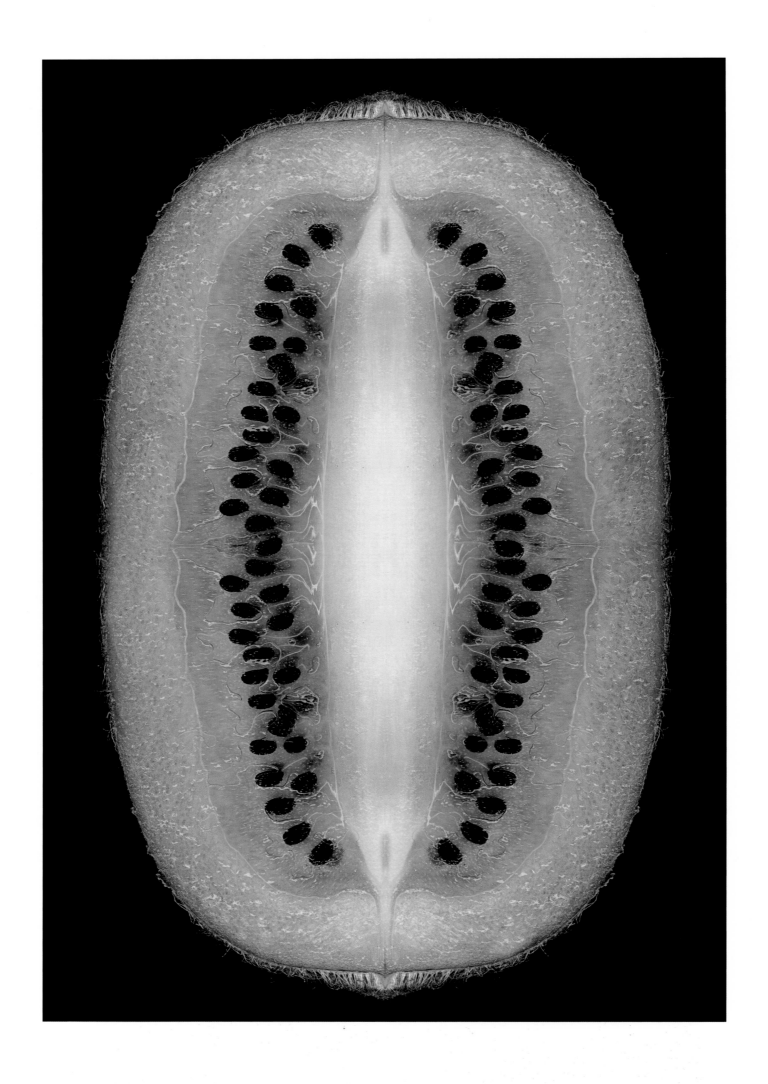

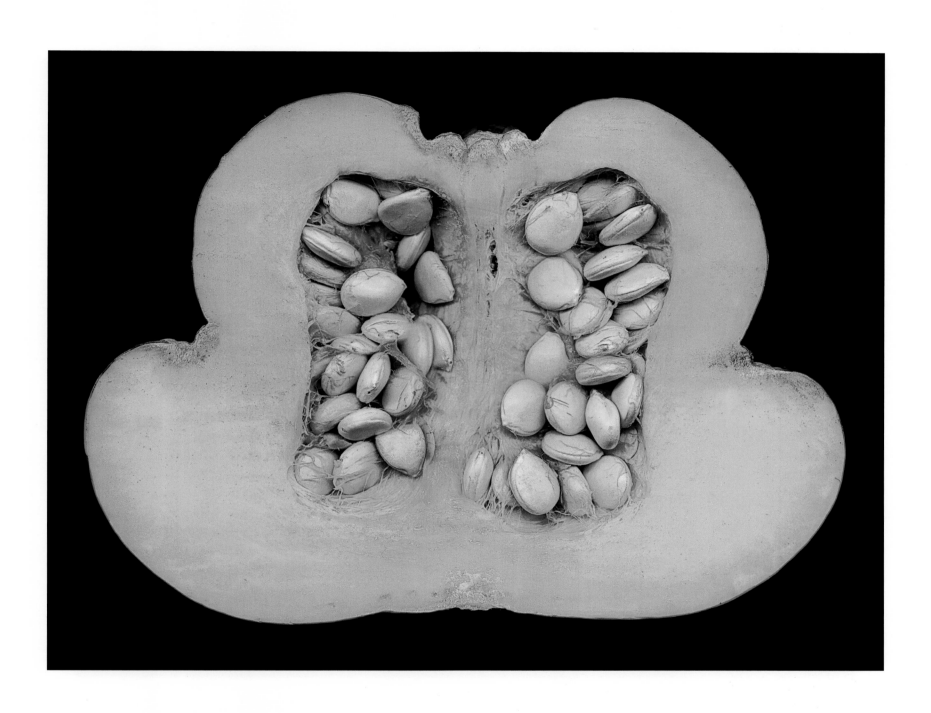

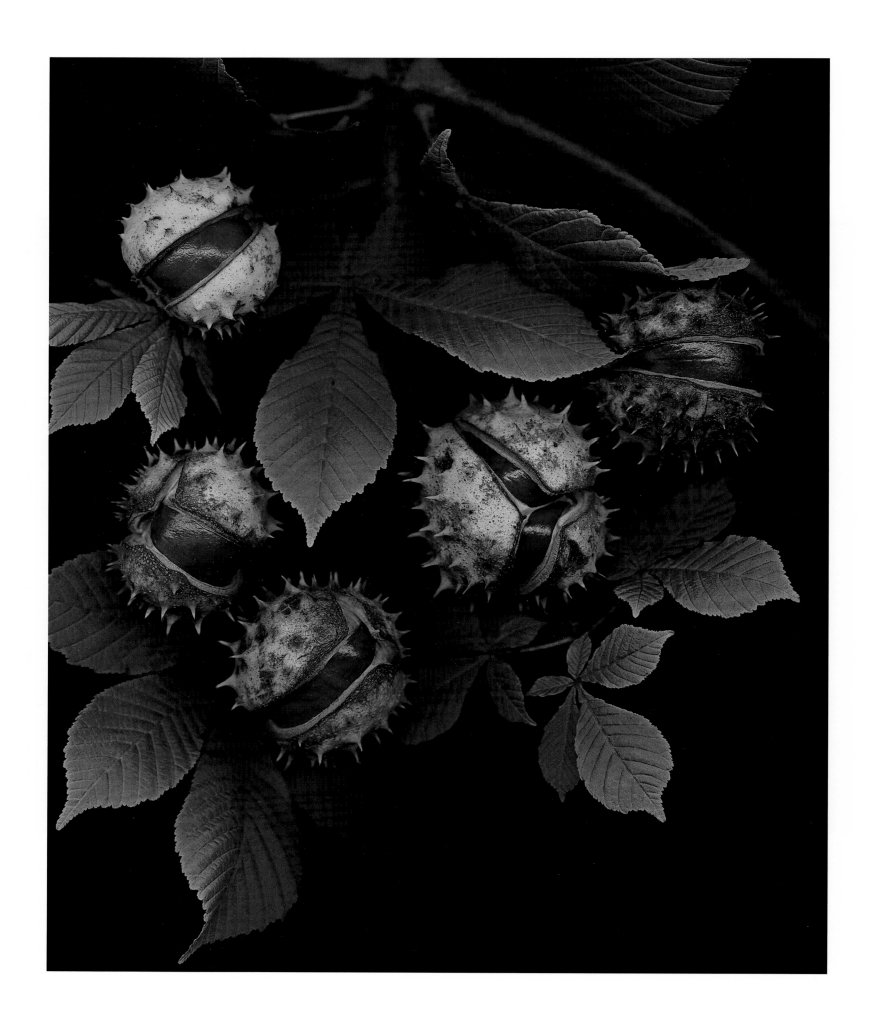

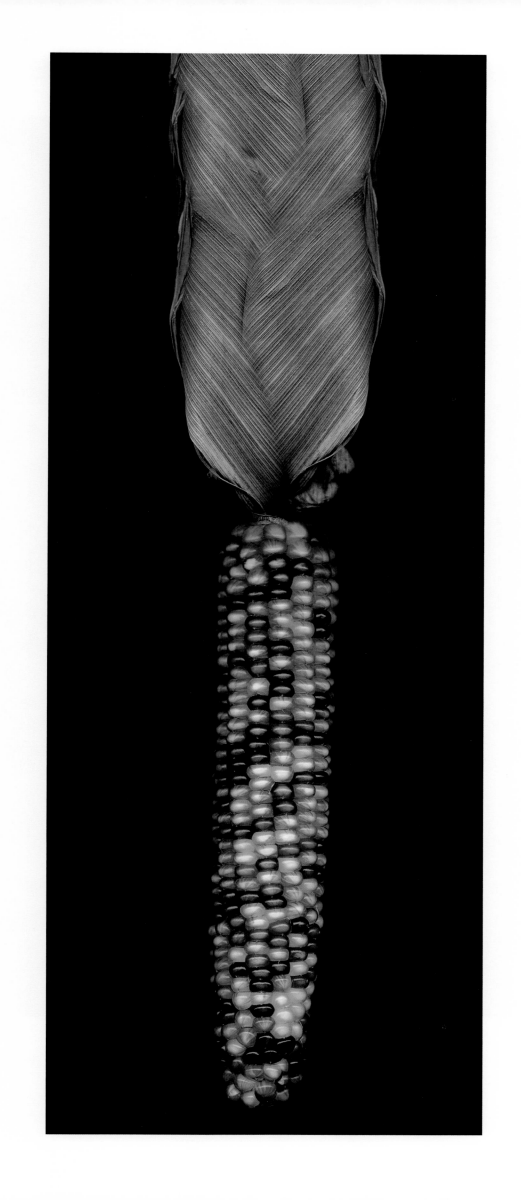

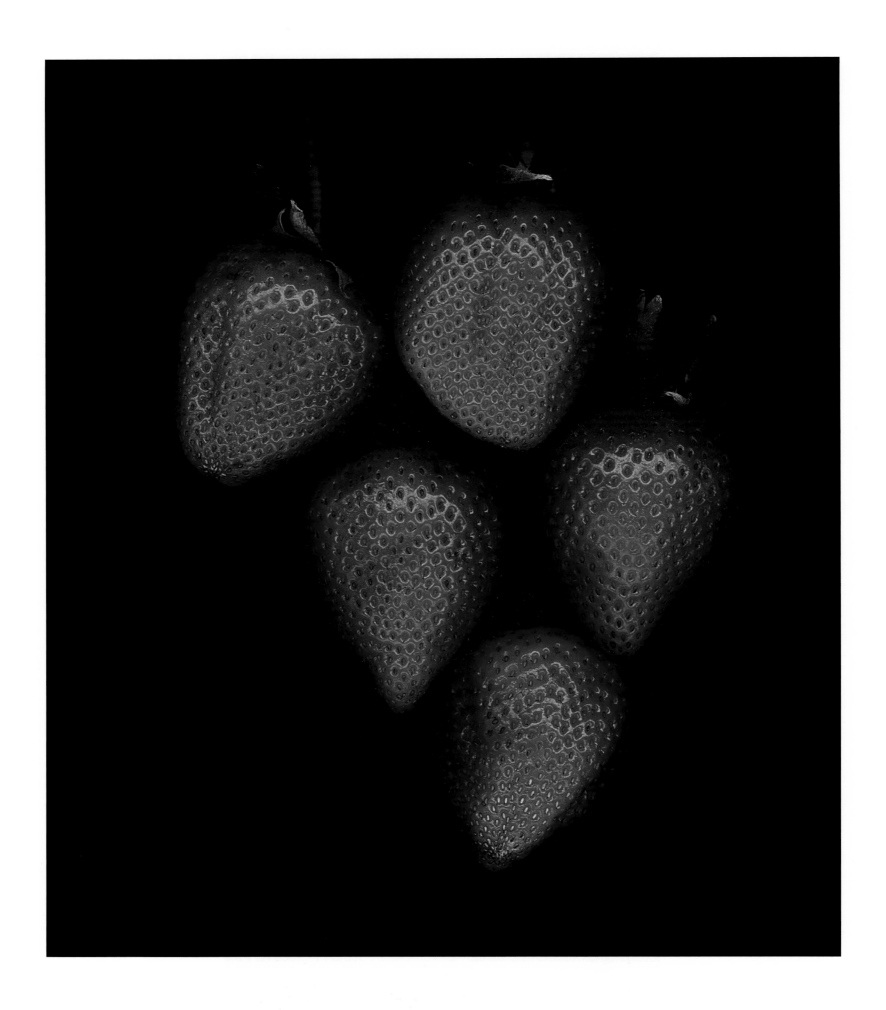

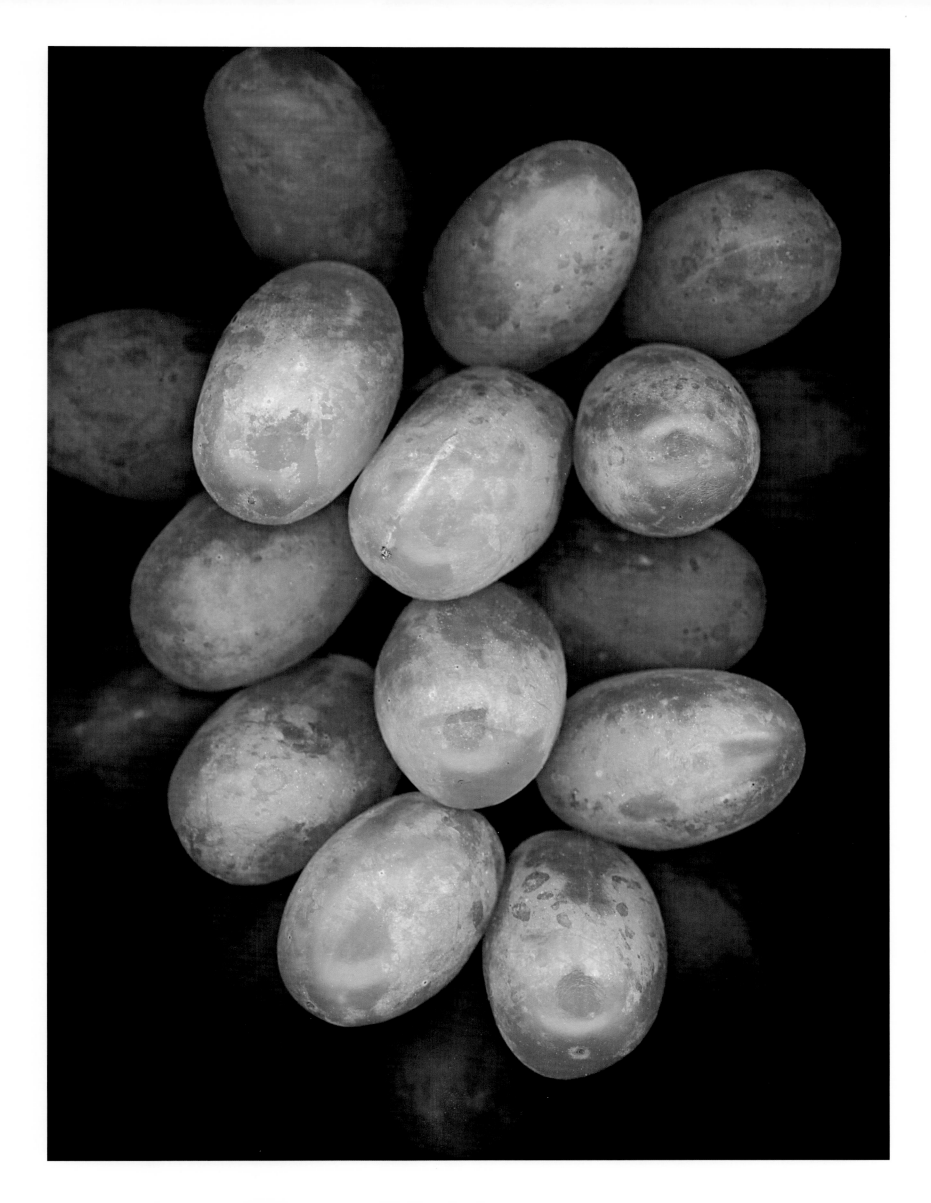

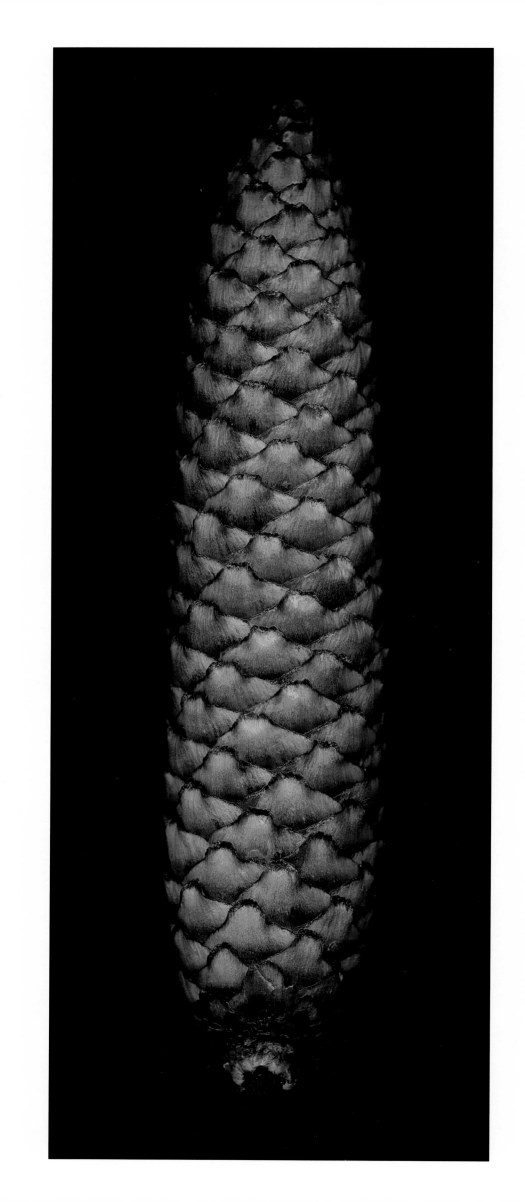

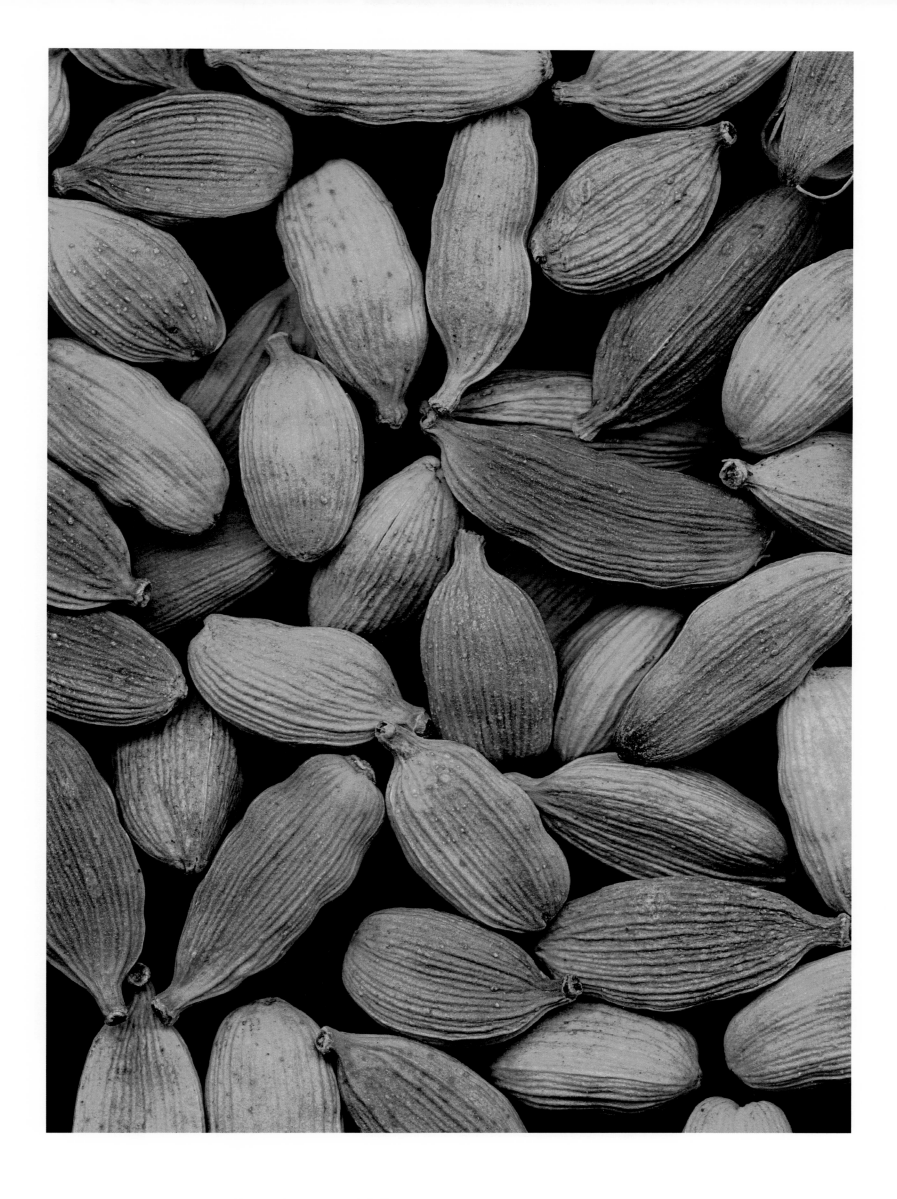

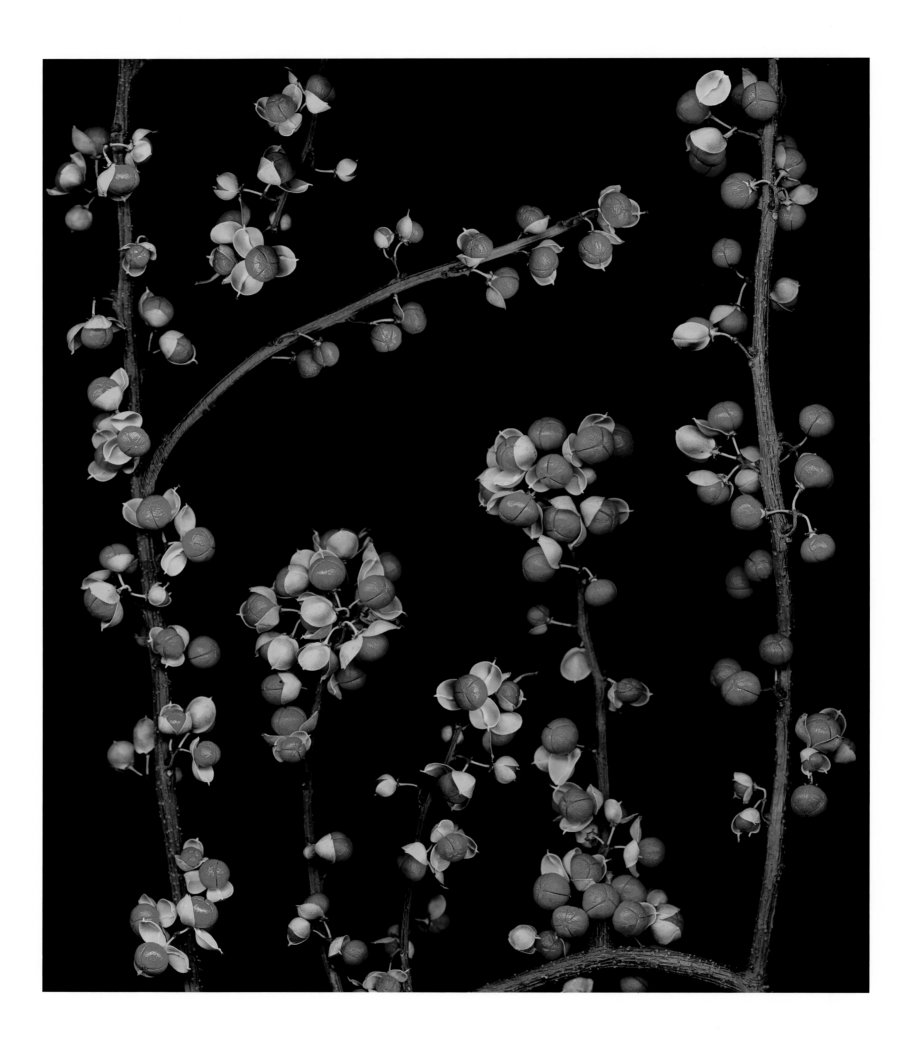

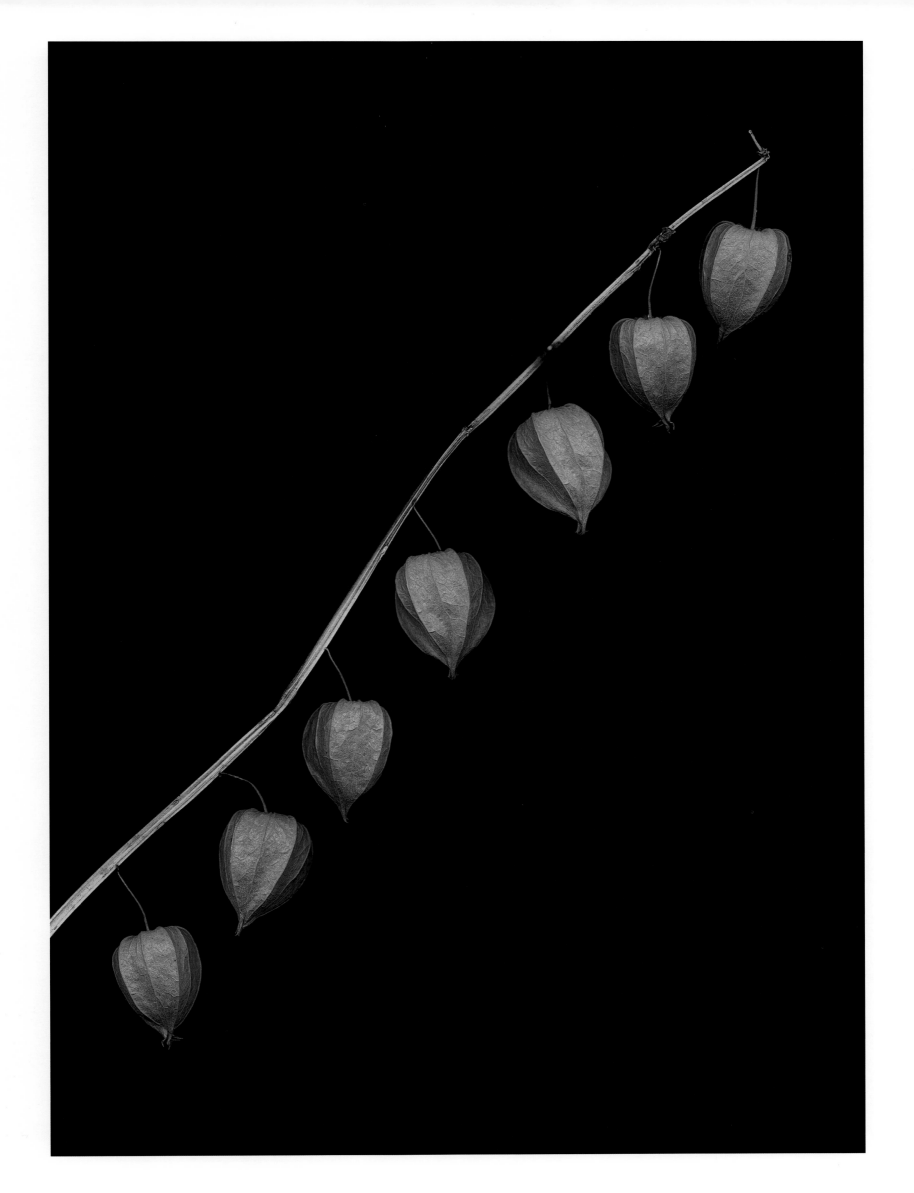

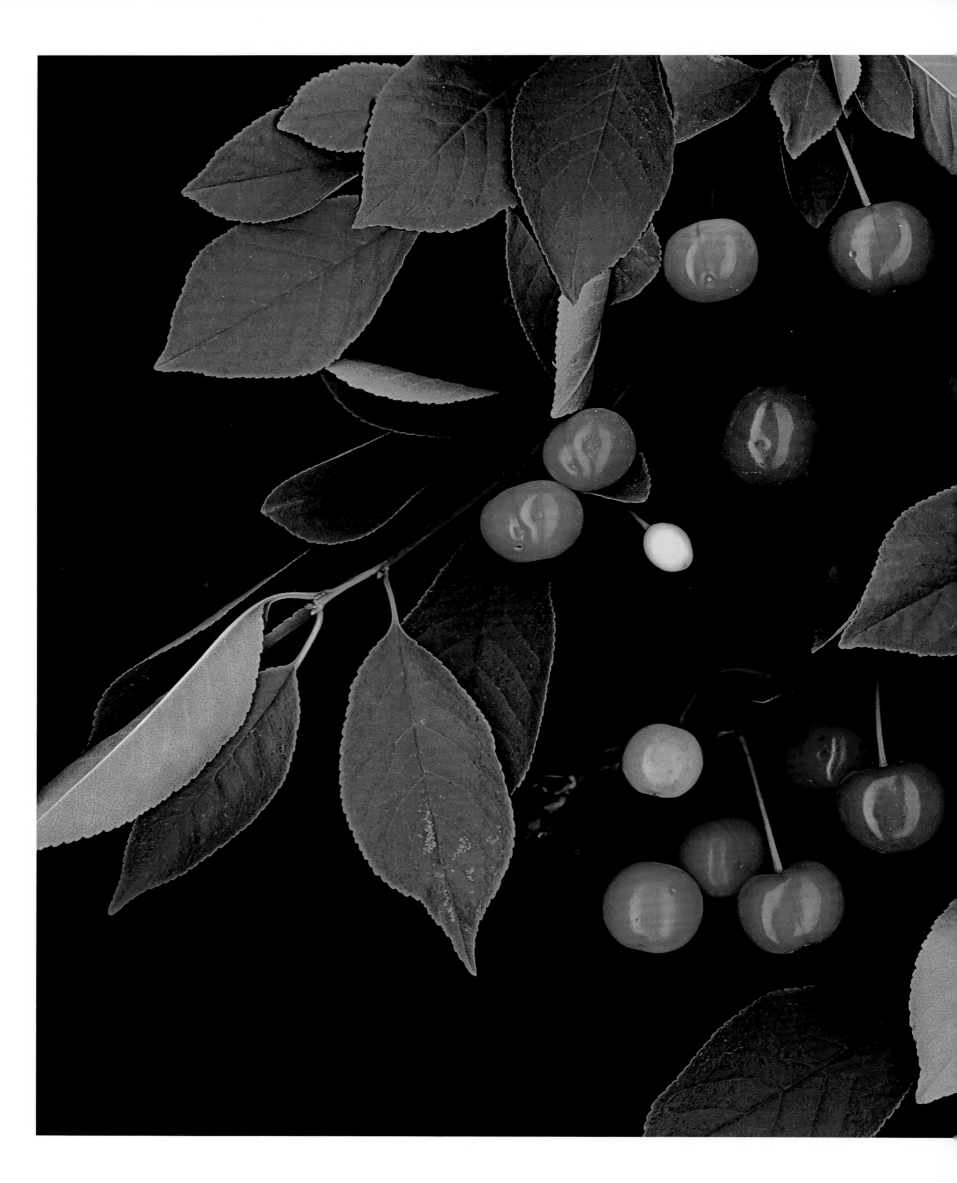

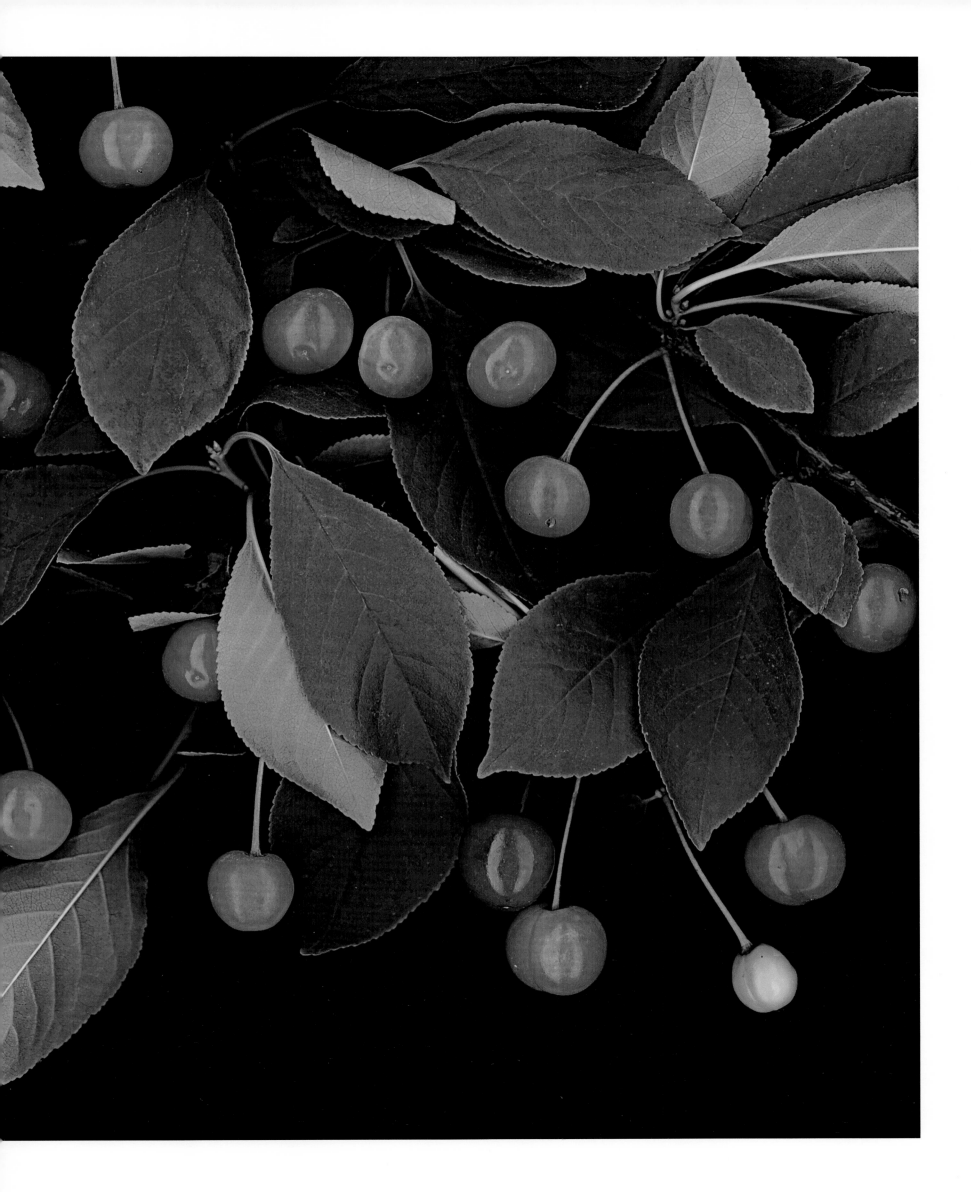

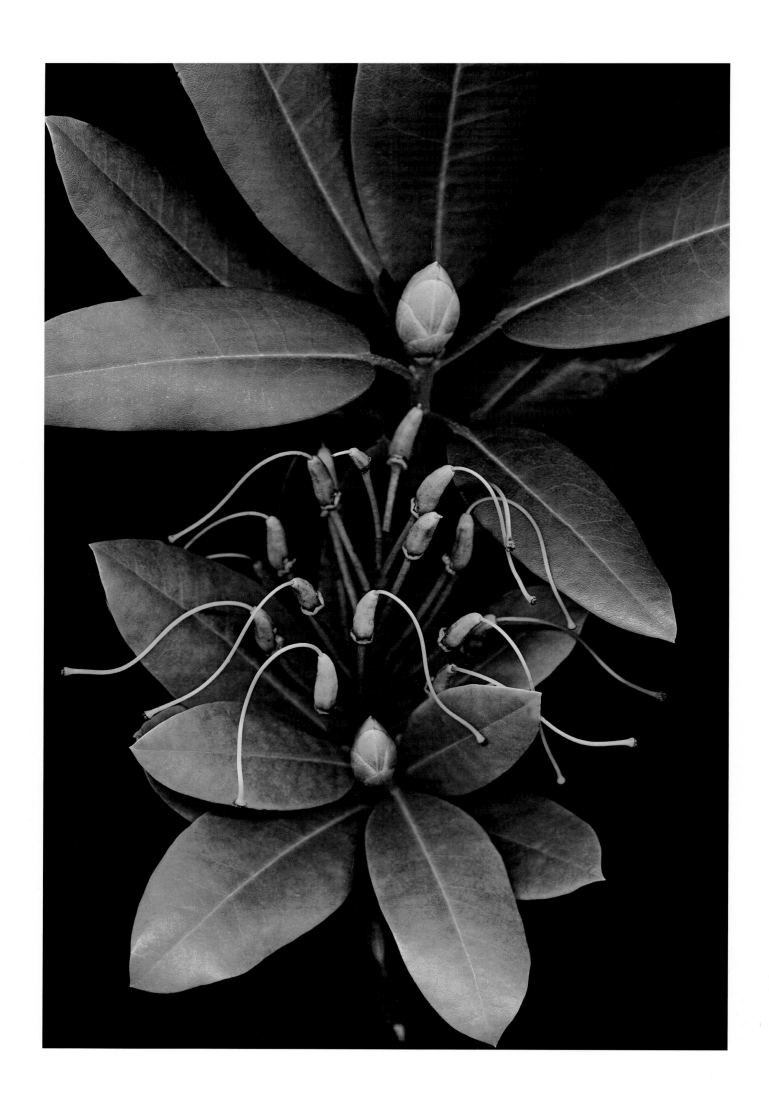

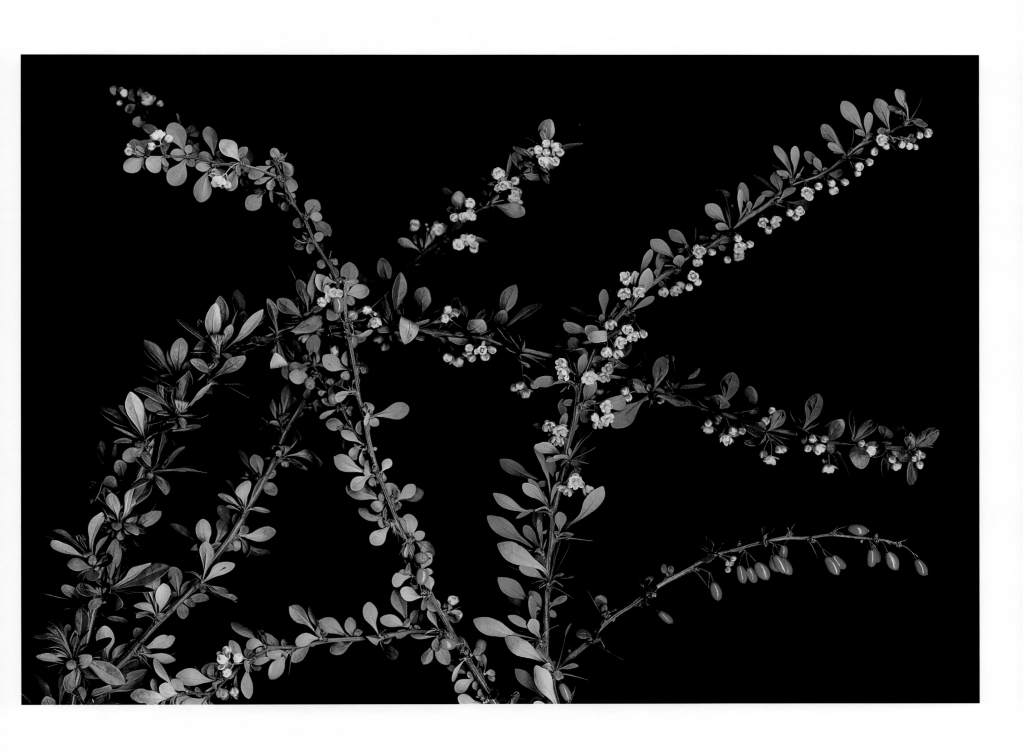

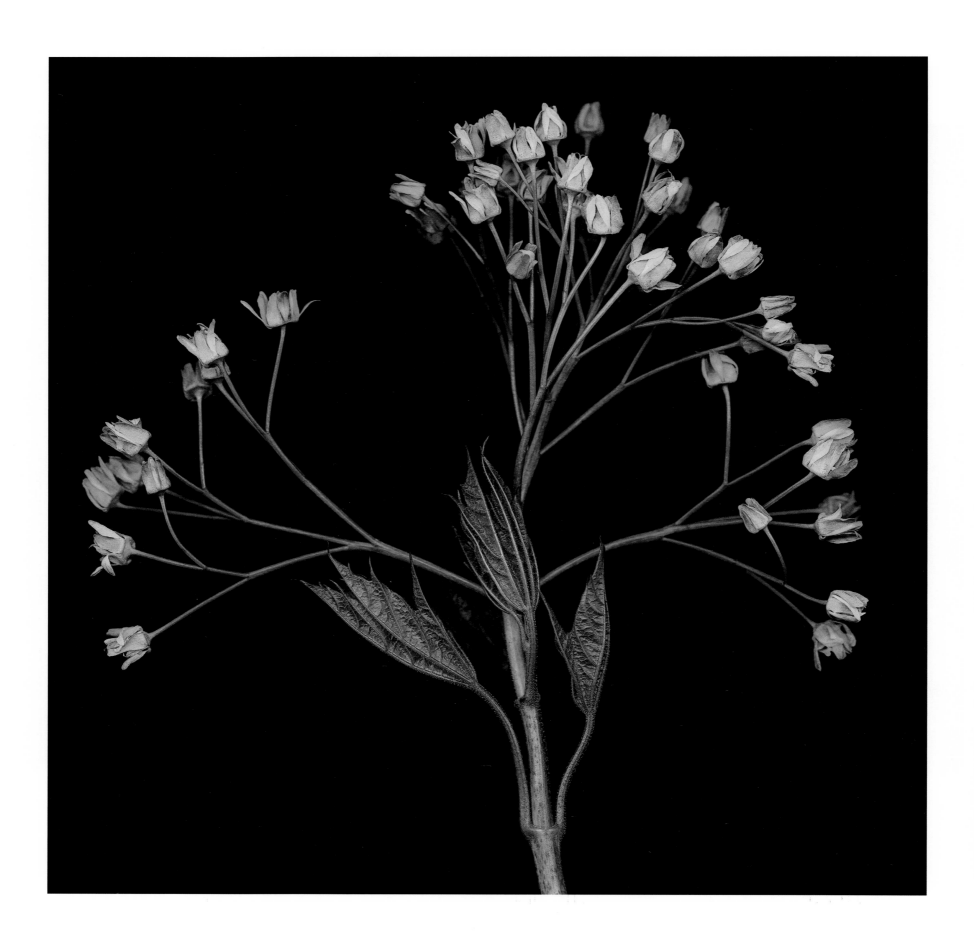

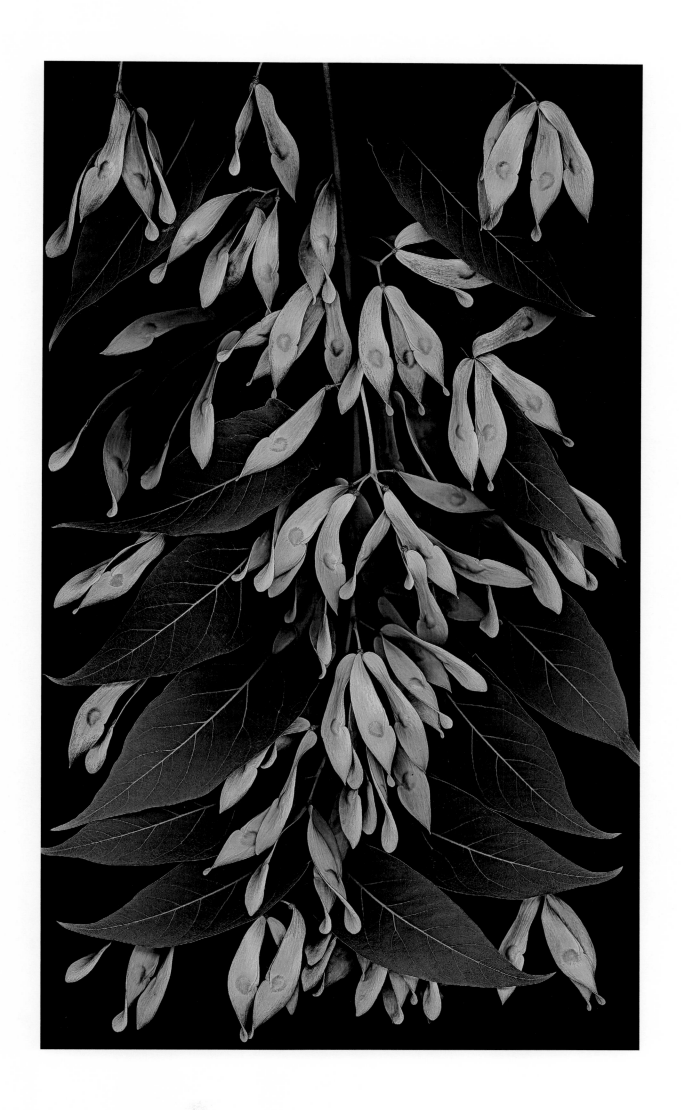

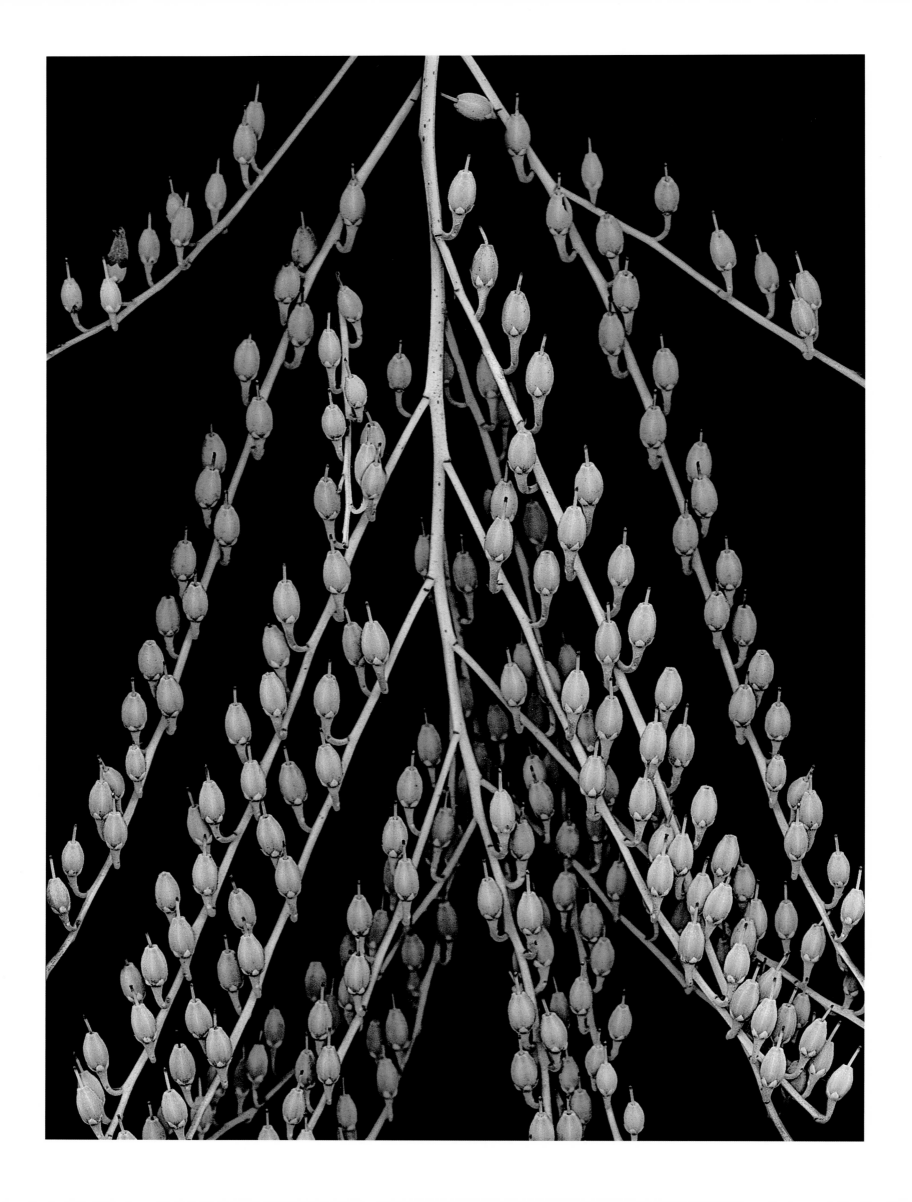

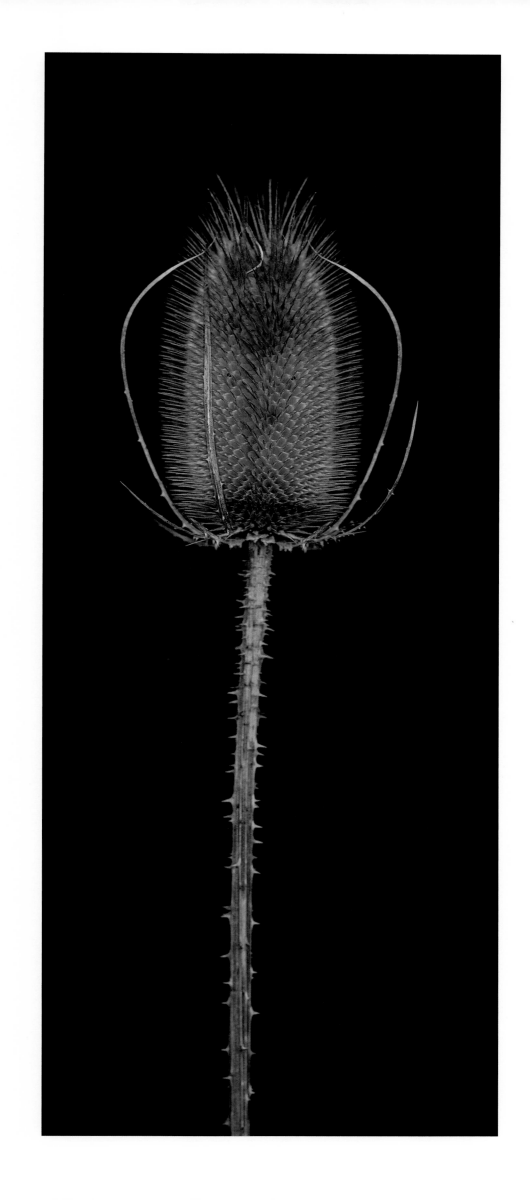

ACKNOWLEDGMENTS

I would like to extend heartfelt thanks to the following individuals without whom this book could not have been realized. To Constance Sullivan of Hummingbird Books, for her wizardry in shaping and producing *Foliage*; her mastery of bookmaking and impeccable standards were an inspiration. To Katy Homans, for her singular design and typesetting, and to her assistant, Christine Moog, for her tireless efforts in implementing the design. I also want to thank Carol Judy Leslie, publisher, and Karen L. Dane, editor, at Bulfinch Press, for their enthusiastic efforts on behalf of the book. Thanks also to L.E.G.O. for their extraordinary printing. The advice and encouragement of curator Leslie Nolan continue to be invaluable.

Others who have provided assistance, support and inspiration are: Beth and Ron Black, Ruth Thompson, Betty and Tom Thompson, David and Nancy Caras, Stephanie Hobbs of PBI, Pat Rodegast, Lou Strano, Tim Daley, Tony Passara, and Rick and Jackie McCabe.

Lastly, I want to especially acknowledge the support of Mark Radogna and Fabia Barsic-Ochoa of Epson America, whose printers and scanners made this project feasible.

H. F.

INDEX

This book is in memory of my daughter Robin Kovary, whose life ebbed and passed away as the images in this book were being created. Her life and work blessed all those who were lucky enough to have known her and the many who never will.

The book is simply a blade of grass in a meadowland filled with wonders. I am overwhelmed with gratitude and inspiration for the abundance of the life that surrounds us, and have tried with these images to convey my sense of joy for the endless miracles of God's work.

Foliage is dedicated to my wife and soul mate, Judith, and my son, Gjon, whose love and support remain a constant source of nourishment in my life.

H. F.

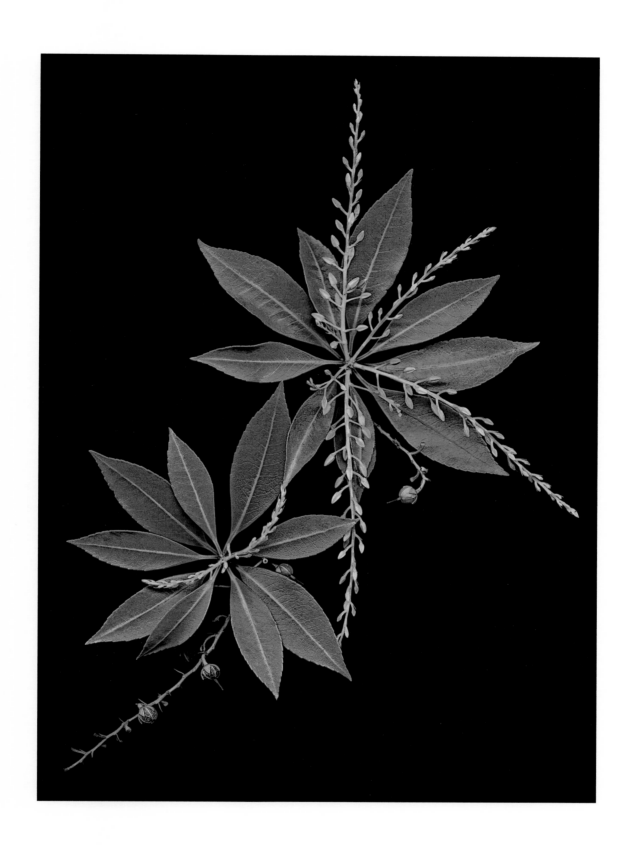